DIGITAL ART MASTERS

: VOLUME 7

DIGITAL ART MASTERS

: VOLUME 7

3dtotal PUBLISHING

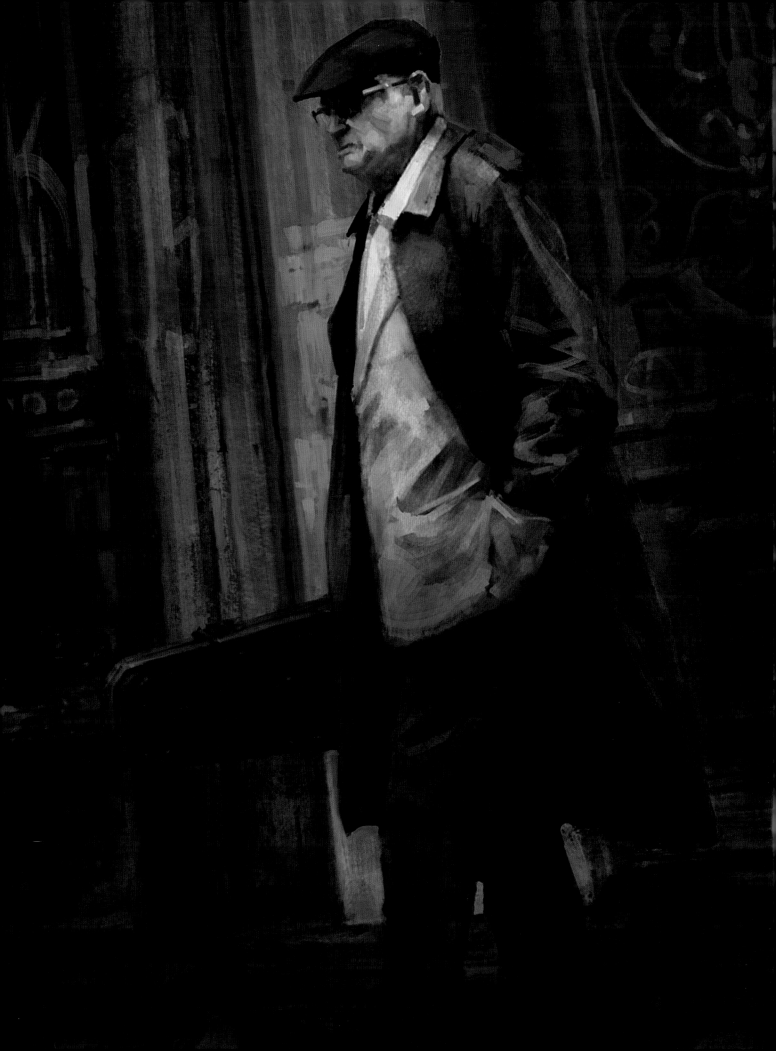

3DTotal Publishing

Correspondence: publishing@3dtotal.com

Website: www.3dtotalpublishing.com

First published in the United Kingdom, 2012, by 3DTotal Publishing

Softcover ISBN: 978-0-9568171-0-5

Printing & Binding

Everbest Printing (China)

www.everbest.com

Visit www.3dtotalpublishing.com for a complete list of available book titles.

MUSIKERN © DENNIS CHAN

DIGITAL ART MASTERS
: VOLUME 7

Over the years I have been working at 3DTotal my knowledge and understanding of the CG industry has grown immeasurably. The development and shift in popularity of certain pieces of software or styles of art has been fascinating to witness, and this artistic evolution has been – and continues to be – beautifully documented throughout the pages of the *Digital Art Masters* series. Now in its seventh year, *Digital Art Masters* is back and better than ever, filled to the brim with another elite collection of stunning artwork courtesy of the best artists from around the globe!

Digital art is everywhere you look. From advertising boards to computer games, movies and even phone wallpapers, you really can't

COMPILED BY THE 3DTOTAL TEAM

TOM GREENWAY	SIMON MORSE	JO HARGREAVES	CHRIS PERRINS	RICHARD TILBURY

escape it – and why would you want to? Every time I turn on the TV I see the latest trailer for the next blockbuster movie in 3D or a jaw-dropping game cinematic, which swiftly reminds me of the ever-growing presence of the CG industry. As CG becomes a more prominent part of our culture, the demands on artists increase. But rather than the quality slipping

under the pressure, artists seem to thrive and flourish and produce the kind of work that you see in this amazing book.

From the end of September to the start of December my inbox was pelted with submissions of varying quality. We saw everything; from the very best the industry has to offer, to the ambitious, plucky artists who dream of seeing their images in print. Choosing just 50 from over 1,000 submissions was hard, and we're very grateful to Tim Appleby and Richard Anderson for helping us to whittle them down to the final images in front of you now.

I can't mention the images without also mentioning the artists behind them. Each is a supremely talented individual who has spent countless hours honing their talents to produce work of the quality gracing these pages. We're honored to showcase their images and would like to thank them for their support and the enthusiasm with which they've embraced *Digital Art Masters*. We look forward to seeing what they come up with in the future on their quest for artistic perfection!

SIMON MORSE
Editor – 3DTotal

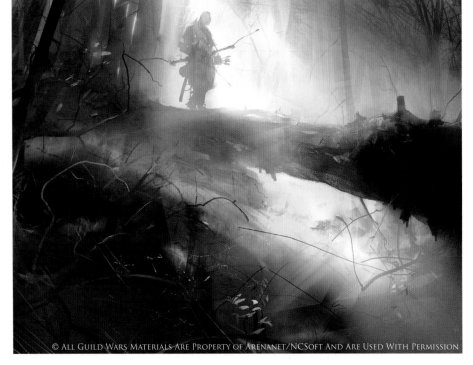

FOREWORD

When Simon first asked me if I would be interested in writing the foreword for *Digital Art Masters* I was a bit bashful. I feel like someone of some sort of caliber should write these things, or at least someone with some wise words to say. I consider myself an artist not a writer, but I think that's OK since this is a book for artists.

I have always loved the media arts. First it was cartoons, then comic books, then (the life-changing) video games with their magazines filled with mind-blowing art of my favorite characters, Scorpion, Sub-Zero, Contra – you know the list. I had no idea that people actually got to create this stuff for a living. As an idea it seemed untouchable; I couldn't fathom it.

> TO SURVIVE IN THIS INDUSTRY... YOU SHOULD ALWAYS, ALWAYS KEEP LEARNING

When I started school in Seattle I was told by someone that animation seemed like a really good fit for me, but at that point I didn't even know that digital art existed. Soon after this I was totally hooked on what I had found people

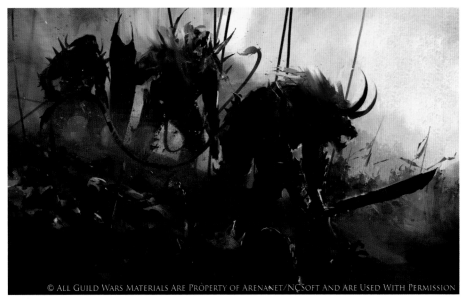

© ALL GUILD WARS MATERIALS ARE PROPERTY OF ARENANET/NCSOFT AND ARE USED WITH PERMISSION

could do and create in some of the programs I was coming across. A whole new world opened up for me.

One thing I have learned, which would be on the top of my list to survive in this industry, is that you should always, always keep learning! Digital art is an ever-changing medium. It is so versatile and there are endless possibilities of where and how to do things. Because of this it's always important to not be ignorant of other ways of working or new software.

I was fortunate enough to be a part of the judging panel for this volume of *Digital Art*

Masters, which was a very difficult job due to all the amazing entries. I believe that what you'll find in this book will be both extremely helpful and inspiring. I know that some of the techniques shown in this book took me years to learn, and all of these pros are sharing a lot of experience with you. I really hope you take advantage of the techniques described in this book and go on to create and enjoy your own work!

RICHARD ANDERSON
Concept Artist – Framestore
flaptrapsart@gmail.com
http://www.flaptrapsart.com

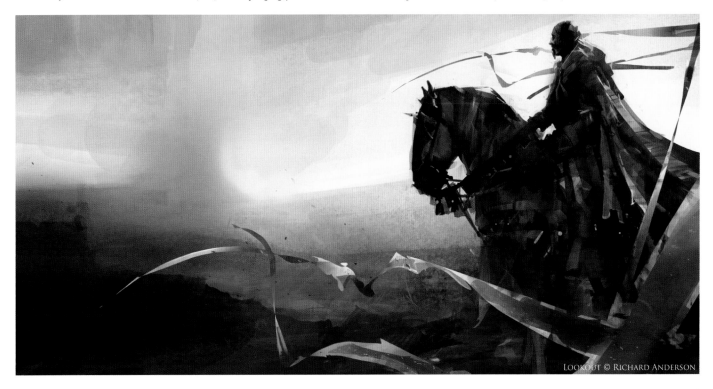

LOOKOUT © RICHARD ANDERSON

Contents

CONTENTS

SCENES

From my point of view, the most important substance of every environment I create is the story. It is the driving force behind details, textures, models and lighting; a faded trail of life that shapes the scene into forms and colors. A scene without a character may look incomplete, but a scene can have a character even without its obvious physical presence. The main goal of every environment artist is to find a way to bring that character and its story into a scene without the need to have an actual subject.

Every scene usually starts as a simple sketch and without a clear vision of where it's going. What once was a foggy idea of what it should be, tomorrow can be changed into something completely different. This is the main reason why I like doing 3D environments. For me it is a process of self-discovery; the tool to get inside my thoughts and form a shape of an idea that was always there waiting to be discovered and materialized in an art form.

TONI BRATINCEVIC

toni@interstation3d.com
http://www.interstation3d.com

DREAMSCAPE 6

BY JAMA JURABAEV

SOFTWARE USED: Photoshop

INTRODUCTION

I created this piece as a concept for my short
animation *Dreamscape*. Without having
something specific in mind I wanted to create
a moody and beautiful picture. When it
comes to concept art I always try to explore
new approaches. To create this piece I used
an approach that is generally known as the
"custom shapes" approach. The essence of this
technique is to extract abstract shapes from
photos, textures or your own works. These
abstract shapes are called "custom shapes"
and are used to build-up different compositions.

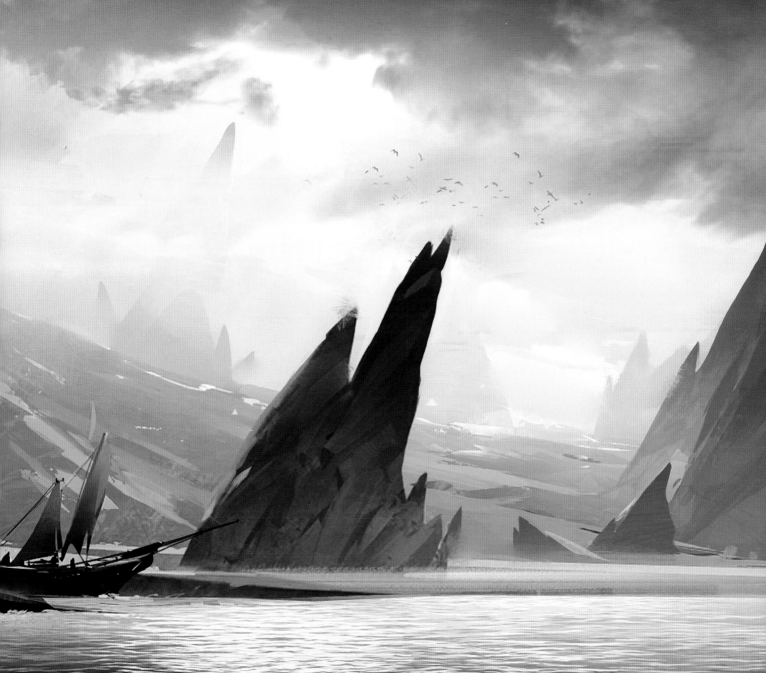

© Jama Jurabaev

Custom Shapes

Whilst showing you how I created my image I will also show you an example of this process. Firstly you need a photo or texture, but be careful not to use copyrighted material. Or you can use one of your old works to be safe. I used my old image published in *Digital Art Masters: Volume 6* (**Fig.01**).

I'm using Photoshop, but I'm pretty sure that other software has similar features to help you get the same result. To simplify the original art and get abstract shapes I apply the Cutout filter.

There is no perfect setup for this filter so each time you use it you will have to adjust the settings and experiment. Generally this filter

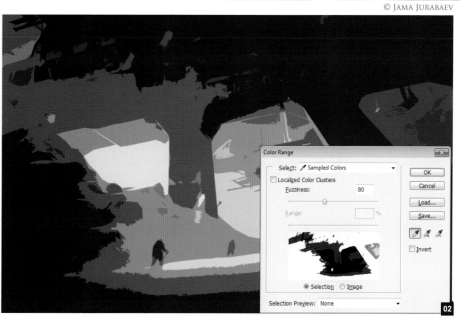

flattens the color palette and reduces details. After applying the filter we get a simplified and abstract version of the original piece. It is abstract enough to move forward and extract a custom shape. To select the shape that you need use Select by Color Range (**Fig.02**).

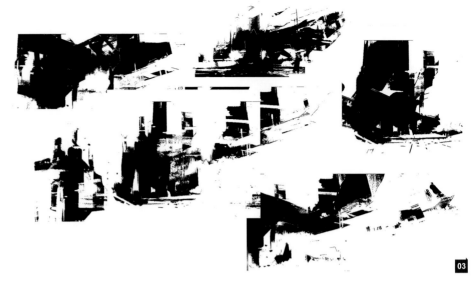

> ## " I USED ONE OF MY OLD PAINTINGS AS THE STARTING POINT TO CREATE SOME CUSTOM SHAPES "

Using the same procedure and different settings for the Cutout filter you can extract many interesting shapes (**Fig.03**). These shapes can be used to build different and interesting compositions.

CONCEPT

Referring back to my *Dreamscape* piece, I used one of my old paintings as the starting point to create some custom shapes (**Fig.04**). Using the Cutout filter and the shapes I had made I was able to create this abstract composition (**Fig.05**).

I find abstract compositions very useful because they help stimulate my imagination. I simply look at them and see new worlds and new stories, which might be very different from the original photo or texture. They are simple enough to be easily rearranged to get a new, balanced composition. Using other custom shapes I then balanced my overall composition (**Fig.06**).

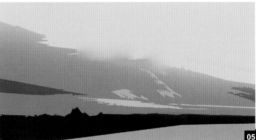

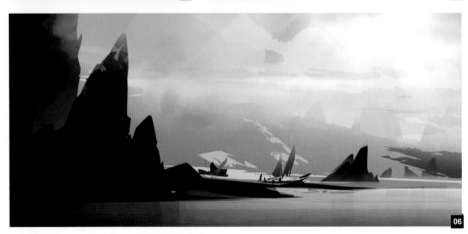

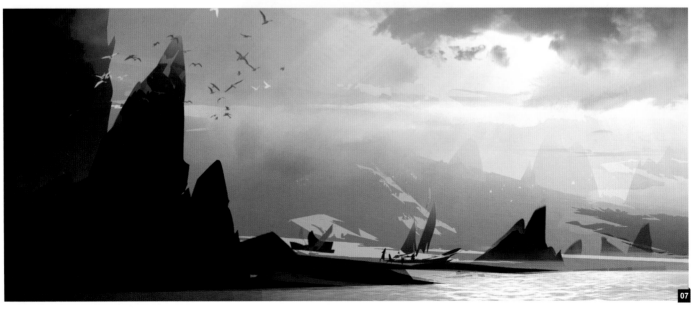

As a thumbnail it was almost there. It now just required some time to detail it and make it more realistic (**Fig.07**).

As a final touch I added some rock textures to those flat areas and added more rocks in the background to enhance the depth (**Fig.08**).

CONCLUSION

In my portfolio you will see more images that were created using this technique. These days I tend to use the custom shapes technique a lot. Many thanks go to Nicolas Bouvier (Sparth) for sharing this technique with everyone. It really helps me to speed up the process and to create something interesting and unique. I always try to experiment with new methods to get out of my comfort zone because I want to grow and develop as a concept artist. If you have any questions, don't hesitate to ask.

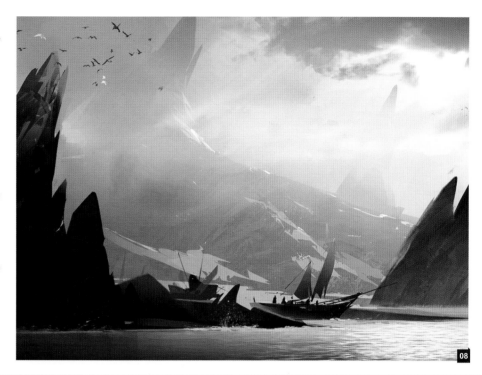

ARTIST PORTFOLIO

MAGRIPPALFCOSTERTIVM·FECIT

THE MARKETPLACE

BY GILLES BELOEIL

SOFTWARE USED: Photoshop

INTRODUCTION

The Marketplace was a request by Mohamed Gambouz, Art Director for *Assassin's Creed: Brotherhood*. He wanted an establishing shot of the Pantheon in Rome during the Renaissance, with a warm sunset key light. The main goal was to show the gigantic scale of this monument and to sell the idea that Rome would serve as a great place for Ezio's new adventures.

THE PAINTING

First, I quickly sketched some ideas on paper, just to get a feel for the subject and what was needed. Then I started with a 3D rendering of a few buildings that I recycled from the first *Assassin's Creed* game. I also found a free low res model of the Pantheon on the web, in order to give me an accurate start. I searched for aerial photos of Rome itself to see the actual building as it exists today, as well as looking at visual references for the color palette. I always use a lot of visual references; for me, it's very important.

Then it became time to establish the viewpoint. I always choose the angle very carefully because I know it is a very important part of the process. This is why I like to play around with 3D software and experiment with a camera even if I don't use it directly in my images most of the time. It is very useful to try various compositions even if it is done quickly. While doing this, I also play around with the focal point, which is great! I then position some 3D characters here and there to determine an accurate scale (**Fig.01**).

I then decided on the position of the sun. I always pay great attention to the accuracy of the lighting, bearing in mind that when I paint the darkest value within the light areas, it is always much lighter than my lightest value within the shadows. I think this rule of thumb helps to create an overall feeling of light throughout my illustrations (**Fig.02**).

You can see in **Fig.03** that I started to paint details in here and there. This is how I generally

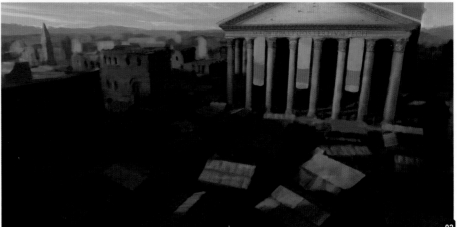

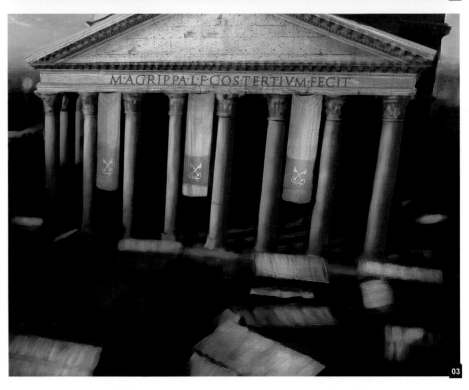

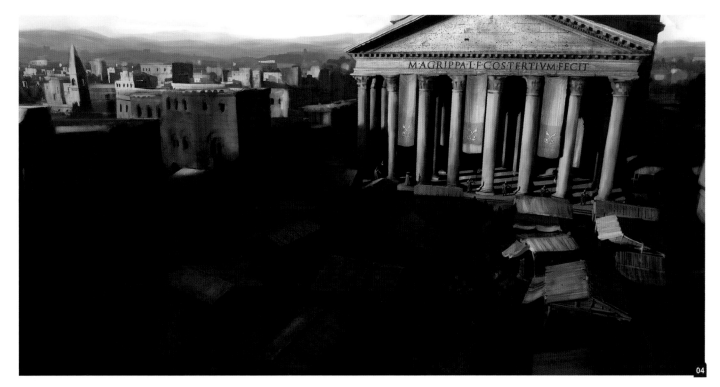

proceed, usually working randomly across the canvas, trying this and correcting that without any real order apart from trying to improve the image. I am always aspiring to attain the quality of the picture in my mind!

> ## I WANTED THE VIEWER'S EYE TO GO STRAIGHT TO THE PANTHEON AND NOT TO A RANDOM MARKET STAND

This was the stage when I began painting the crowd. It's essentially a big mass, but when you paint with some defined edges, then it resembles a crowd from a distance. I also added more clarity to the background. I didn't want something too distracting so I didn't add a lot of detail. It just required some large forms to help describe a city behind the Pantheon. I also set up a value for the sky and added more contrast overall. I must confess that at this point I wasn't happy with the pattern of light across the market; it was too distracting for my taste. I didn't want to emphasize any particular areas but rather wanted to keep a consistent and overall relationship between all the lights and darks. Most of the time this is a proven method of maintaining an overall feeling of unity. It is also important to decide whether you want the light to dominate the shaded areas in terms of

how much space they occupy. If both are equal, the result will be weak for sure. I can remember struggling with this aspect more than anything else and went through numerous variations before I found a solution (**Fig.04**).

At this point it began to come together! I preferred this pattern of light, especially the how it looked inside of the Pantheon, although it was still a bit distracting on the front right. I wanted the viewer's eye to go straight to the Pantheon

and not to a random market stand. Bearing this in mind, I continued adding interesting shapes, highlights and temperature variations (**Fig.05**).

Feeling that the arrangement of the market was a little chaotic, I included a main path in front of the Pantheon. I also painted in guards and more detailed characters to attract the viewer's eye even more (the character in red, for example). Now we get a far clearer sense of the scale (**Fig.06**).

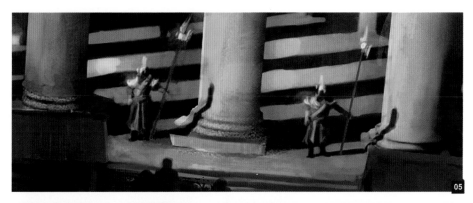

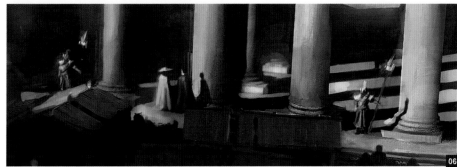

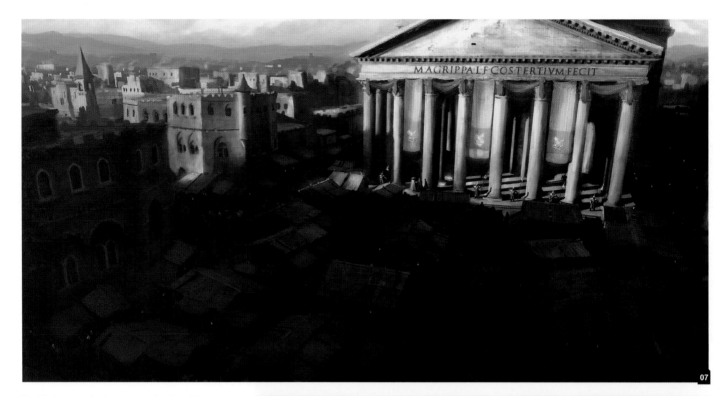

I added some dark areas and painted in some bounce light here and there. This made a huge difference and I must say it began to add more realism/ I was much happier with this new light pattern, at last (**Fig.07**)!

I then added details where I felt it was necessary. These included the chimney smoke, incandescent lights in dark areas and some interesting shapes such as the dungeon on the left building as the previous shape looked boring to me (**Fig.08**).

This kind of detail entertains the eye while creating a more realistic image. I also used some matte painting tricks, namely birds (so clichéd, but it really works!) and more smoke (in the foreground).

I continued adding color temperature variations, keeping in mind the influence of the light (cooler when facing the sky, warmer when facing an illuminated area such as the street on the left of the Pantheon)(**Fig.09**).

Following on from this I added the final touches, including darkening the corners of the image (vignette) a little to refocus attention where I wanted it. This helps create a photographic quality to some extent. Alongside this I included some more variation within the shapes, values, edges and color temperature.

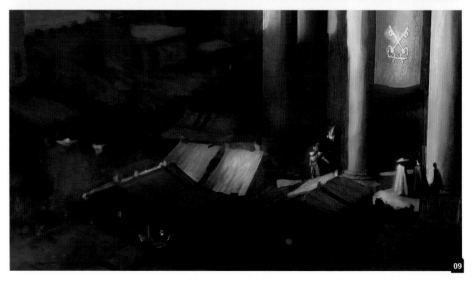

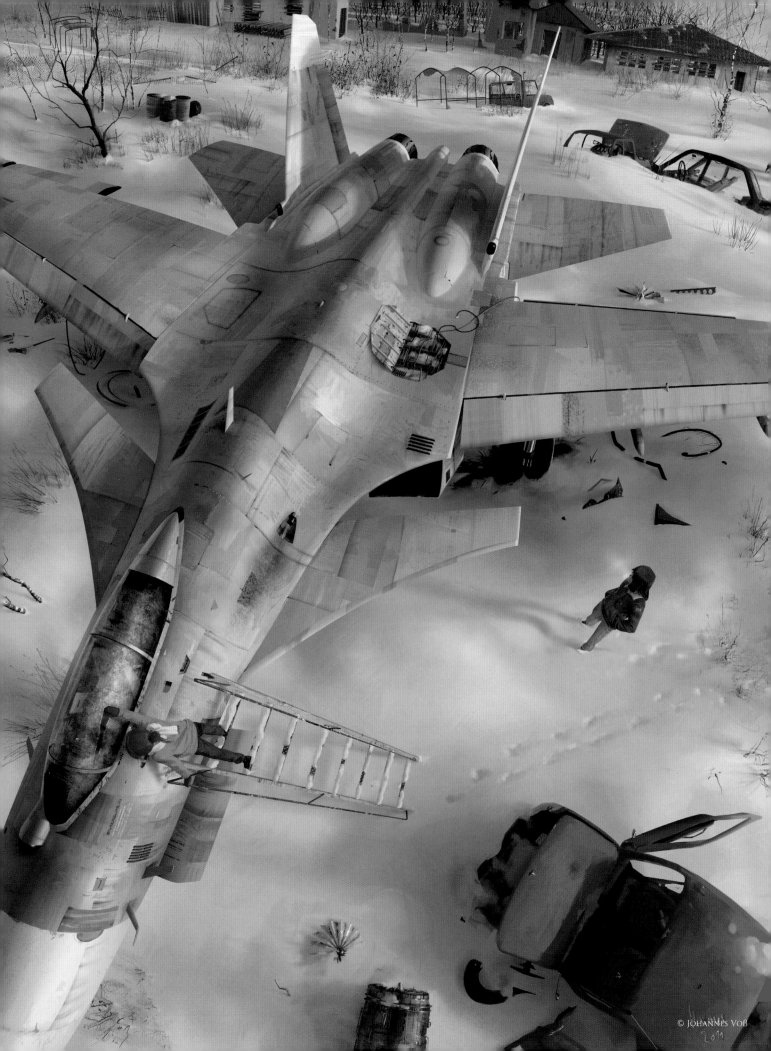

© JOHANNES VOß
2011

CLOSE YOUR EYES

BY JOHANNES VOß
SOFTWARE USED: Photoshop

INTRODUCTION

I spend most of my time drawing, looking at the sky and thinking about nothing in particular. I did this piece a few months ago and it differs from the rest of my work in that it is not just a technical exercise. I spend most of my time just practicing technique, whilst the plan here was that if I got this out of the way, eventually my creative expression would be a lot less constrained. I'm still far from this point however!

IDEAS

There are many ways of generating ideas and everybody goes about it differently. Thumbnail sketching is a good method if you have a brief or vague idea already, and also if you have yet to come up with one. Creating random shapes and then trying to see something in them, sleeping, or even going outside is something lots of people recommend.

Weird as I am, none of those have ever really worked for me, so what I've ended up turning into a habit is spending most of my time doing studies. From time to time, an idea will pop into my head to say hello, and I will pretend I haven't noticed and let it evolve for a while. Then after a time, I usually grab a pencil and scribble out a tiny thumbnail. This doesn't necessarily have to be an actual drawing; it's more of a visual note – something here, something there and a few scribbles in the background. With this, basically the whole

image is done and all that's left to do is to draw and paint it. Unfortunately, working like this requires a lengthy timespan involving lying around doing nothing and because of this it makes commissioned work harder. I usually don't accept jobs with tight deadlines because I'm never sure if I will have an idea in time.

SKETCH

Since the composition was pretty much decided at this stage, drawing now was more about form, construction and perspective. I made some rough sketches to get a feel for the space and design of the scenery, and tried to figure out how much distortion I wanted (**Fig.01**). It's important to always try to be accurate and put down actual information rather than faking it with random lines that might look interesting in a drawing, but won't translate into form once you begin painting.

Once I felt comfortable with the perspective, I established the vanishing points and then properly constructed all the things that are made up of solid geometry, such as the plane, buildings and cars. This was also the time to balance out any issues in the composition and

watch for weird tangents in the drawing. It is important to make sure you get at least some spatial overlap to create depth, as this is harder to fix later on.

STUDIES AND REFERENCES

One area I'm particular about is references. I just try not to use any, ever, unless its client work (where obviously a good result is more important than my personal preference). If I don't know how to draw something I usually take a break from what I'm doing and go and study that subject for a while, trying to understand it, mentally taking it apart and putting it back together. I like being able to see something from numerous angles until I feel confident enough to draw a similar thing from my imagination. The intention is to avoid copying two-dimensional information, which is the natural temptation when using references, and instead increase my understanding and ultimately my speed. Drawing something from one's imagination is faster than searching for references, but only if you can draw it. I believe life is long enough to learn how to properly do something; we're all young and learning should take priority over results.

Painting

Once the drawing was done I blocked in the elements on separate layers, which I then locked (**Fig.02**). This makes painting a lot easier since I don't have to worry about edges getting lost all the time.

Before I started putting in the basic color I spent some time thinking about it. I considered the strength and direction of the light, as well as the time of day and resulting balance between local colors with the aim of visualizing things in my head. Then I tried to put down the colors and match what was in my imagination (**Fig.03**).

A thing to watch out for here is to avoid accidentally upsetting the compositional balance. A dark blob in the wrong spot can carry a lot of visual weight, and it's important to be careful with contrast. Contrast does not just represent value, it can be texture, edges, details, saturation, and all of these are tools that you have at your disposal to direct the viewer's eye (**Fig.04**).

With the drawing and colors in place, all that was left to do was render everything. Ironically this was the least interesting part, yet accounted for 90 percent of the actual work. Since all of the important decisions had already been made, I put on some music and blasted through it! Along the way there was a lot of time to add little things here and there, to think about the story or plan the next piece (**Fig.05 – 08**).

That's it from me! I hope you girls and guys got something out of this.

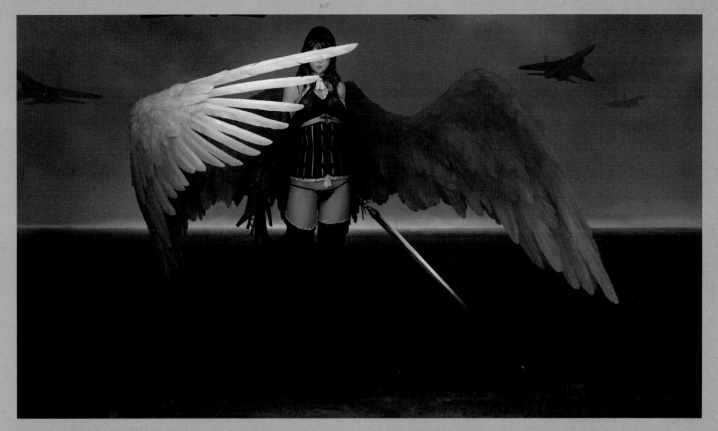

SCENES

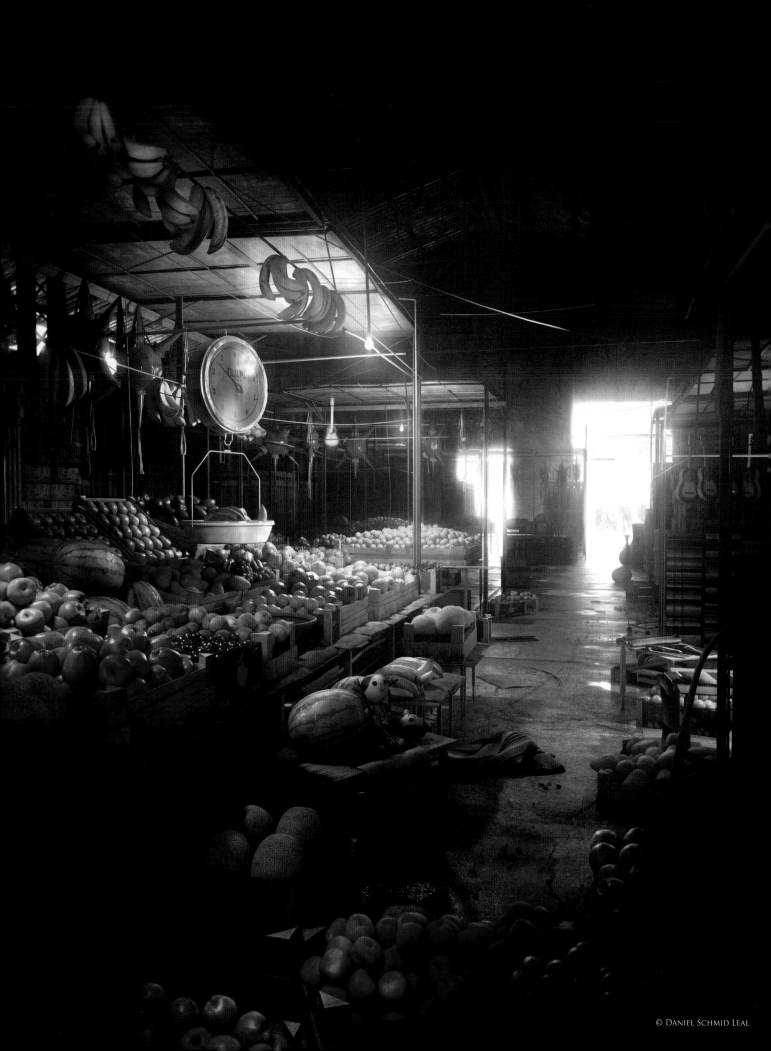

SAN JUAN

BY DANIEL SCHMID LEAL

SOFTWARE USED: 3ds Max, V-Ray, Photoshop and Fusion

INTRODUCTION

I have always said it is important to have an awesome topic in mind before starting a new image, otherwise you may find an excuse to not finish.

One day I was in a market in the city where I live, Guadalajara, called San Juan de Dios. All of a sudden I stopped and noticed everything around me. I saw the colors, shapes, textures and at that moment I knew that this was the inspiration I had been searching for. I spent the following days looking for images of fruit markets from around the world. Armed with this information I started to set the foundations for my image, such as composition, elements, color temperature and exposure.

I started roughly sketching an image to get the overall feel and once I had established the composition and proportion I started working on the scene assets. At this point I decided to go with V-Ray due to the fact that I've seen some very good CG images that have been created with this engine. This was a big decision to make because I had been using mental ray over the past two to three years.

MODELING

Once I started to classify the assets necessary for my image I felt overwhelmed by the challenge of generating them and populating the 3D scene. I tried to be careful and organized while generating the assets (**Fig.01**). I created a Max file for each final asset ("banana.max", "apple.max", etc.,) and then started to manually fill the fruit crates before being made aware of a big problem – realism! It just looked weird. After considering this for a while I remembered the "behind the scenes" features for the movie *Ratatouille*, where they ran into the same issue of the props looking unrealistic. Their solution was to let gravity do the job for them, similar to a real life situation.

I created a lot of instanced fruit geometry and using the RayFire plugin I controlled the dynamics of the fruit falling onto the crate (**Fig.02 – 05**). Once satisfied I collapsed the

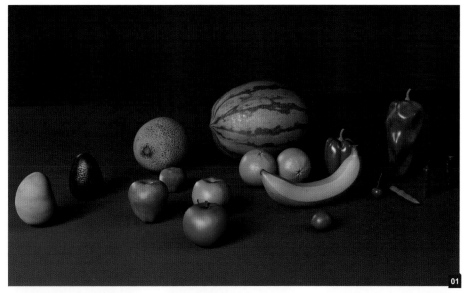

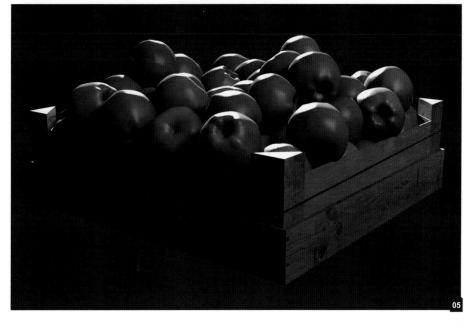

entire object (now a full crate of fruit) as a V-Ray proxy. This allowed me to easily handle a single object composed of thousands of polygons.

The next thing I wanted to try was to properly populate the scene with thousands of objects. From the very beginning this was a real challenge and as I said before, I had a great number of different assets, such as fruit, crates, guitars, stalls, lamps, garbage, etc. They were all previously textured and shaded ready to be used.

Due to the fact that I didn't have a final sketch to work from, I populated the scene until the composition looked right using a trial and error process, but undoubtedly more artistic. A few days passed before I reached a satisfactory stage with a properly populated scene and both a colorful and acceptable composition. However I had to take a step back several times to model objects that I realized were missing. For example, guitars, a few piñatas, serapes and rag dolls. These models added a traditional and regional flavor to the image and were not as common as the others (**Fig.06 – 07**).

Whilst creating the scene things started to feel a bit chaotic and disorganized. There were plenty of repeated elements, so I decided to add one unique object: the scales. I made these a focal point using the rule of thirds. This would allow me to enhance the composition in a natural way. Using this technique I positioned several objects to help frame the image more effectively, maintaining the scales as an key component (**Fig.08**).

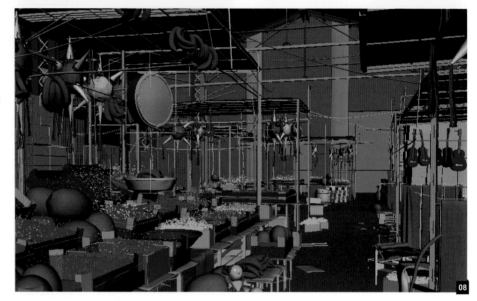

LIGHTING

My next and favorite step was the lighting. This is what I enjoy the most, so I took care when working on it. I undertook several tests with my camera, compared my image to a bunch of pictures from the internet and after a while I managed to achieve the look I wanted. During the lighting process I found it vital to maintain a realistic feel between the 3D camera, the lighting, exposure and lens effects.

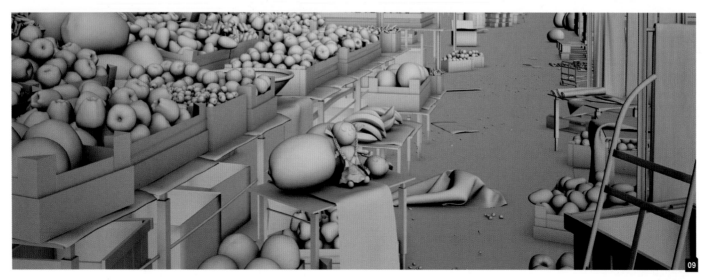

The lighting set up for the scene was very simple. I started testing with an exterior light (direct light) and then added the more obvious lights such as those above the fruit stalls (V-Ray lights). I rounded everything off by adding extra lights in a few spots as I felt it needed enhancing.

POST-PRODUCTION

Finally I used Photoshop for a few improvements as I wanted to create a richness in color and contrast that is only possible in image-editing software (**Fig.09 – 10**). At this point I added extra texture to the floor details, objects and signs of dirt and wear. As a final touch I used Digital Fusion to add film grain and chromatic aberration.

That is it! I hope you found the article useful. I would like to add that at the end I was very happy with the result, but I am hoping to improve for the next one.

© DANIEL SCHMID LEAL

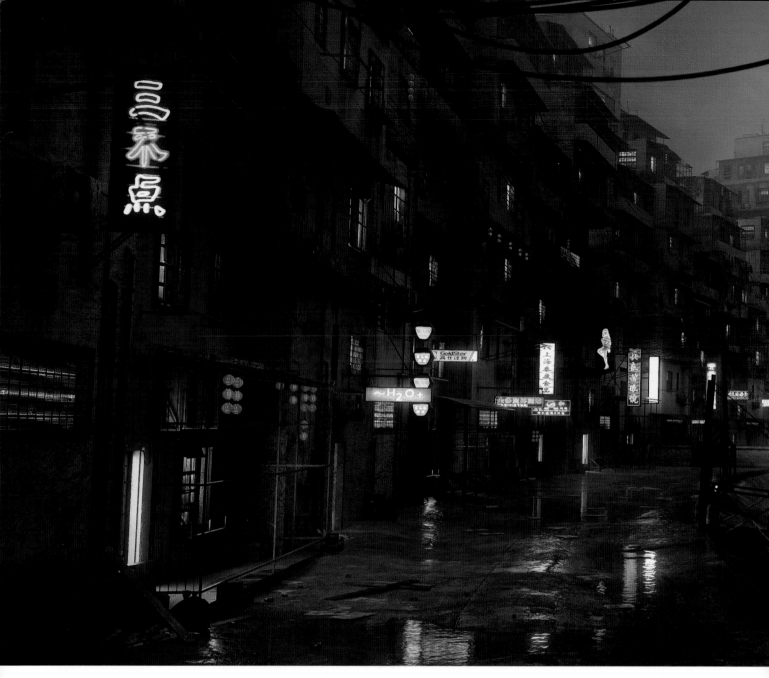

FINAL STAND
BY BRANDON MARTYNOWICZ
SOFTWARE USED: Maya, 3ds Max, V-Ray and Photoshop

REFERENCES

By starting off with a sketch I immediately knew I wanted to create something old, dirty, grimy, urban and somewhat "sci-fi-esque" that was vast in size and scale. This led me to the Kowloon Walled City in Hong Kong. This is a well know place, so finding references was quite easy. I immediately fell in love with its size, scale, weathering and the amount of detail.

MODELING

The modeling process for this piece was simple. Low res building facades were poly

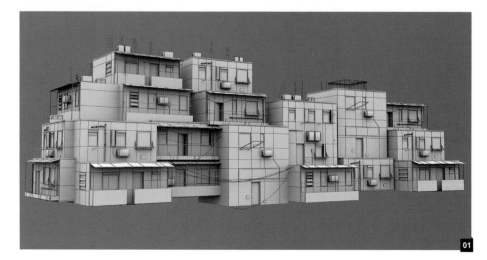

01

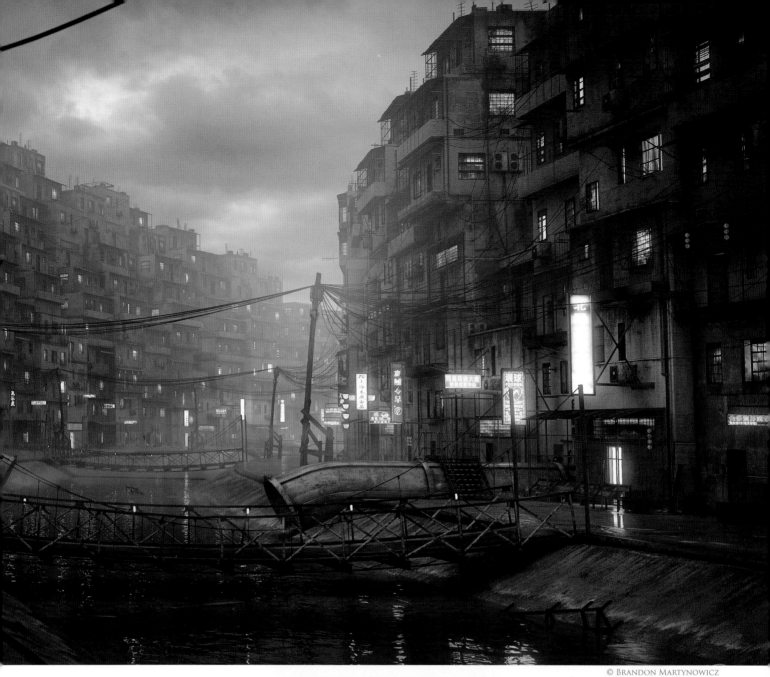

modeled in Maya in a modular way. Once the model was complete the UVs were laid out, one per object. External pieces such as window frames, hanging deck pieces (over and under), air conditioning units and pipes were also modeled in low res. I knew I would be relying heavily on textures and the paint-over so I did not get too involved when modeling the details (**Fig.01 – 02**).

TEXTURES AND SHADERS

For this piece I used around 20 different 1k and 2k texture maps. Each texture has its own Specular and Bump map, so around 60 maps were created for the entire piece. With this number of different shaders and texture maps, it is critical to keep everything properly named and organized (**Fig.03**).

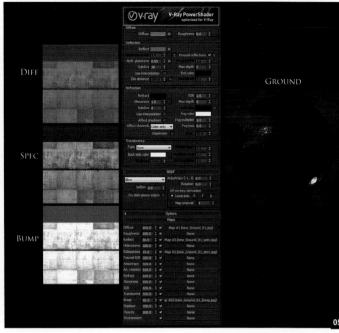

The shaders were set up with the basic V-Ray power shader. The Diffuse component was made from painted and color corrected photo-based maps, primarily collected from CGTextures.com. The Reflection component utilized a grayscale Specular map piped into the Reflection and Rglossiness slots. Reflection was used with the glossiness turned down (around .95), Fresnel reflections turned on, IOR based on the material properties and the subdivisions around 24-36 (always in powers of 12). The Bump component was also a grayscale, high frequency image used on all the shaders (**Fig.04 – 05**).

SCENE LAYOUT AND ORGANIZATION
One of the problems I ran into with this project was the large number of individual objects. Since everything was modeled independently and in a modular fashion, this allowed for hundreds of thousands of different assets. Max and Maya don't really like this, so once everything looked good on an independent asset level, I merged them together by material type and began creating layers based on these materials. The layout began on one side of the river, with all of the wires and junk attached. I then mirrored and flipped it, moving some things around to create interesting shapes. These were then duplicated and moved down, and everything was grouped together. I applied a Bend modifier to get a suitable curvature to the buildings (**Fig.06 – 07**).

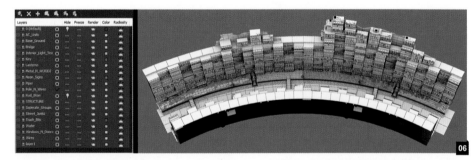

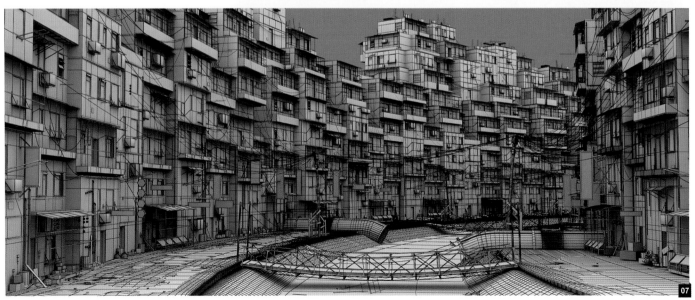

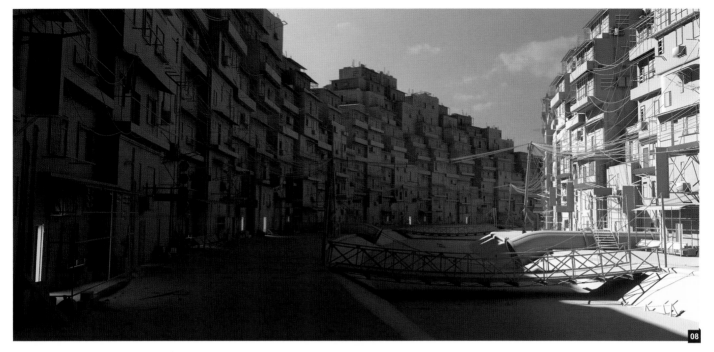

Lighting

In my first concept I explored a few different lighting scenarios. I had my mind set on a somewhat strong key light coming in from the left of the screen. I really liked the raking shadows, warm sky and happy mood (**Fig.08**).

The only problem with the sun representing a key light is the aspect of the neon signs and windows. I wanted to include dominant pools of light cast from doorways, windows and the signs, but unfortunately this created an unpleasant juxtaposition in the image. I

> " I WANTED TO INCLUDE DOMINANT POOLS OF LIGHT CAST FROM DOORWAYS, WINDOWS AND THE SIGNS, BUT UNFORTUNATELY THIS CREATED AN UNPLEASANT JUXTAPOSITION IN THE IMAGE "

eventually decided to kill the sun light and pop in a cool and stormy Environment map instead. I then started adding neon glows coupled with window and doorway light (**Fig.09**).

Composition

By using the rule of thirds my goal was to focus the eye at the mid-left center of the image (the

bright area with the neon signs). From there I hoped to lead the viewer back and to the right, following the wires across the water to the other bright area and then trace the bridge back to the original focal point. Using the rule of thirds together with the arrangement of the structures and lighting, I created a loop for the viewer. The idea was to create a continuous loop where you

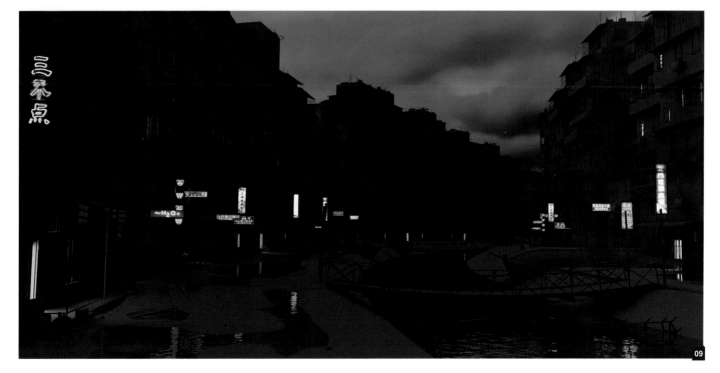

would pause and study the details a little more each time. As the artist I wanted to keep you (the viewer) sucked in as long as possible.

POST-PRODUCTION

With *Final Stand* I knew I would need to render out more than just a beauty pass, but was also aware I would have to be sensible. Consequently I rendered out a beauty pass which included all the lights, Z-Depth and Ambient Occlusion. I got quite a bit out of my three render passes, added a sky and tweaked some levels and contrast. With that as my base, I started to overlay some grime and dirt textures, added a glow on top of the neon signs and dabbed in a little more atmosphere.

> " I LOVE PERSONAL PROJECTS; THEY ALLOW US TO USE COMPLETE CREATIVE FREEDOM AND TO SHOW THE WORLD WHAT WE CAN IMAGINE "

The final step in Photoshop was color balancing. With this piece I tried a few different color options, but found the blue/cyan color worked the best. Although I really like the warmer yellow feel, the cool blue with the neon signs just seemed to fit (**Fig.10 – 11**).

CONCLUSION

I love personal projects; they allow us to use complete creative freedom and to show the world what we can imagine.

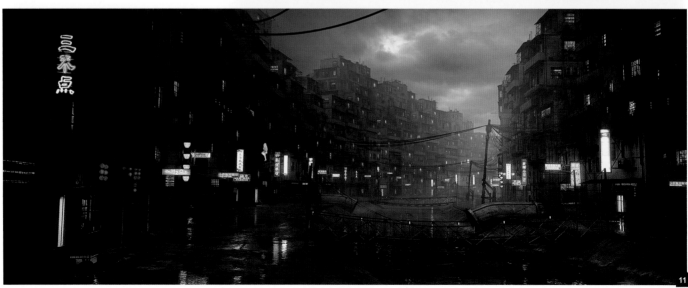

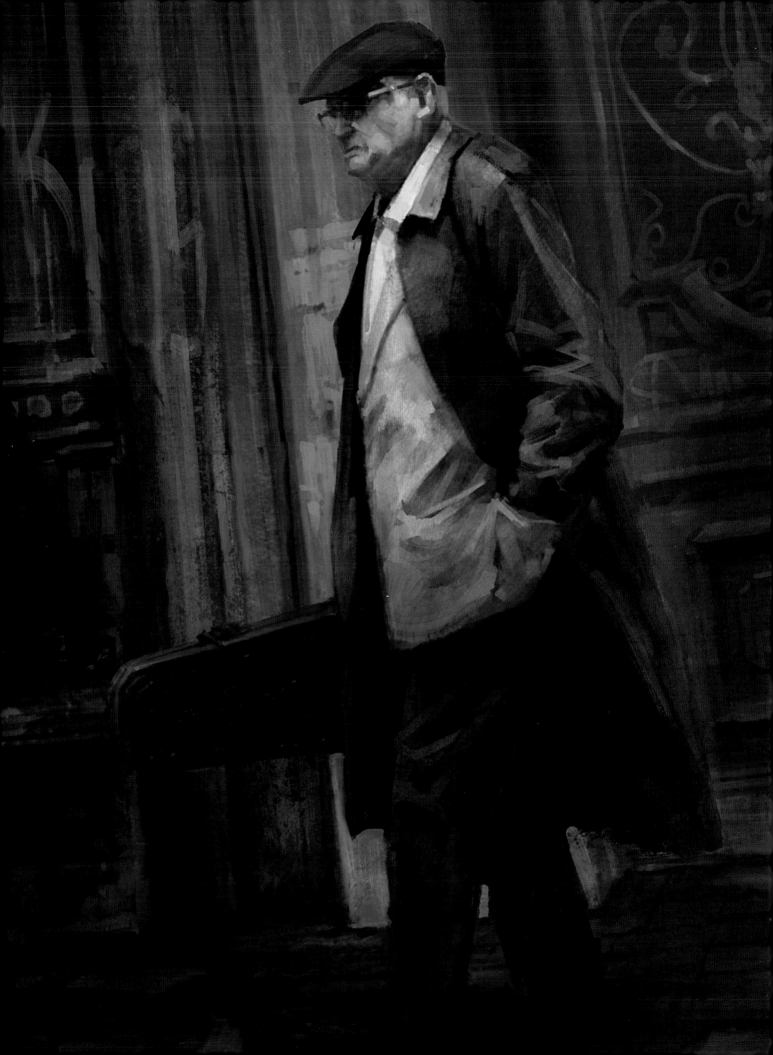

© Dennis Chan

Musikern

By Dennis Chan

Software Used: Photoshop

Introduction

A lot of my work is based on quick sketches and thumbnails from my sketchbook. Many of the ideas come from daydreaming or drawing from life. I like to walk around the city or sit on a park bench as often as I can, just sketching and being inspired by my surroundings.

Musikern was based on a quick sketch made from life whilst I was hanging around the city of Frankfurt. I saw this old man walking around by himself, looking a bit confused. I remember asking myself the question, "What's his story?" For some reason I kept thinking of funk and jazz music, and the old man kind of got imprinted in my brain. For me he was not stereotypical, but was kind of generic, which can be very interesting depending on how you portray it. By generic I mean things we are used to seeing; things we experience every day. This is what interested me and my biggest challenge was how to tell the man's story and make it interesting for the viewer. I wanted them to think about the story by drawing on their own experiences when looking at my work.

My Painting

When a subject or idea gets stuck in my mind I want to sketch the same thing several times, mostly through rough sketches and thumbnails. The tools I mainly use for this are my pilot G-Tec-C4 pen and my moleskin A5 sketchbook. These sketches and thumbnails are generally rough, often abstract and something people rarely see. During this stage I try to be as laid back as possible, trying to figure out if this is something fun and interesting that I want to develop further (**Fig.01**).

I use Photoshop as my digital tool and I prefer starting from scratch even if I have it roughly sketched out on paper (**Fig.02**). The reason is I don't have a scanner, but I have noticed that re-sketching and repeating myself helps me to better understand the subject matter. I prefer to avoid working to a solid line drawing and then adding color; not that it's a bad thing, but for me I feel that I am restricted by the preliminary decisions. I like to keep my work very rough

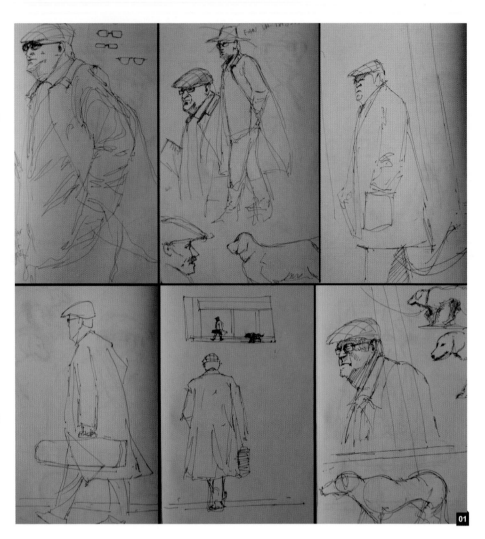

> I LIKE TO KEEP MY WORK VERY ROUGH TO BEGIN WITH SO I CAN CHANGE OR ADD FEATURES, WHILE STILL MAINTAINING THE OVERALL READABILITY OF THE IMAGE

to begin with so I can change or add features, while still maintaining the overall readability of the image. The first step lies in trying to frame the picture I have in my mind, just to get me started. At this point I usually have a basic idea of what I want to do so I only spend a couple of minutes on this stage. Allowing my decisions to be driven by instinct helps me stay interested in the painting.

I like to start the coloring process as quickly as possible and, as you can see in **Fig.03**, usually start with a large range of colors. I find having a lot of color to play with and balance is both challenging and fun at the same time. I try not to be afraid when working with numerous colors, and aim to lend the final image a subtle palette and range of values that I try to achieve throughout my work. In this image, I blocked out my basic colors on a layer below the line work so that the drawing remained visible.

Once I had established the basic layout I framed the character a bit more to focus the viewer's attention on him rather than the environment (**Fig.04**). I wasn't happy with the strong light source in the background so I moved it outside the frame (**Fig.05**).

At this point I was feeling inspired and motivated to continue, so I decided to merge my layers and work with a maximum of two layers at any time (**Fig.06**). This is when the fun part starts! I started to define the shapes and

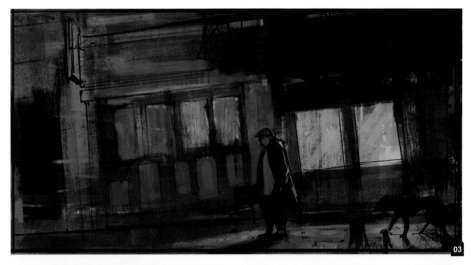

work out the values and do most of the painting. Muted lighting and a subtle palette was my aim, but I always remained open minded, never dismissing making changes or even taking a completely different direction.

I like working across the whole painting, rarely zooming in to paint. I work from a 3500 to 5000 pixel width to avoid pixelated edges, especially on smaller details. The only time I zoomed in for this image was when I was painting the character's eyes.

I find using references pictures very useful in my work and I love to take pictures of everything. I always try to have reference material on my second monitor, relating to color palette, mood, lighting conditions or texture. But although I use references, what I always try

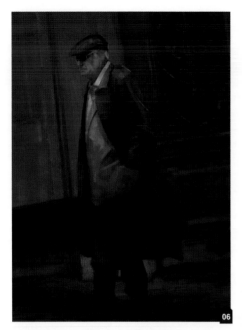

06

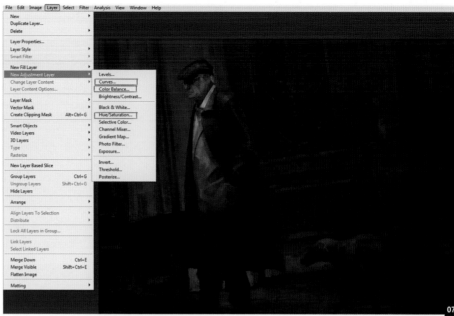

07

to do is break up the original design and make it my own. I do this by combining designs and avoiding copying what I see.

I had a couple of references that I used to help paint the background and the dog. With regards to the clothing folds, I used myself as a reference by basically putting on a coat, standing in front of a mirror and making some quick brush strokes. I like to study anything I am unsure about instead of just imagining it while painting.

> *IT IS VERY HARD FOR ME TO DESCRIBE MY PAINTING PROCESS. THE EASIEST APPROACH IS TO SAY THAT I JUST TRY TO PAINT THE VISION IN MY MIND*

I have a bunch of custom brushes in my library that I have made myself or gathered from other artists who were sharing them in forums. However, to be honest, I always end up using only one or two custom brushes throughout the painting process. Photoshop is a tool with so many possibilities, allowing me to achieve results in a variety of ways. Because I am not very technical I've become used to using just a few tools in almost all my work over the years. Adjustment layers, Curves, Color Balance and Hue/Saturation are great tools and probably save me about half the time it takes me to

create a painting (**Fig.07**). These tools allow me to change colors and values at any time during the painting process without ruining what I have already done, as shapes and brush strokes remain the same. They give me complete control (**Fig.08**).

It is very hard for me to describe my painting process. The easiest approach is to say that I just try to paint the vision in my mind. It helps to feed my brain with knowledge about life and how things work as much possible! Irrespective of whether you are using traditional or digital tools to express yourself, it is not possible

without some level of knowledge. I believe all tools are useful, but it is how you use them that matters and it's valuable to understand how these tools affect your vision. I have been through so much trial and error and I still go through it now! I try to be open-minded and not restrict how I work, as digital tools permit a lot of freedom and I want to exploit this and be as creative as possible. I think it's good to be receptive, experiment and try new things as every technique is useful in its own way; it's a matter of finding works for you and what is comfortable and fun.

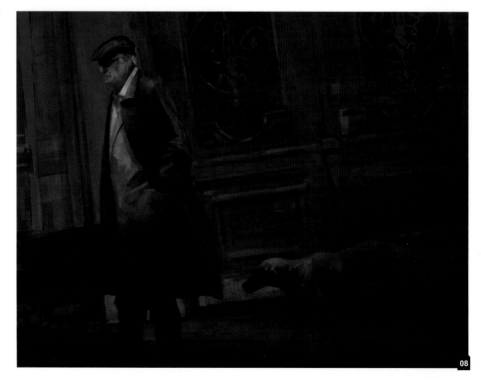

08

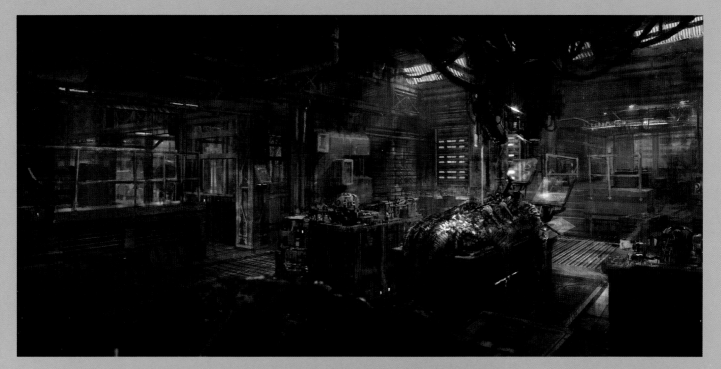

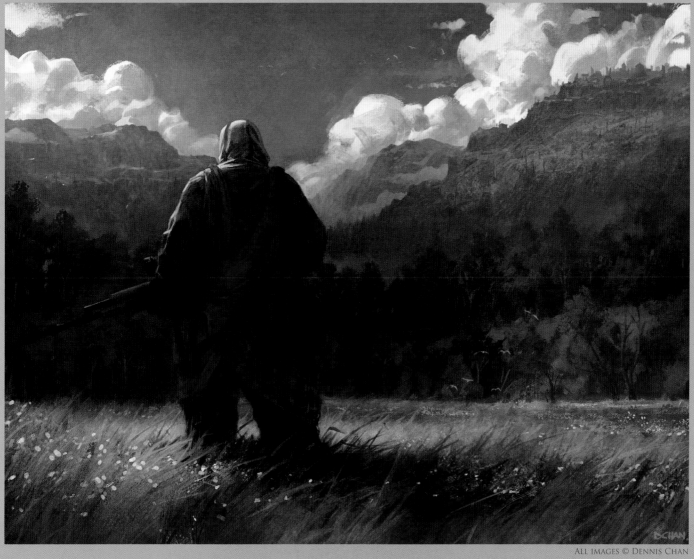

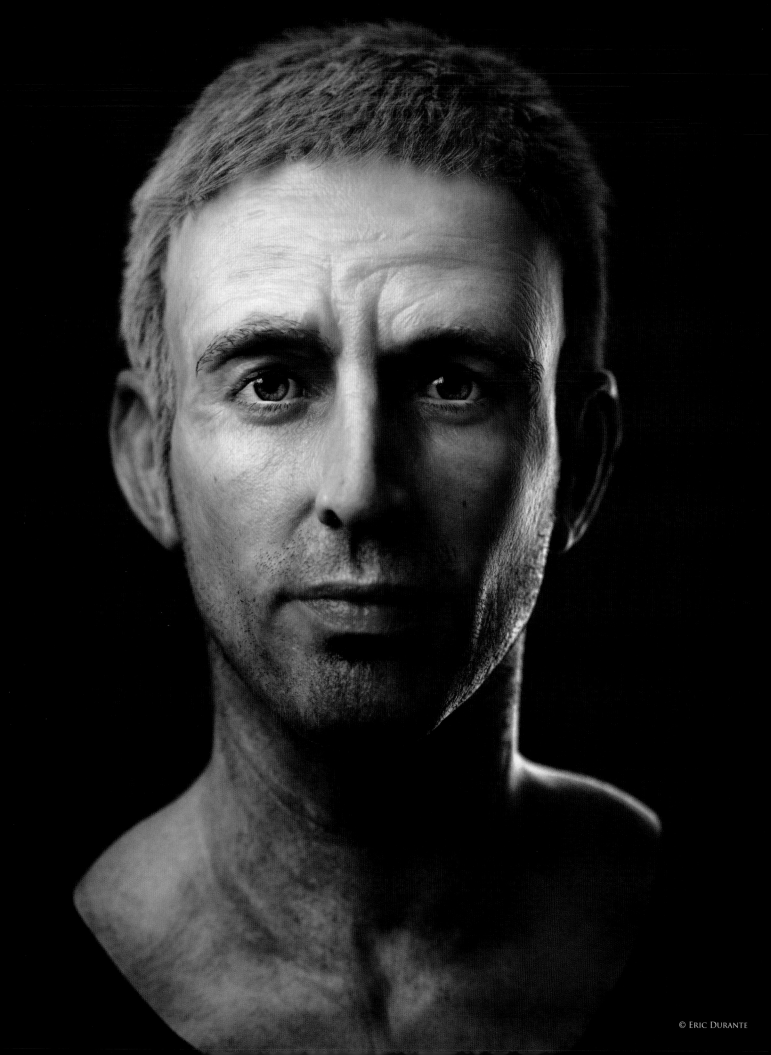

CHARACTERS

Character creation is a fun and challenging process, but one of the most important steps is to use references. References are key to creating a believable character. Without references your characters will have no grounding in believability, whether they are stylized or realistic. Your character's silhouette is also very important; if it doesn't read well as a silhouette then it will not work. Also, from time to time you should zoom out from your character so you can just see the big shapes and silhouette; this will also help you with composition.

Once you have a reference and a clear idea of what your character should be, there are three steps that will help you along. First, just focus on the big shapes and don't worry about the details – this goes back to creating a good silhouette. Second, once you have the big shapes down start creating the shapes that define the character, such as clothing. The third step is creating all the small details. I know this is one of the most fun steps, but if your character doesn't have a strong silhouette and/or believability then no amount of awesome detailing will make it a good character.

ERIC DURANTE
etdurante@gmail.com
http://www.eric3dmesh.com

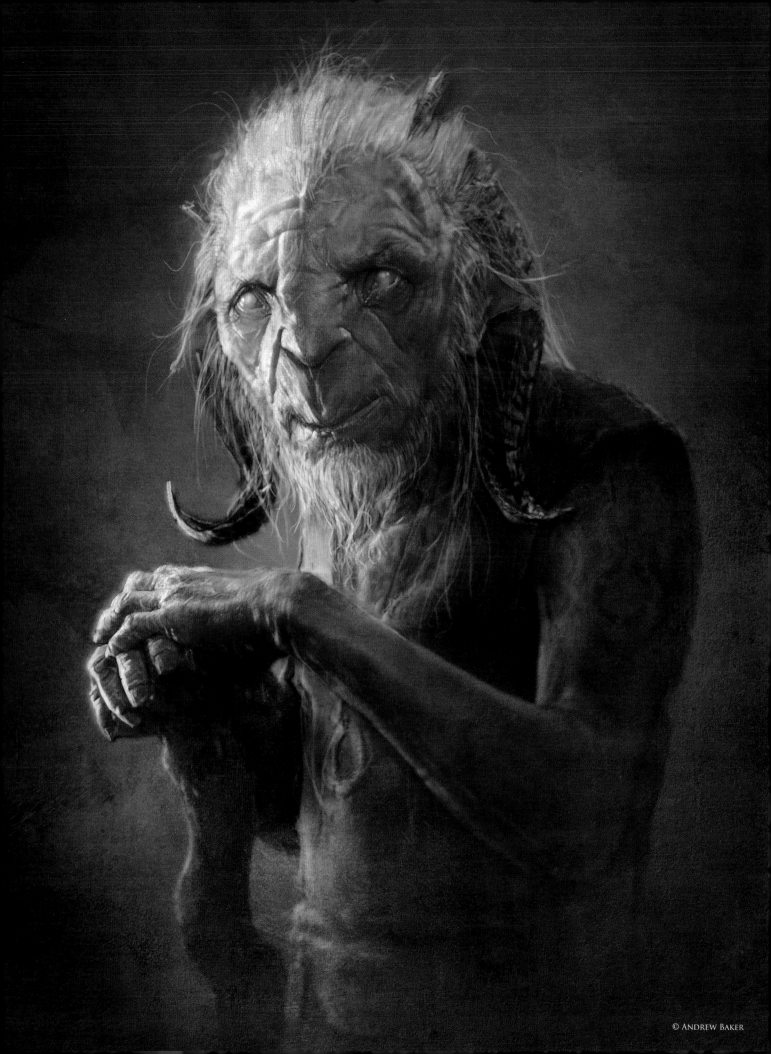

TAO – THE ANCIENT ONE

By Andrew Baker

SOFTWARE USED: ZBrush and Photoshop

INTRODUCTION

I am an artist who works at Weta Workshop Design Studio doing mainly creature and character design for film and occasionally for games. I've always been inspired by fantasy and myth. I wanted this character's face to tell a story; not necessarily a story that I've made up, but one the viewer can sense for themselves.

He was essentially my take on a Pan-type character and Tao came from the abbreviation of the original title of the piece, *The Ancient One*. I thought Tao suited him so the name stuck. I wanted to make him look quite fragile, but counter that with a knowing and wise face. An example of this is the cataract eyes, which add to his fragility but still allow the feeling that he is looking at the viewer to come across. I've always loved how Yoda seemed so frail and yet was probably the most powerful of all the Jedi. It was this kind of feeling I wanted to portray with this character (**Fig.01**).

> " SEEING A CREATURE OR CHARACTER YOU'VE DESIGNED IN A NICE ILLUSTRATION AND VIEWING IT FROM DIFFERENT ANGLES AFTERWARDS IS SO VALUABLE "

THE IMAGE

Generally the types of imagery I make for work are ones that highlight and show a design in the most photorealistic or cinematic way possible, frequently making the images feel very studio lit. For this piece I wanted to use the same tools but create a more moody and atmospheric portrait. I decided that for this particular illustration it would be all about the final framed render. In fact, it was to be printed out for an exhibition held here in Wellington so it was less about the sculpting and more about the overall piece (**Fig.02**).

The software I used to create Tao was Pixologic's ZBrush and Adobe Photoshop. I use these two packages extensively at work and enjoy using them for personal projects as

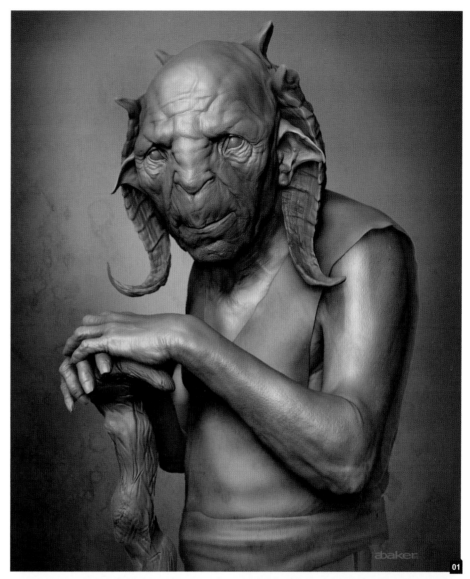

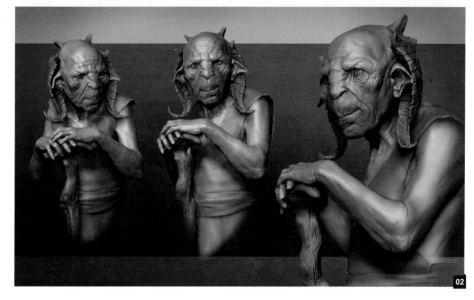

well. Although the sculpt was only intended to be viewed from one angle, ZBrush adds great depth to your image. This is another reason why I use it so much for design work at Weta. Seeing a creature or character you've designed in a nice illustration and viewing it from different angles afterwards is so valuable. As you can see in the image with the hands, I've only really sculpted detail into the side that will be viewed (**Fig.03**).

However, with the face I spent a little more time sculpting up the texture. I don't normally go this far with work pieces, as time to finish the whole piece is more pressing, but seeing as this was for myself and to be exhibited I enjoyed adding that extra detail in his face (**Fig.04**).

> " I'M CONSTANTLY EITHER PHOTOGRAPHING OR DOWNLOADING INTERESTING TEXTURES LIKE MOSS OR RUST. THESE CAN CREATE SOME INTERESTING NOISE AND ARTEFACTS ACROSS THE CHARACTER AND THE IMAGE AS A WHOLE "

I started the sculpture from a generic mesh and tried a few different poses, but I knew roughly where I wanted to go with the pose. At one

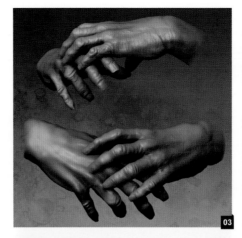

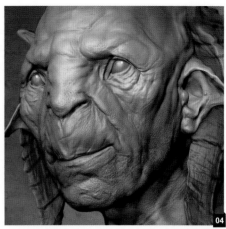

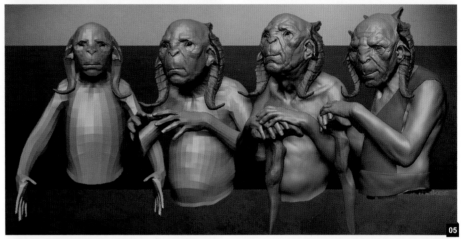

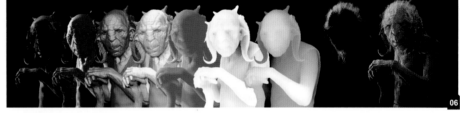

stage I found it made him look a little too weak and that the direct eyeline with the viewer gave him a little more strength (**Fig.05**).

I always try to plan my composition and with this piece I wanted the initial focus to be on his face and hands, with a direct eyeline weighted towards the top. I consistently like to use this sort of weighting as it always feels right. The old golden ratio!

For my design work created with ZBrush, including this one, I always bake out a number of shaders on the model to use in my final Photoshop piece (**Fig.06**).

This gives me a lot to play with when I'm developing the look and feel of aspects such as lighting, reflection, color, skin translucency

and even texture. As long as I have my alpha channel from ZBrush I'm able to do whatever I want to the background and sometimes this can lead to interesting developments in the overall piece. I also like adding some texture images and I'm constantly either photographing or downloading interesting textures like moss or rust. These can create some interesting noise and artefacts across the character and the image as a whole (**Fig.07**).

This technique came in particularly handy for this image. I used it extensively to create the worn and old feel of the piece.

It is a huge honour to be a part of this amazing publication of incredibly talented artists. I hope what I have shared has been helpful and I look forward to sharing more work in the future.

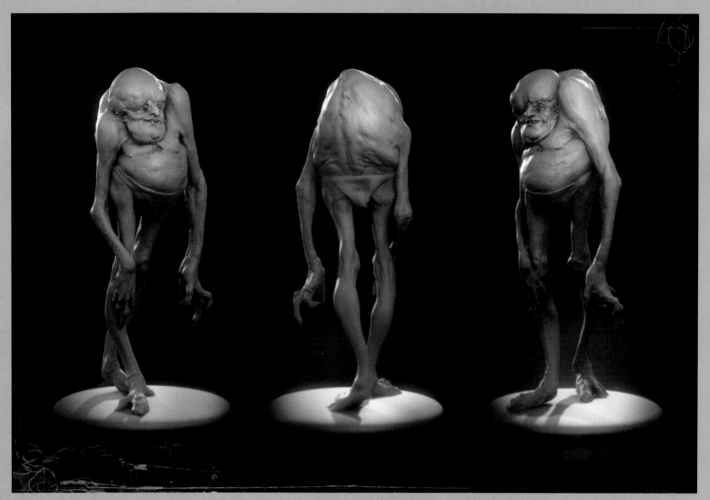

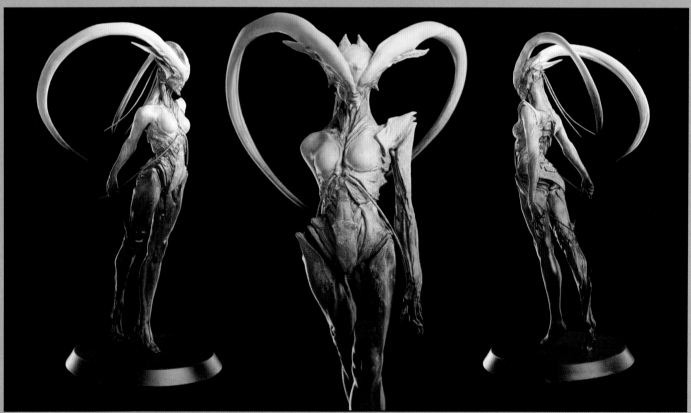

CHARACTERS

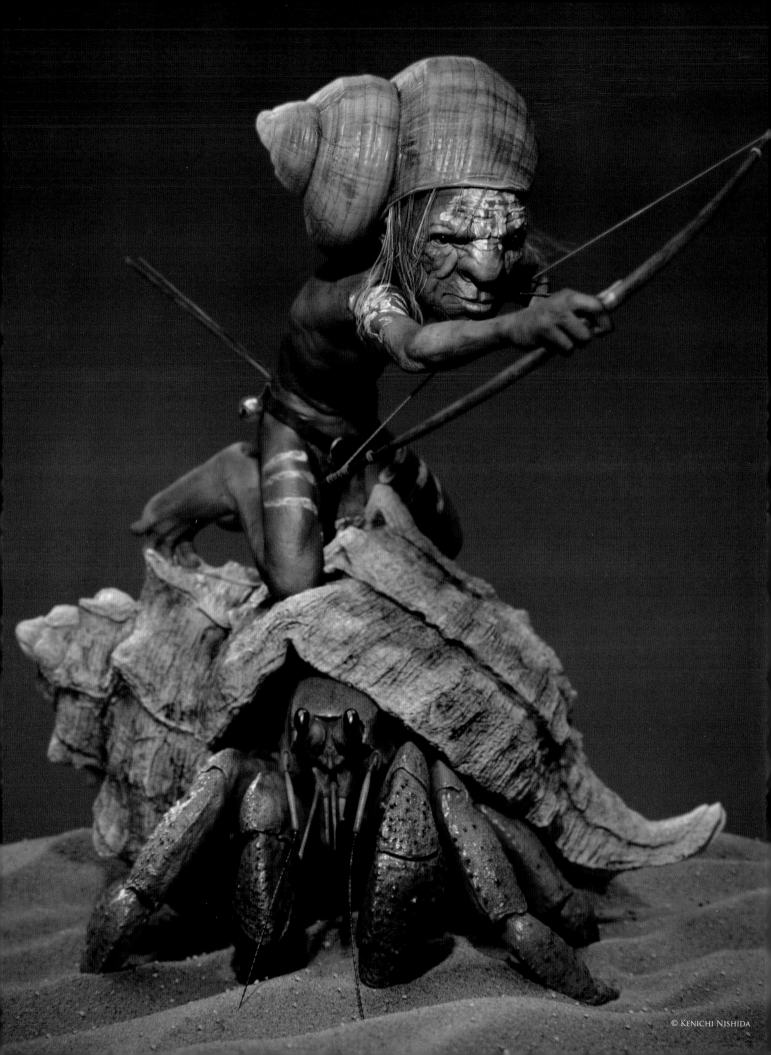

A Little Warrior

By Kenichi Nishida

Software Used: Mudbox

Introduction

I'd like to thank 3DTotal for giving me this opportunity to talk about my work. As well as having the honor of winning first place in a competition with this picture, since the challenge I have received a lot of comments from many artists and friends that I appreciate very much.

Concept

When I saw the challenge brief I intended to make a huge muscular character and created some concept art along these lines. However this seemed too ordinary to me and not unique. I wanted to create something new, so I quit drawing muscular characters and came up with some concepts of the indigenous people of southern Africa. They are not particularly muscular and don't have any tough weapons, but I feel they are warriors nevertheless.

> " I CREATED A ROUGH CONCEPT FOR A CHARACTER LIVING IN A SMALL WORLD AND RIDING A SMALL ANIMAL OR INSECT INTO BATTLE "

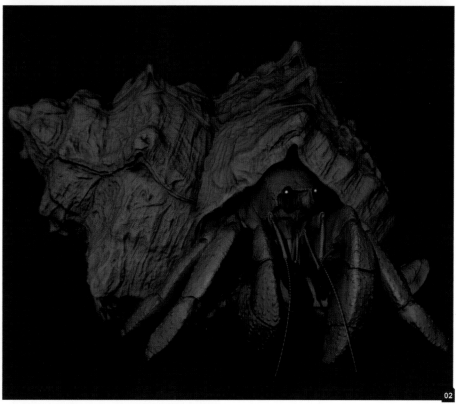

I created a rough concept for a character living in a small world and riding a small animal or insect into battle. I then had the idea of using a hermit crab and other sea creatures. They have really nice details and I wanted to show different materials in the image such as skin, wood, shell, etc.

Concept Sculpting the Shell

First I tried to do a concept sculpt for the crab's shell using a really rough base mesh. It didn't have great topology for sculpting, but it didn't matter at this stage because I intended to retopologize the mesh using TopoGun. After finishing the concept I imported the model into TopoGun and did the retopology. I transferred the concept details onto a new topology model using Mudbox and did some tweaking.

On this new model I sculpted the really tiny details because it had clean topology and UVs (**Fig.01**).

Sculpting the Crab's Body

The second step involved sculpting the hermit crab's body using the same method as I used on the shell. I then combined the two parts in Mudbox. As for their UVs, I used Roadkill UV in conjunction with Maya (**Fig.02**).

Pose and Layout

Next I tried to combine all of the models into the same Mudbox scene (**Fig.03**). Mudbox has really nice preview features (Lighting, Shadowing, Filtering and so on) and also allows you to check Normal maps. I didn't use a high res model because it was really intensive to

preview all the models with high res Shadow maps. Instead I used a low res model with Normal maps for posing and layout checking.

CONCEPT SCULPTING THE WARRIOR

For the warrior's body I started with a concept sculpt as the base pose, as usual. I then did some retopology using the same method as before, starting with his face before posing the body. However it was only during this stage that I painted a wireframe using Mudbox before retopologizing, a technique that is really helpful for re-building polygons (**Fig.04**).

> " I USED MUDBOX TO START PAINTING. IT HAS A LOT OF PAINT AND LAYER FEATURES WHICH MAKES IT VERY EASY TO PAINT ON YOUR MODEL "

SCULPTING AND RENDERING TESTS

After the retopology work I transferred the concept details onto a new model and also tweaked and sculpted other parts. Finishing all the sculpting I carried out some rendering tests using mental ray and a Vector Displacement map. I couldn't identify any major problems so declared the sculpting complete (**Fig.05**).

PAINTING

I used Mudbox to start painting. It has a lot of paint and layer features, which makes it very easy to paint on your model. It was difficult to use a Displacement map for every tiny detail, which I believe is unnecessary, so I used Bump maps instead. I made Diffuse, Specular, Gloss, Bump and AO maps during this stage (**Fig.06**).

RENDERING AND COMPOSITING

The rendering was done via linear workflow and mental ray, with each pass imported into Toxik for the compositing. Toxik supports a node system, so is really easy to build and allow access to your schematic. To create the depth of field (DOF) is just as easy and you can see and adjust the Depth and Blur Range settings.

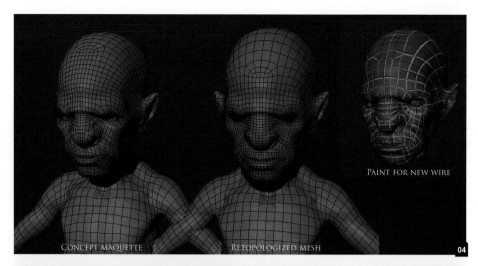
CONCEPT MAQUETTE RETOPOLOGIZED MESH PAINT FOR NEW WIRE 04

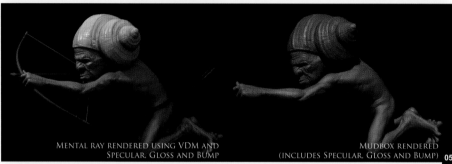
MENTAL RAY RENDERED USING VDM AND SPECULAR, GLOSS AND BUMP MUDBOX RENDERED (INCLUDES SPECULAR, GLOSS AND BUMP) 05

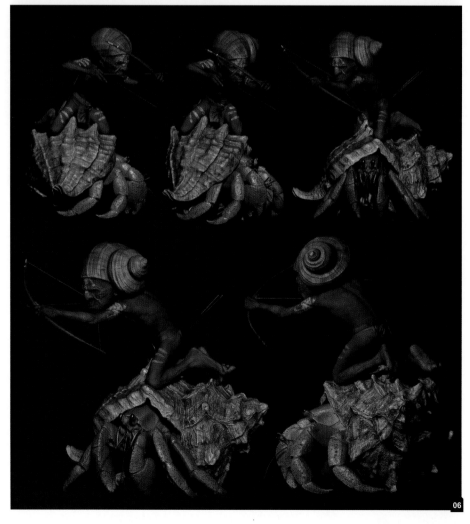
06

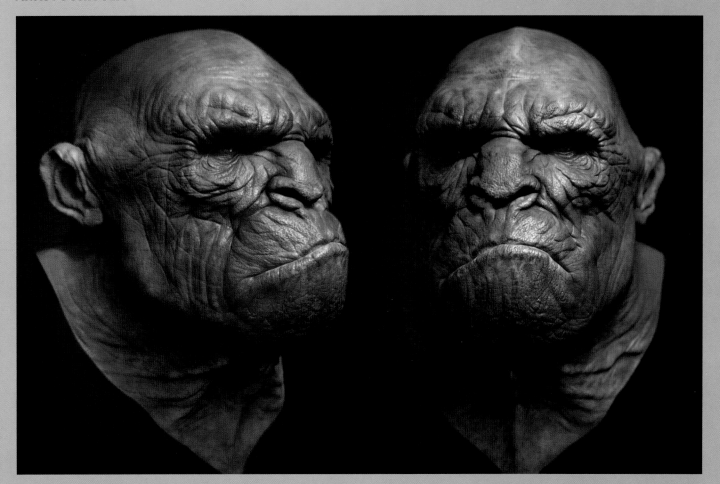

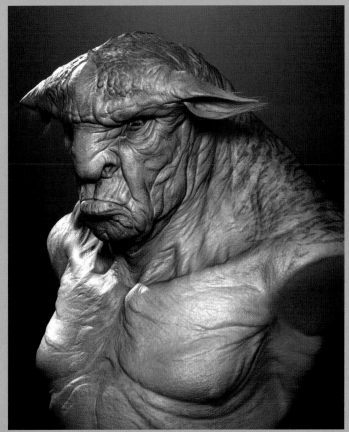
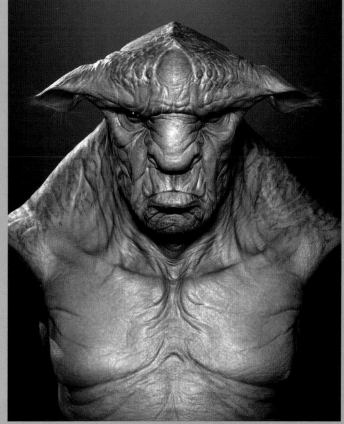

CHARACTERS

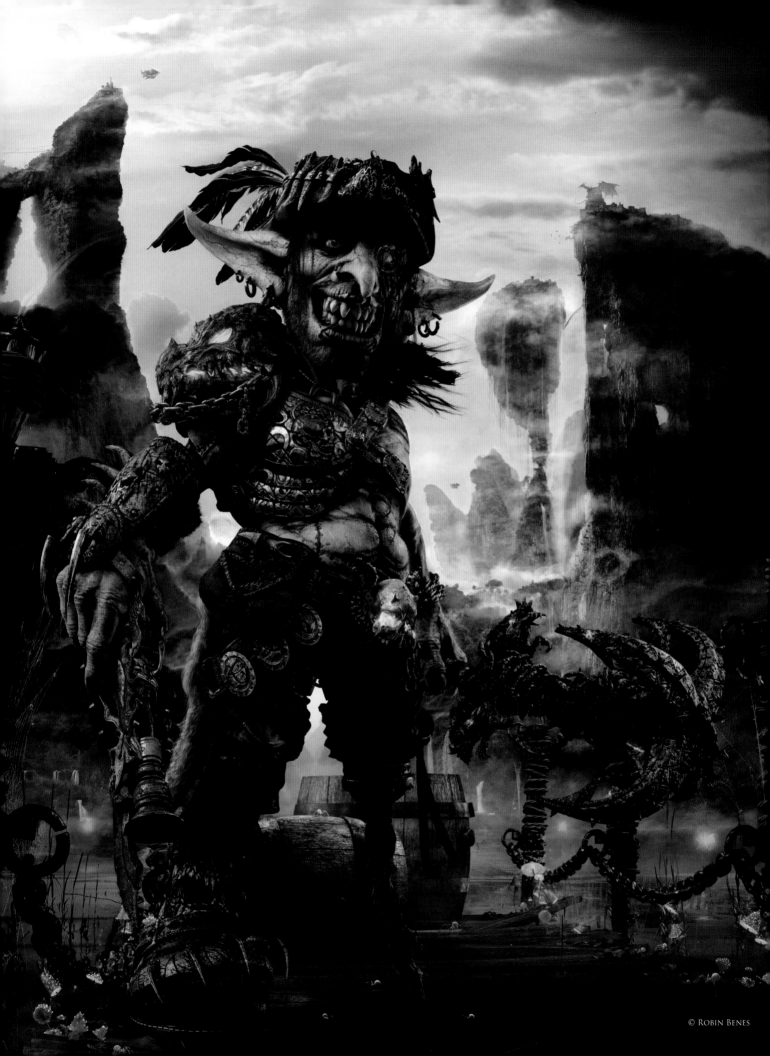

© ROBIN BENES

GOBLIN

By Robin Benes

Software Used: ZBrush and Photoshop

Introduction

After a long time spent on various commercial projects, I decided to enhance my portfolio with something massive that would help test my abilities and skills gained in the CG industry. From the very beginning I knew there would be no animation, so I didn't have to care about rigging and other linked aspects. As a fantasy fan, I decided to create a goblin character. I didn't want to copy anything well known so I decided to create a bloodthirsty pirate boss with epic equipment gained during his journeys overseas. Before any work began I searched the internet for references so that the character would be interesting and have its own history rich in details. Building a character's story is very important to me!

> " MODELING IS WHERE THE REAL FUN IS, AT LEAST FOR ME, SO I TRY TO THINK AHEAD AND MAKE PREPARATIONS SO I DON'T HAVE ANY PROBLEMS WITH UVs, ERRORS IN GEOMETRY OR UNITS "

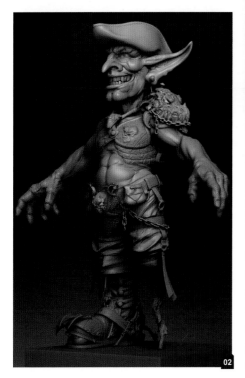

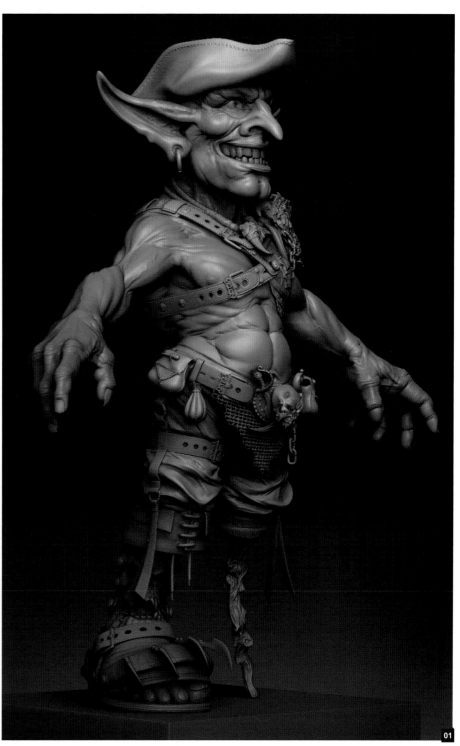

Modeling is where the real fun is, at least for me, so I try to think ahead and make preparations so I don't have any problems with UVs, errors in geometry or units. Where modeling is concerned I have a standard pipeline, which is long proven and very effective at doing what I need.

I began with a basic low poly model equipped with basic UV mapping and a standard setup. The basic mesh was exported into ZBrush where I started to process muscles and the body shape (**Fig.01 – 02**). Finishing this, I exported the second subdivision set back into 3ds Max and started to prepare the body with

low poly meshes of the goblin's equipment, which by the end resulted in 22 subtools.

Before detailing the equipment I prepared all the items in the UV set so they could be textured and easily identified. Every part of the goblin's equipment was processed until I was happy with the result. In the end the model consisted of 78,531,268 polygons.

> ## " TEXTURING WAS A REALLY FUN PART. I ALWAYS PREPARE THE BEST MAPS I CAN FROM THE GEOMETRY "

To create the very precise details and ornaments I used a Photoshop mask system, which turns out to be very good for creating breastplates (**Fig.03 – 04**).

When the goblin model was done I tried a few poses using the transpose tools and picked the best one. Then it was just a case of adjusting and adding all of the other elements (**Fig.05**).

To get the maximum possible level of detail whilst preventing hardware collapses caused by high numbers of Displacement maps, the Decimation Master was used. The final polycount for rendering in 3ds Max was 8.5 million polygons.

TEXTURING

Texturing was a really fun part. I always prepare the best maps I can from the geometry. This means that texturing turns into a simple process of coloring followed by adding photo textures

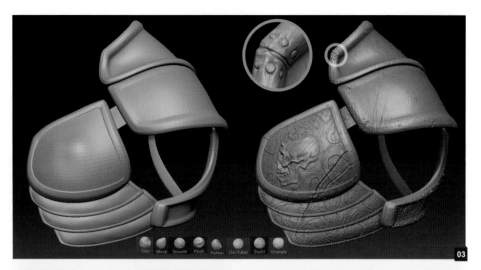

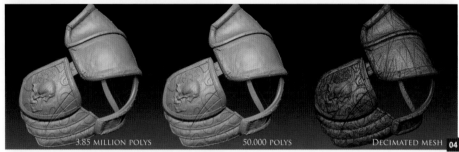

3.85 MILLION POLYS 50.000 POLYS DECIMATED MESH

for the metal, leather, dirt and scratches. Cavity maps helped me to mark the small details from the ZBrush model and Ambient Occlusion maps combined with Cavity maps were used as a mask for the armor rust and overall dirty look. To achieve the clean texture transitions I used a Solidify plugin by Flaming Pear (**Fig.06**).

SHADING

The time spent on this process was long due to the fact that it was the first time I had used mental ray on such a scale and I had to cope with a huge number of problems because of this. For the skin I used a skin shader by Mr.Zapa, which turned out to be great for getting a good SSS effect and overall organic look. For the rest (metal, leather, etc.,) I used mr Arch & Design shaders. I didn't want to use anything simple, so I took advantage of numerous masks to achieve the material blending. This was used on the breast armor, golden hat ornament and the leather belt decoration (**Fig.07**).

> " **THE BACK LIGHT WAS USED TO ENHANCE THE SILHOUETTE. THE COLOR OF THE LIGHT HELPED PROVIDE A REAL WORLD ILLUSION AND SET THE OVERALL MOOD OF THE PICTURE** "

HAIR AND FUR

As I wanted the hair and beard of my goblin to be greasy I decided to buy a Hair Farm plugin, which was ideal for my needs.

LIGHTING AND RENDERING

For the lighting I chose a standard three-point key light setup, which worked as the main light source. I also used a fill light from the side to add an additional light source. The back light was used to enhance the silhouette. The color of the light helped provide a real world illusion and set the overall mood of the picture. I used a blue key light, an orange fill light and a white back light. In this case I used an environmental HDRI map for reflections and a few black and white planes to enhance some of these (**Fig.08**).

Mental ray was used for the rendering (**Fig.09**). I always use a linear workflow with Gamma 2.2. Due to the fact I wanted a large format print I utilized a high Anti-Aliasing setting and set Indirect Illumination to low. I also used an exposure control, which helped me effectively control the output. I always try to get a clean output directly from 3ds Max so I need only do a small amount of post-production. The picture was rendered into separate 16-bit TGA layers to keep the best possible quality. By having separate layers I was able to adjust everything easily (**Fig.10 – 12**).

ENVIRONMENT

I started to plan an environment that would work with the character. I decided to choose a lost wharf in a swamp-like area with a backdrop of foggy cliffs resembling those in Thailand. The foreground including the webs etc., were produced in 3D with the rest of the scene created in Photoshop similar to a matte painting. For the reference pictures I mainly used Fliker.com and Shutterstock.com.

CONCLUSION

In the end I was happy with the result. The purpose was to learn about new technology and techniques, and to test my abilities by going through the entire creative process, even those parts I don't really like.

This has certainly helped me to understand a few things, which I plan to use in the future.

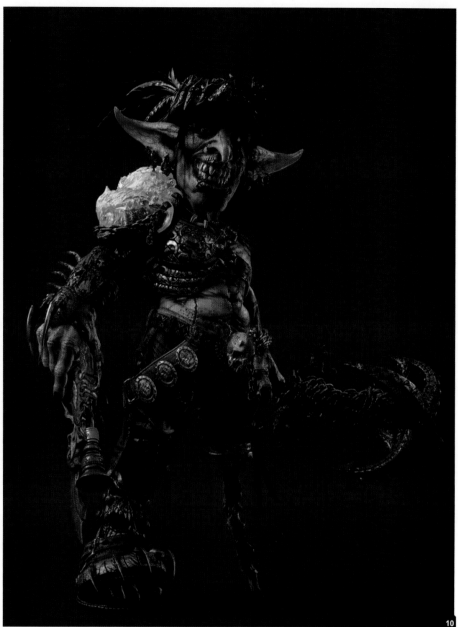

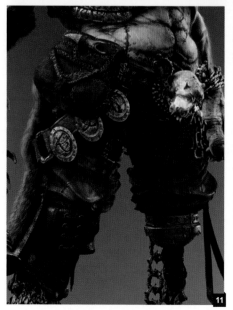

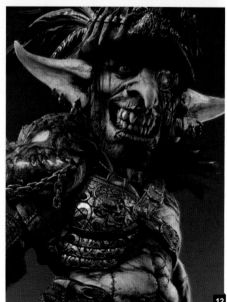

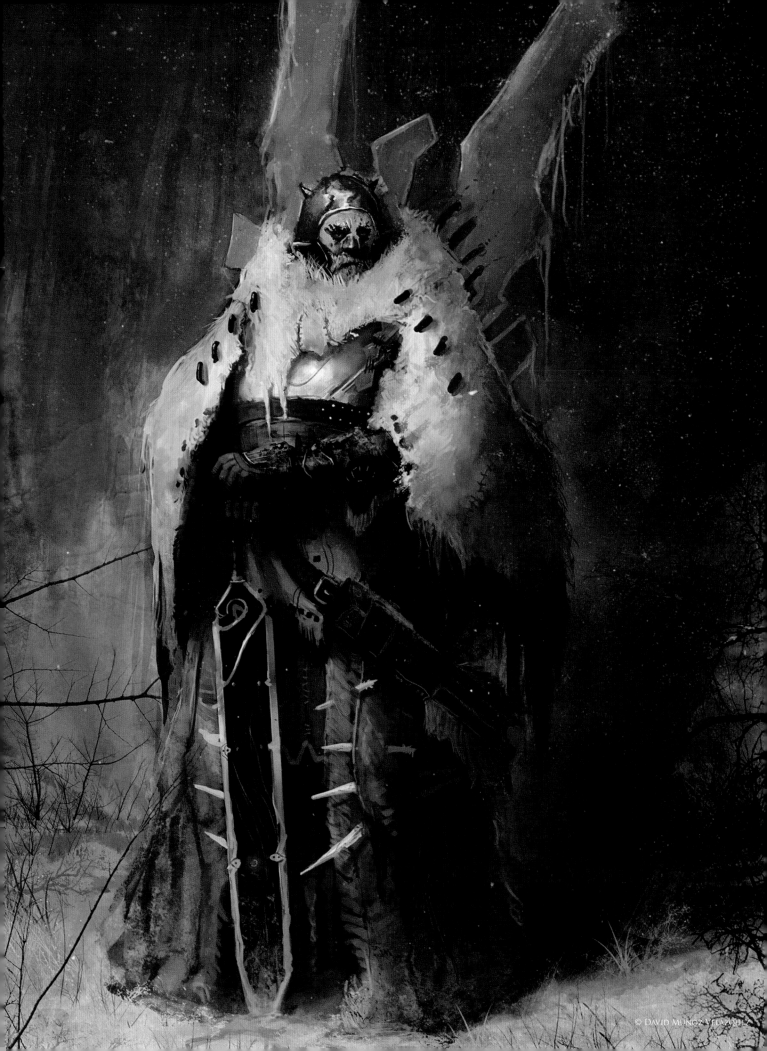

LOFTSLAG BLADE

By David Munoz Velazquez
SOFTWARE USED: Photoshop

HISTORY OF THE CHARACTER

Here is a brief story about my character: An expedition travelled from the northern tribes to the most remote parts of their lands. During the journey most of them passed away, until only two of them remained alive. They reached a zone without visibility and were blinded by a strong blizzard. They finally glimpsed a small area with calm and peaceful weather, like an oasis in a desert. Both of them ventured into this place and found something that looked like a black stone sword. One of them held the blade in his hands and the peaceful place suddenly became frozen. The one holding the blade remained frozen, turning his surroundings into ice, including his friend. One day, life returned to him, but he was no longer human as he once was.

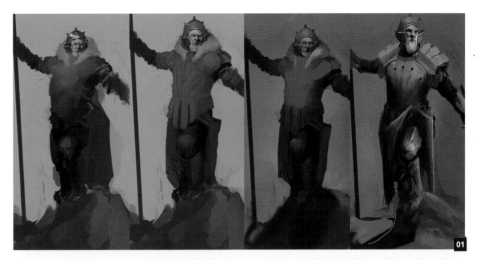

> ## I WANTED TO CONVEY A CHARACTER WHO RULED THE WINTER

The black stone blade creates winter wherever it goes, allowing its owner to master the cold weather at his will, and from that day on winter has gone with him. Sometimes he can be seen within storms and blizzards by careless travellers; however, he is never able to leave the blade or winter alive.

PROJECT OVERVIEW

This article is about how the idea evolved as the image suggested design changes during an organic and flexible process, which I continued to use until the image was complete.

I started the image a while ago, working on it from time to time. I wanted to convey a character who ruled the winter, but also wanted to add hints that he ruled the weather itself. **Fig.01** shows the first concept before I had a clearer notion of the story.

I continued to develop this concept, moving towards a more kingly or warrior-like character, which I thought would look more dynamic (**Fig.02**). He was still a little too "human" for my

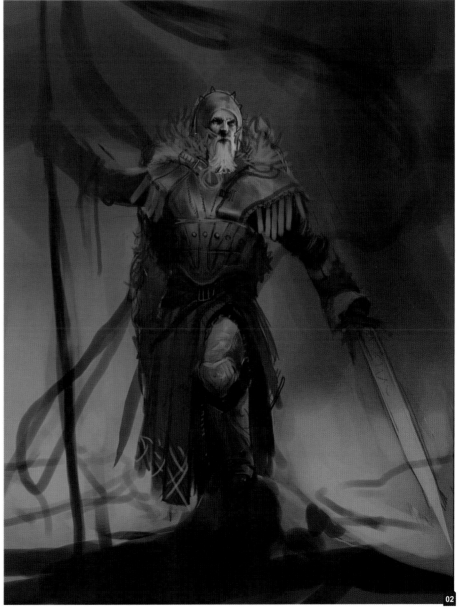

liking, but I really preferred the face from the original design and so decided to keep it.

Whilst still aiming for a warrior/kingly quality with a bit of movement, I tried a different overall color. I developed the ground to help locate him, but most of the effort still went into the face (**Fig.03**).

I made some further alterations to the armor and the proportions, but the major changes were made to the face, which continued to be my favorite part (**Fig.04**).

> " I ADDED SOME ICE-LIKE WINGS TO MAKE HIM LESS HUMAN AND FOCUSED ON MAKING HIM LOOK BOTH FROZEN AND ALIVE AT THE SAME TIME "

In **Fig.05** you can see some variations to the armor, which incorporated different colors and designs and seemed to achieve the "kingly look" I wanted. The face was also starting to feel right at this point.

Next I got rid of the whole environment and placed him on a neutral background. I usually change my mind quite a lot while developing an image, often maintaining some aspects while dropping others altogether. I preferred a monk-like statue, believing it to be more sympathetic to the subject, so I made the image black and white in order to start it again from scratch (**Fig.06**).

Using color I reworked the new design with quite a clear vision of the final concept in my mind. I added some ice-like wings to make him less human and focused on making him look both frozen and alive at the same time.

I started adding some background details with the intention of situating him in a more hidden location (**Fig.07**).

I continued by adding some lighting and more details to the character to clarify the concept (**Fig.08**).

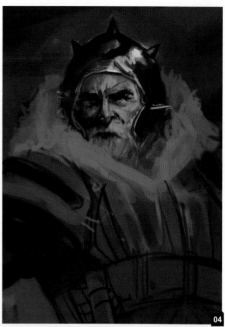

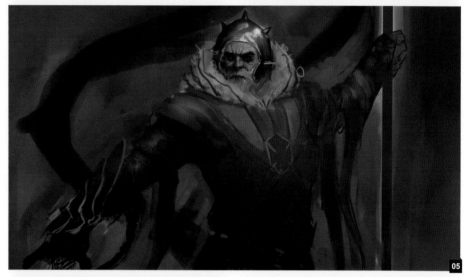

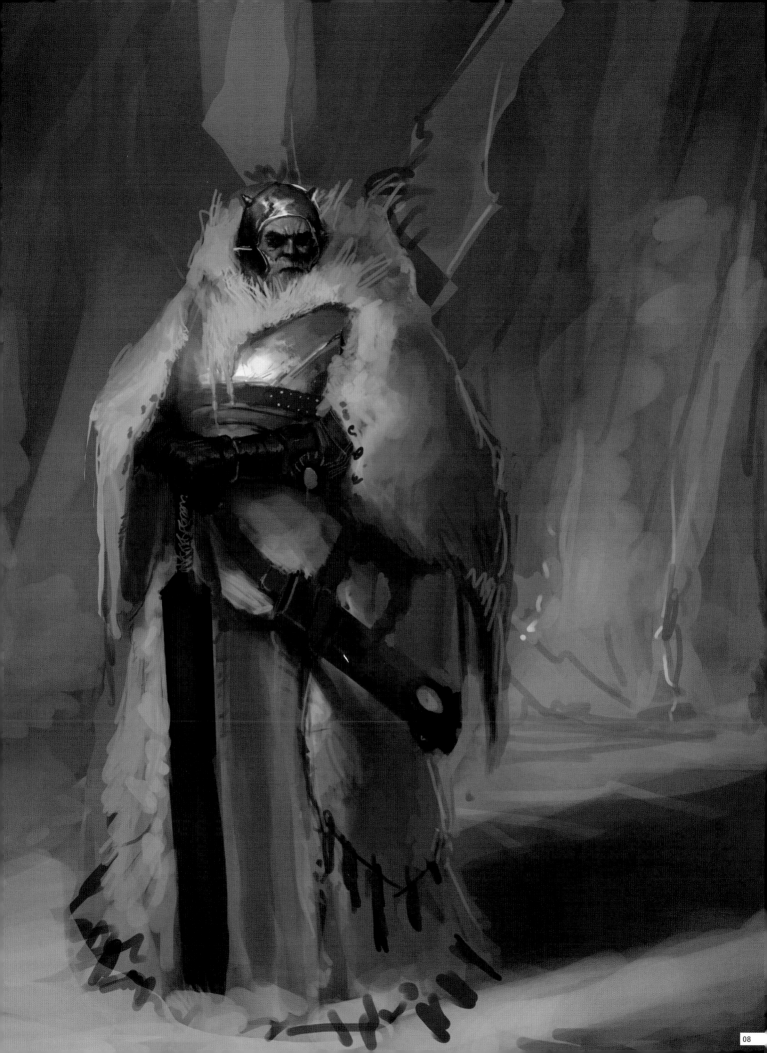

This stage of the image was interesting in terms of seeing how far I could go using the Contrast and Color Variations tools. Any parts that I felt to be of particular interest were retained (**Fig.09**).

In **Fig.10** you can see some further contrast and color across the character's costume. I made the background a bit more neutral and reflected the colors in the character.

> ❝ AT THIS POINT I MADE AN IMPORTANT DECISION CONCERNING THE FACE AND ADDED A SORT OF ICE-SATURATED MASK TO CREATE A LESS HUMAN APPEARANCE ❞

I now focused on the composition as a whole, using light and dark areas to emphasize the character. Using some natural elements was a good way to make him look like he was in a cold environment (**Fig.11**).

I repositioned the character for compositional reasons, experimenting with the color variation in order to avoid having completely cold colors. At this point I made an important decision concerning the face and added a sort of ice-saturated mask to create a less human appearance (**Fig.12**).

This is the final stage, where I repositioned the head and made it bigger. I added all the details, such as fur and snow etc., including some dirt variations. I also reduced the reddish tint in the shaded areas slightly and promoted a cooler palette throughout the image as a whole (**Fig.13**).

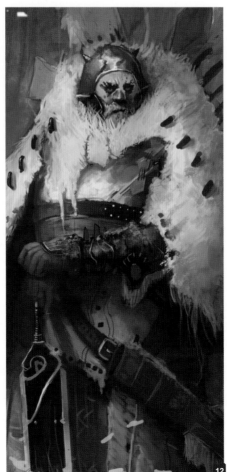

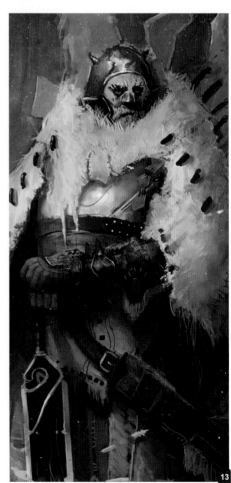

CHARACTERS

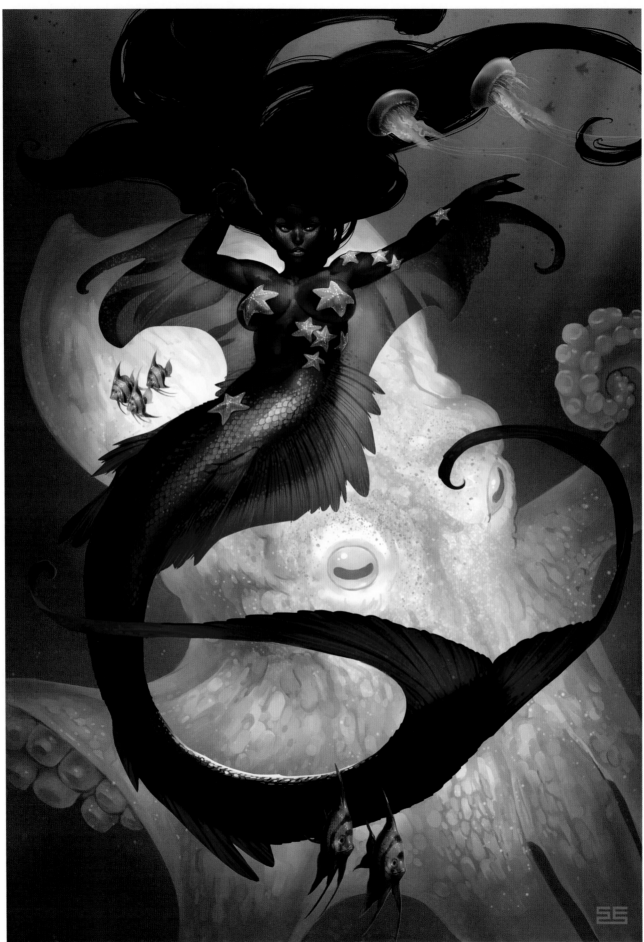

© SIMON ECKERT

RISING SQUID

BY SIMON ECKERT
SOFTWARE USED: Photoshop

INTRODUCTION

Mermaids and octopuses! Who doesn't like them? And since they share the same habitat, why not combine these two beings in a decorative painting with no deeper meaning or elaborate background? I will try to provide you with some insight into my working method from the starting sketch to the finishing touches.

SKETCH

I simply wanted to go for a beautiful mermaid pin-up with a creepy twist to it, accompanied by a giant looming octopus that would form a large part of the background. With these simple ideas in place I began sketching the figure (**Fig.01**). To create the impression of underwater movement the most important thing was to use flowing, elegant lines and harmonious curves. To draw the viewer into the picture and to create perspective in a featureless environment, I chose to paint the mermaid swimming away from the viewer.

As soon as I was satisfied with the shape of the mermaid, I made a selection area using the Lasso tool and then inverted it. I drew in the rising octopus to complete the composition and fill the background with dynamic shapes. Now that the foundation was set and the composition and shapes were all in place I could start designing and rendering the final image.

DESIGN

When designing mermaids you can gather inspiration from all kinds of sea dwellers, though I stayed with a more classical design. A very important thing while designing is to keep a good balance between areas that are rich in detail and larger, calmer zones to create contrast and keep things interesting to look at without becoming confused.

Details are also a very effective way of creating a focus. As you can see most of the detail in this picture, such as the starfishes, is arranged around the upper body and face. That's because the most important part of a figure (particularly a pin-up) is the face and it's always a good idea to focus the viewer's attention

here. The design of the arm fins is not really functional, but the shape simply looked good and helped add to the flowing impression and so I imbued it with a pseudo-functionality.

COLOR AND LIGHT

The first choice I had to make was to decide whether the figure should look dark in front of a lighter background or vice versa. I actually made the decision while I was still designing in black and white, and I went with the first option for several reasons. A dark shape pushes forward towards the viewer and I also wanted

the mermaid to be illuminated by some soft light from the surface, hence the surrounding water would have to be lighter. I also wanted the fins to be backlit by the pale octopus, which would merge with the background to create a sense of depth.

Having established a refined black and white sketch I started adding colors using multiple layers and experimenting with the blending modes until I found a color scheme I liked (**Fig.02**). Normally I opt for Soft Light, Hard Light or Overlay as a mode to create the basic

color scheme. Using a separate layer for each color makes it easier to make swift changes to the overall color mood and tone. I also create focal points through more saturated colors and brighter contrasts (**Fig.03**). The Lasso tool proves very useful for selecting specific areas.

I wanted to make the figure really stand out so I separated the mermaid from her surroundings by using warmer, more saturated colors in the foreground and colder, duller colors in the background. I didn't want the octopus to distract too much from the mermaid and so used a smaller range of tonal values to flatten it out and to make it recede.

RENDERING

The shapes, design, color and contrast were all established so I could continue rendering the picture. My rendering technique is a mix of softening down previously sketchy areas with a soft-edged airbrush and defining focus areas and hard edges using a hard-edged airbrush (mostly the default PS brush). My first step is always to add a new layer on which I work so I can always hide it and compare my progress with the older version. This way I can check if I

have lost some qualities or dynamic lines from the sketch that I should have kept. If I'm happy with what I have done I merge down the layers and, from time to time, I save a new version to which I can return if necessary.

For the scales I made a custom brush and used it to paint the reflected light across parts of the tail. I left out the darkest areas and extended the scaly texture with a hard-edged brush so it would fit in better and look less artificial (**Fig.04**).

While rendering important areas such as the face it's important to zoom out from time to time to see if what you're painting still works from a distance (**Fig.05**). Also flipping the canvas from side to side helps you to see if everything is in place and in proportion. The reason for doing this is because the eye gets used to a picture very quickly and then tends to overlook any distortions (**Fig.06**).

Having finished the rendering of the main character, I then added the smaller sea-dwellers on separate layers in case I needed to move them around to adjust the composition. I used references for the fish, but converted them to a semi-realistic style so they would fit in properly (**Fig.07**).

The last steps were to enhance the focus on the mermaid by adding another Linear Dodge layer and to paint along the sharp edges of objects, adding detail like the scales on the sides of the tail and softening hard edges left from the use of selections.

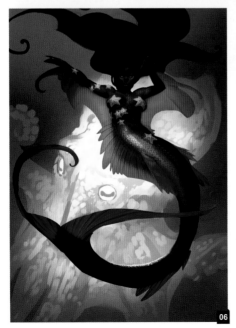

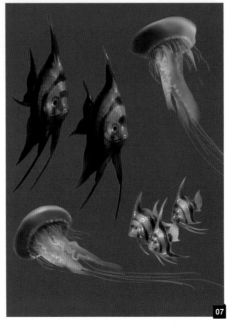

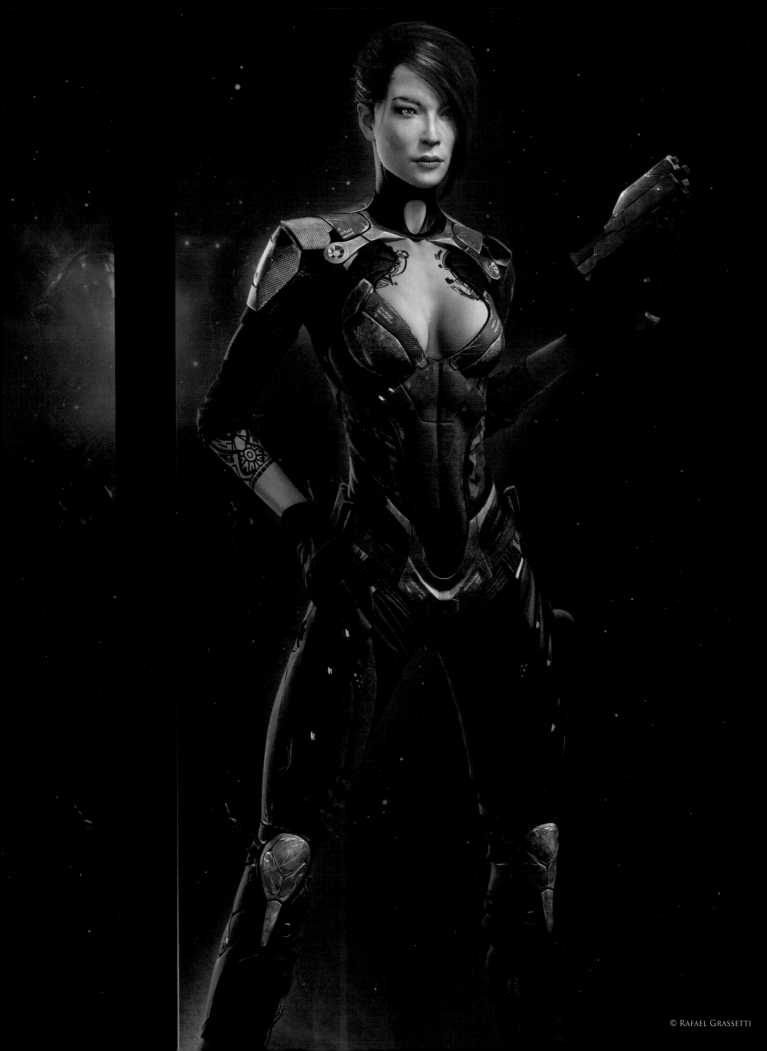

HOSHI

BY RAFAEL GRASSETTI
SOFTWARE USED: 3ds Max and ZBrush

INTRODUCTION

This model was inspired by the *Mass Effect* game universe. My first idea was to create a new character for an online challenge, so using ZBrush I tried to sketch a few ideas in 3D.

MODELING

I started to sketch with a simple base mesh in ZBrush, trying to find the overall idea for the design. At this stage I just used simple brushes in ZBrush, such as the Move and Standard brushes. When working I try to keep everything within one subtool until I have found a design that I like. During this stage I usually change my mind a lot!

> " I GENERALLY USE NEW OBJECTS TO BUILD EVERYTHING, BUT SOME THINGS ARE FASTER USING RETOPOLOGY TOOLS IN 3DS MAX AND ZBRUSH "

After I had found a good shape I started to refine the model by breaking it into many subtools and adding new pieces that completed the main idea. I tried not to go crazy with details at this stage, because I knew everything would have to be redone from scratch later. As soon as I had the main idea and overall shape of the design, I stopped using ZBrush (**Fig.01 – 02**).

Once the sketch was ready I used the Decimation Master and imported the model into 3ds Max to be used as a guide when it came to creating the final model. I generally use new objects to build everything, but some things are faster using retopology tools in 3ds Max and ZBrush. In this instance I created some simple geometry and retopologized them to build the shoulders and legs, after which I refined and finished them in 3ds Max. At the end of this stage the entire model was done (**Fig.03**).

When the model was complete I opened the final model in 3ds Max, along with the UVs, and organized them into a basic layout, one for the

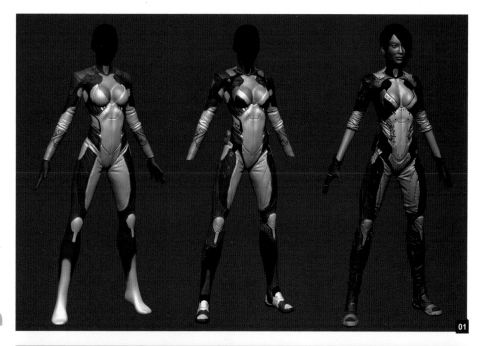

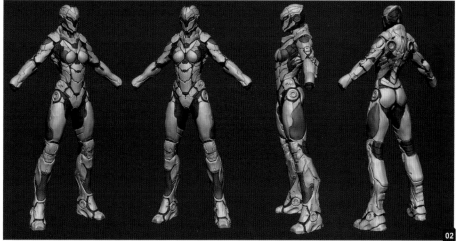

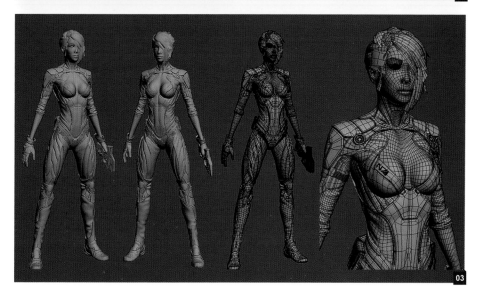

head and eyes, one for the torso, one for the skin and one for the legs and hair (**Fig.04**).

For the head I used 3ds Max to create a base mesh and ZBrush for the final sculpt. I used references from a few Asian actresses like Lucy Liu and Bai Ling. It's really important to break the symmetry at this stage, even if it's subtle (**Fig.05**).

With the modeling and UVs finished it was time to go back into ZBrush and add detail. This time I used some specific brushes in ZBrush to create the cloth and metal scratches. This was a fast and easy stage of the project, because on this character almost everything had already been built in 3ds Max.

Following on from this I added a few colors in ZBrush using polypaint, which I would use later as a guide to create the final textures in Photoshop. I re-imported the model from ZBrush into 3ds Max again and exported the Normal and Displacement maps from ZBrush. It's important to create as much detail as you can on the topology of the model in this kind of project so that the Displacement and Normal maps are reserved for the small details. This way the final model will be ready for production. I usually use a mix of Displacement and Normal maps. I use Displacements maps with the Displacement modifier in Max to add small changes to the topology and Normal maps for the small detail, enabling a faster render at the end.

I used the color guides from ZBrush to create the final textures in Photoshop, using a

04

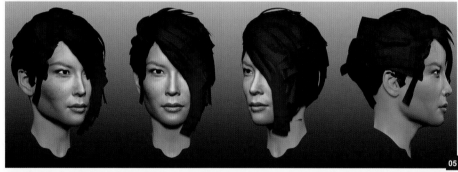
05

HAIR DIFFUSE — HAIR SPECULAR — HAIR BUMP 06

combination of hand-painting and photos. A Diffuse, Specular and Bump map were created for each layout. ZBrush was used again at the end to fix seams and make a few color corrections. When not making models for games I usually don't bake any shadow or light information onto the textures (except for an Ambient Occlusion map that I generate in 3ds Max). I create the realistic final effect using shaders, lights and render settings.

I created the hair using planes that incorporated Diffuse, Opacity, Specular and Bump maps, commonly seen in game models (**Fig.06**). The shader and modeling in this case helps

to create a realistic look. I usually create six plane variations in one UV layout and organize the planes on the head, always using hair references as a guide.

After this I added a new Edit Poly on top of all the objects and worked on her pose (**Fig.07**). I usually do this in ZBrush, but in this case I achieved it by way of Max pivots.

The lighting in this scene involved four simple point lights, one main light, two fill lights (with cold and warm colors on each side) and one big backlight for SSS. The model was rendered in V-Ray.

Artist Portfolio

QEV

By Etienne Jabbour
Software Used: 3ds Max

INTRODUCTION

Qev was conceived as an internal R and D project at our character art studio Slide. He was primarily the result of an exercise in creating a face that was believable, yet entirely imagined. However, as we always try to squeeze the most out of our internal projects, one of our other main aims with Qev was to produce a model that would look great at both mid-distance and in extreme close-ups. This is something often requested for cinematic jobs where shots are always subject to unexpected, last minute changes.

As art director/artist on the project (working with the co-founder of Slide, Robin Deitch, who helped formulate the technical approach) I knew from the start that I wanted Qev to be an anti-hero from UK youth culture with a sci-fi twist. I wanted him to display all the stereotypical traits affiliated with the strata of UK culture known as "chavs", but also wanted to subvert these with a few elements that would make the character sympathetic. I decided that these elements would primarily be conveyed through the design of his face, which we wanted to be realistic, but entirely imagined so as to give us maximum creative control over his appearance.

The wish to create a realistic, yet characterful, face was both an ongoing personal goal and something Slide as a studio had seen a greater demand for in the games industry as we moved towards the end of the current gen cycle and into the next generation.

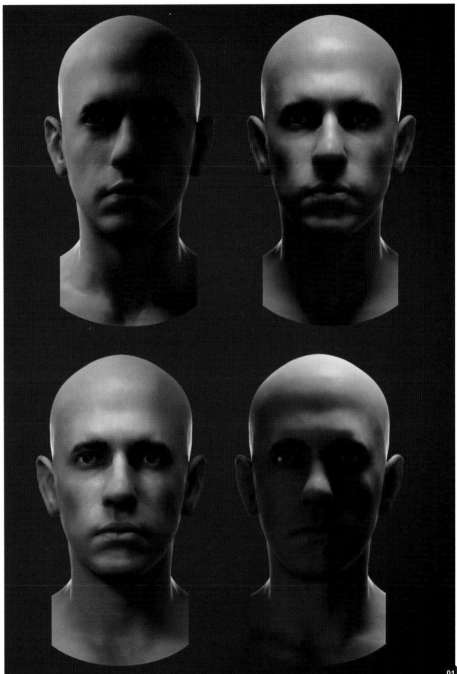

01

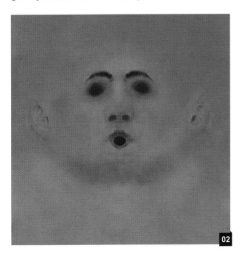

02

Generally in this console cycle detailed human characters have commonly been developed in one of two ways: illustrative and hyper-real (usually based on concept art) or actor photo/scan based and "photoreal". Each of these methods has strengths we wanted to tap into and weaknesses we wanted to try and avoid. In the case of the more illustrative approach, the strength lies in the ability to convey a lot of personality and have full creative control over the look of the character. However, going down a strictly illustrative approach means characters can end up looking archetypal and lack subtlety and depth. On the other hand, in the case of an actor/scan-based approach you can achieve wonderfully subtle results, but are restricted by the look of the actors you cast. This, in turn, limits your creative choices and you run the risk of ending up with a "death mask" quality once the character is in the game.

MODELING

So our goal was to develop our skills and techniques for the purposes of realistic human facial design and harness the strengths of both these methods. Qev was our first full production character created using this process; an approach we have since fine-tuned and successfully used across multiple AAA projects coming out over the next year or two. The process relies on observation and artistic judgment, so it is not something that can be conveyed in a tutorial. At a high level though the key to it lies in learning the bounds, limitations and constants of the human face in real-world terms, and developing an instinct for how to bend these rules to achieve a specific result without destroying the illusion of realism.

A key to our approach, which helps the process, is to get broad color information on a head model as early as possible and regularly create renders under varying lighting conditions using appropriate shaders as we sculpt (**Fig.01 – 02**). This helps to catch areas and features that may have become too extreme during the sculpt or that just need a little more "TLC" to really sell them.

This process took several days on Qev as it was my first attempt at formulating my approach into a repeatable, production-ready technique. Once this was done we had a face and likeness around which we could start to build the character.

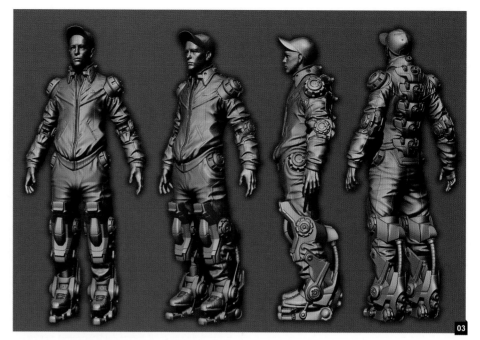

> FOR HIS COSTUME DESIGN WE DECIDED TO DEVELOP THE IDEA OF SPORTS LEISURE WEAR BY CLOTHING HIM IN A TRACKSUIT AND INCORPORATING A CYBERNETIC EXOSKELETON USED TO AUGMENT RUNNING (PRESUMABLY FROM THE POLICE WHILE CARRYING A RECENTLY "DISCOVERED" HD TV)

For his costume design we decided to develop the idea of sports leisure wear by clothing him in a tracksuit and incorporating a cybernetic exoskeleton used to augment running (presumably from the police while carrying a recently "discovered" HD TV). This contrast of cloth and hard surface structures would allow us to test out a pipeline for multiple high resolution texture tiles across both displaced and subdivided geometry, as each have their own specific requirements and foibles (**Fig.03**).

When sensible UVs had been assigned and we could apply a measured checkerboard map, it became clear that we'd need to spread the UVs over a number of pages to maintain the desired texel resolution, whilst keeping individual textures at a workable size in Photoshop.

Materials in 3ds Max can usually only take a single bitmap as a texture input, but we wanted to avoid duplicating our shader networks to handle the multiple source textures. Consequently, we laid out the UVs to cover multiple tiles (0-1, 1-2 etc in UV space) and used a Composite texture node, along with the Offset controls of each referenced bitmap node, to assemble the individual source textures (bitmapDisp_u4_v2 etc) into a single "mega texture" (bitmapDisp).

Instances of this mega texture could then be plugged into a material in the same way as a traditional single-map texture (**Fig.04**).

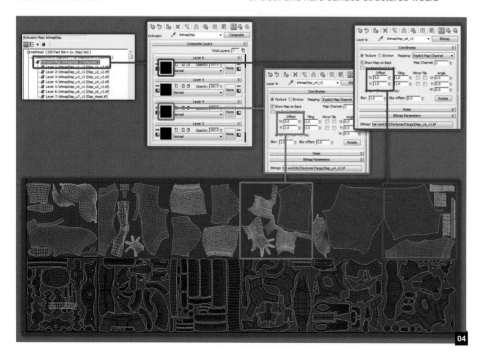

Once this was done we set up a fairly straight forward mental ray scene with area lights and Final Gathering. We ignored passes on this occasion and just rendered out a final render of Qev with an alpha channel in order to composite him into a fairly abstract photo of an urban environment taken in the area around our studio, which is in Old Street, London, England (**Fig.05**).

With some final color balancing, hand-painted environment effects and smoke rising up from his cigarette, as well as the addition of his favorite alcoholic beverage, Qev was complete and ready to cause trouble.

ARTIST PORTFOLIO

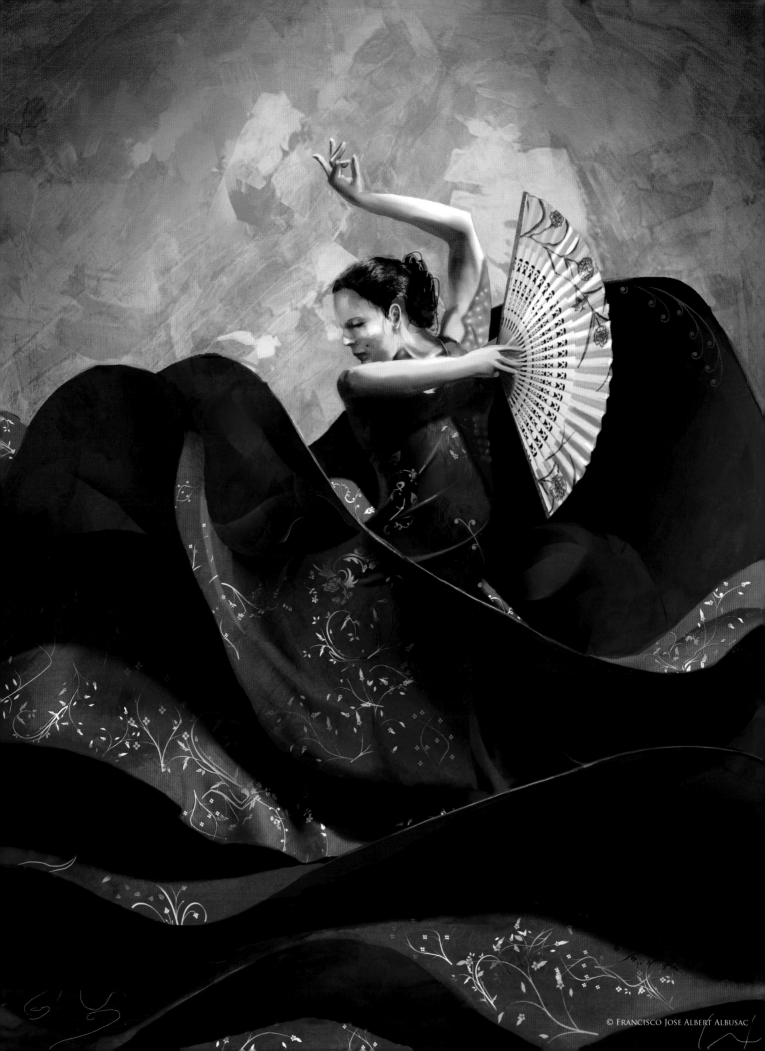

FLAMENCO

By Francisco Jose Albert Albusac

SOFTWARE USED: Photoshop

MY PAINTING

When I started this image I was inspired by a few ideas, among which was the film *Hero*. I particularly liked the color palette and the motion of the clothes. I was thinking about these things when I found myself painting something that resembled red waves surrounding a girl (**Fig.01**). It was a picture that barely worked, but had a feeling that I liked.

As you can see, I needed to work the idea more but it was a start and, as always, "everything starts with an idea". I generally work with Round brushes and the Gradient tool, using gray hues to begin with. Working in gray allows me to be more objective because one's eyes suffer more when dealing with saturated colors and greater contrast – something you notice if you are painting for a long time in front of a screen.

From my own experience, I think it is always easier to saturate a picture than to desaturate it and so during this process I will awaken the colors as opposed to toning them down.

I must confess I created the girl with Poser. I had some existing models and thought this model would be fine; however I treated this like an experiment because as a painter I need to address anatomy. Only during the initial steps do I permit myself to be a little crazy and play around with the focus of being creative.

It was in this moment that I realized the first problem concerning the composition. Although waves are interesting and offer many possibilities, the girl is not as fluid. Her body is rigid. She is centered and almost concealed, which kills the picture. I needed to break up the shapes and try to improve the composition by uncovering the girl (**Fig.02**).

I realized my idea had been wrong from the beginning, without any sense of logic. I wanted to portray a flamenco dancer, but had painted a ballet dancer instead. I spent several days thinking, scribbling poses and changing the original idea before finally settling on a classic pose that felt more organic and alive (**Fig.03**).

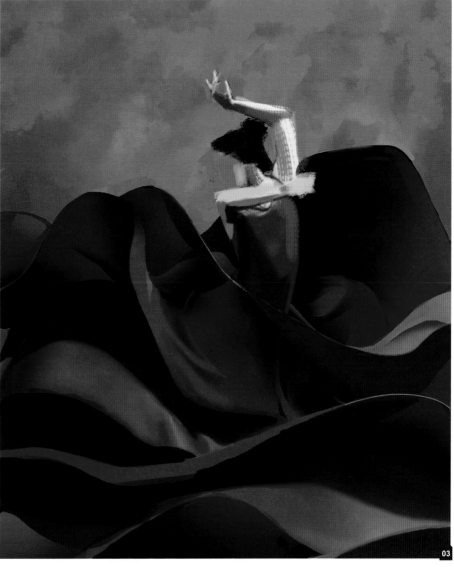

I preferred this pose because the girl now demonstrates motion and breaks up the shapes. It looks as though the motion of her dress is due to the movement of her hips. Having made this step it was time to go on to a new phase: dealing with the main hues and lighting. I chose to work with two layers: the background and the girl.

I started introducing a little blue and cyan into the background, with complements of red. However I needed to be careful that they were complementary and avoid any jarring (**Fig.04**).

As you can appreciate, the colors are conflicting and furthermore the blue in the background causes the girl's skin to appear redder. This phenomenon is called "simultaneous contrast" and refers to where one color alters our perception of a neighboring one, especially a complimentary color. This problem can be solved by desaturating one of the colors (red or blue). After introducing a little bit of red into certain parts of the background I was able to create a more harmonious relationship with the dress. This is essentially what harmony is: a color containing part of its neighbor. This is very useful when you work with grays (**Fig.05**).

I felt at this point as though things were going well, although the girl appeared somewhat dark. I wanted her skin to shine and create the impression that she is the most important element in the picture, but it looked too dark. Because of this I redefined the color scheme.

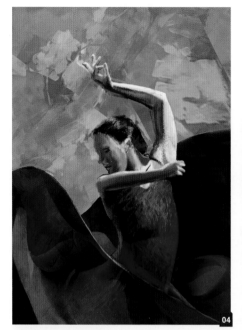
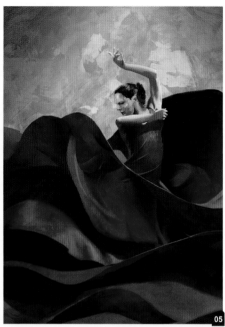

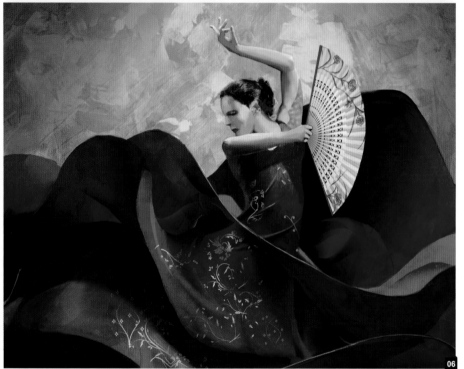

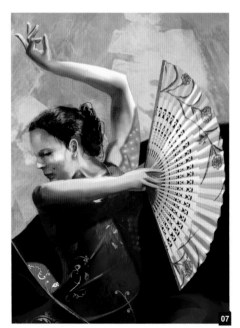

It was also necessary to relax the red color because the light in the scene is white. Had I chosen red then I would have used a more saturated red in the dress (red elements reflect red light).

At this point I had the idea of placing a fan in her hand, which I thought would help the image come alive and feel more balanced. I took a photograph of a fan before painting it a little and then putting it into the image. The color of the fan lends realism to the composition because the girl resembles a model posing for a photograph in a real studio situation. Finally, I added some embroidery to the dress, which is easy if you use custom brushes. It's important to use a different layer because this element is added before painting the shadows and highlights (**Fig.06**).

From this point on I only need to improve the skin and the dress (**Fig.07**). The color seemed right, but they needed more detail and texture. I achieved this by adding new hues. Finally I modified the color levels and the image was finished.

CLOSE-UP PORTRAIT

By David Moratilla Amago
Software Used: Maya, Photoshop and ZBrush

BASE MODELING

I reused the geometry of an old NURBS body
that I made years ago as a base for this project.
I converted it to polygons in Maya, making
sure that all the polygons were four-sided for
better subdivisions. I adjusted the proportions
in ZBrush as it's easier using the Move and
Standard brushes to do this (**Fig.01**).

UV UNWRAP

Back in Maya I created the UVs. I decided to
separate the head into two pieces, each one
with its own texture and UVs to help me get
more texture resolution. I tried to place the
seams in parts of the model that wouldn't be
seen (**Fig.02 – 03**).

SOURCE PHOTOS

I used photographs from the Ballistic Publishing
DVD *Essence – The Face* as the source for
the skin textures. I made several projections of
the photos onto the geometry and then merged
them all together in the final texture.

PHOTO PROJECTION USING
BODYPAINT

Using BodyPaint I created and assigned a
white 4096px texture to the geometry. I then
chose a photo to project onto the geometry
and positioned the 3D view in a similar way. I
created a projection layer by way of projection
painting and then used Freeze 3D View. This
creates a snapshot of the current 3D view
placed in the projection layer (I chose 4096
as the resolution as it meant I didn't lose any
resolution when the image was re-projected)
(**Fig.04**).

ADJUSTING THE PROJECTED IMAGE

I placed the original photo into a new layer in
Photoshop and made adjustments to match
the geometry. Back in BodyPaint I merged the
texture with the new one and disabled Freeze
3D View. This bakes the projection into the
texture and then saves that texture.

I repeated this process several times to cover
the whole face with projections. I made five
projections (two laterals, two quarters and a

CHARACTERS

81

ALL PROJECTION. NO ADJUSTMENT FINAL TEXTURE

05

front view) and added some extra details to the lips and nose. When I had completed all the projections I merged them all in a PSD, chose the best amount of pixels for each one and matched the colors so there was no difference between them (**Fig.05**).

DETAILING IN ZBRUSH

I already had the base geometry and texture, so I subdivided the base in ZBrush and added details using the information on the texture. I created a black and white version of the color texture and used it as an Intensity mask to create the first layer of detail (**Fig.06**).

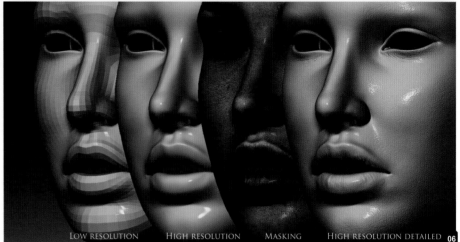

LOW RESOLUTION HIGH RESOLUTION MASKING HIGH RESOLUTION DETAILED 06

I also added small bumps with a spray-enabled brush to create less uniform skin. Once I had the final detail I chose a level of subdivision to use in Maya for the render and deleted the lower subdivisions. I then created the Normal and Cavity maps for that level using ZMapper (**Fig.07**).

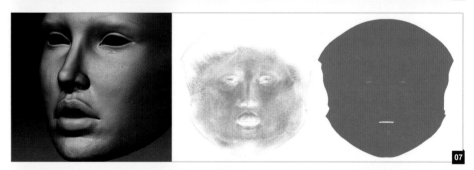

07

LIGHTING

I wanted soft and lateral lighting as I think this kind of light creates great result for portraits, and it also highlights the skin texture. Before deciding on the lighting I created a quick skeleton to experiment with some different poses. I made some render tests with Lambert and using some geometry as hair to give me an idea about how it would look. For each pose I created different lighting conditions using only one area light (**Fig.08**).

SKIN SHADER

I used an SSS mental ray shader for the textures. I broke down the shader and composed all the layers in Photoshop, so the

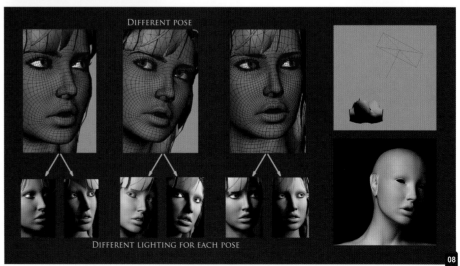

DIFFERENT POSE

DIFFERENT LIGHTING FOR EACH POSE

08

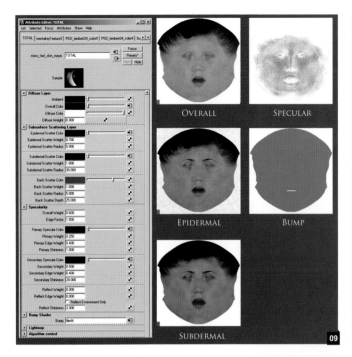

OVERALL SPECULAR

EPIDERMAL BUMP

SUBDERMAL **09**

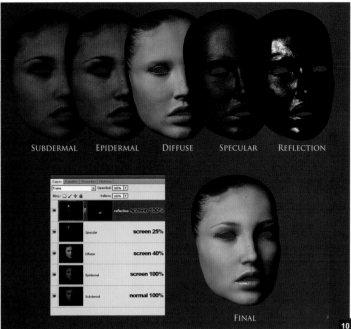

SUBDERMAL EPIDERMAL DIFFUSE SPECULAR REFLECTION

reflection screen 100%

Specular screen 25%

Diffuse screen 40%

Epidermal screen 100%

Subdermal normal 100%

FINAL **10**

weight values seen in **Fig.09** are not important. When breaking down the shader I duplicated the original and made a new one for each layer. Then I changed the values and weights individually. For example, the weight of the Diffuse was one and the Epidermal, Subdermal, Specular, etc., were zero. I only altered the weight values, leaving all the others the same. Using this technique I could quickly adjust each skin layer and change their color, contrast and levels. In **Fig.10** you can see my passes and how I adjusted the reflection pass so that it only showed up on the lips.

THE EYES

These are made up of three meshes: exterior, iris and a back cover (pupil). The exterior mesh uses a Blinn shader with transparency in the center that allows you to see the other parts. The transparency map is a Maya circular ramp (**Fig.11**). I took photos of my own eyes to create the textures, and for the reflection I mapped a HDR texture onto a sphere and deleted the faces that didn't contain the light source. I carefully placed it to simulate the look of light coming through a window (**Fig.12 – 13**). I created extra geometry to create a tear line and to improve the blending between the eyeball and the face. For the eyelashes and eyebrows I created polygon cones of different sizes.

THE TEETH

Once I had modeled the teeth I used photos to create the textures. For the shader I made

EXTERIOR IRIS PUPIL **11**

ORIGINAL PHOTOGRAPHS EYEBALL COLOR TEXTURE IRIS COLOR TEXTURE **12**

13

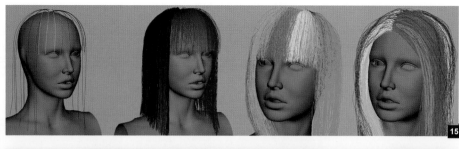

several tests to simulate good translucency. Finally I used the SSS Fast Skin shader and adjusted its configuration (**Fig.14**). The reflection across the teeth came from a separate pass made with a Blinn shader, which I would compose later in Photoshop.

HAIR MODELING

I created the hair using a NURBS curve together with the Shave and Haircut plugin. I created two hair systems for each style to add some variety. I created two different hairstyles and a bald version (with the hairs from the skin texture), which meant that I had a total of three different styles to choose from for each pose (**Fig.15**). I used the shaders_p hair system, which I adjusted slightly to fit each hair type.

FUR

I wanted to add fur to the face because the camera is so close and I think this adds to the realism. I created different systems and varied the width, length and orientation. I used the Paint Fur Attributed tool to paint the baldness of each system, then rendered it as a separate layer and composed it in Photoshop using the Screen blending mode (**Fig.16**).

COMPOSITION

I then merged all the rendered layers. There was nothing special done at this point; it was merely a case of configuring all the layers and passes in Photoshop. Finally I added a Noise layer, a bit of blur and some chromatic aberration to try and reduce the CG appearance (**Fig.17**).

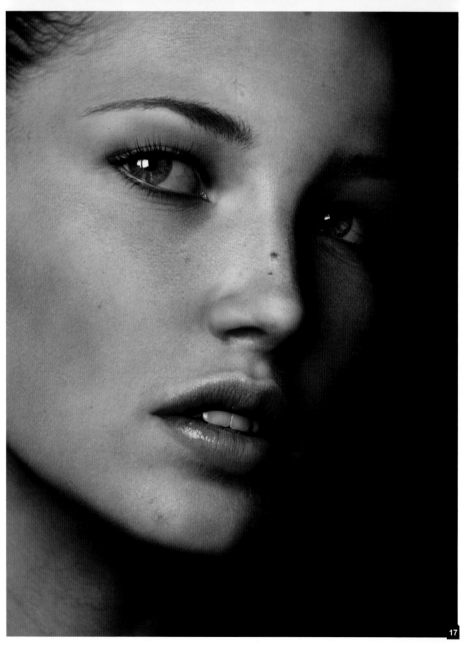

1984 ★ SPACE SUITS

© SERGIO DIAZ

SPACEGIRL

By Sergio Diaz

Software Used: Photoshop

INTRODUCTION

Ever since I was a kid I've always been into science fiction and fantasy. I've drawn for as long as I can remember. I would draw when I was bored and would make up characters or copy pictures I liked.

I thought about many professions while I was growing up and during my teens considered fields from engineering through to construction. Finally when I was around seventeen years old I realized that my personal and professional life were bound to be art related, although I still didn't quite know what direction I would take. Nowadays I work mainly as an illustrator, 3D modeler, concept artist and character designer for commercials, movies and video games, etc.

WORKFLOW

I usually draw the first sketch on my computer as it's quicker and allows me to try different ideas more efficiently than it would with traditional methods. This is particularly true now that I use a Wacom Cintiq. I haven't tried the larger version, but the one I have (12 inches) is highly recommendable. However, if I find that I have some free time I enjoy drawing on a real notepad with a real pencil.

I don't tend to follow a specific method when painting, although I will try to talk you

through my process. Usually I start out with a (pretty blurry) mental picture of what I want to accomplish. This is why I don't draw many sketches and prefer to correct the initial sketch as I go along.

For this illustration I started drawing the basic idea of a girl in a space suit in Photoshop. I hadn't figured out the colors and background or even if I was going to retain the gun. The

anatomy wasn't fully finished either. The only thing that was really defined at this point was the pose. In short, this sketch only depicts the general idea that I had in my head (**Fig.01**).

Instead of starting with grayscale and applying color afterwards, I mostly work with defined colors. To me it's simpler and I believe that in the end, the color mixes are richer that way (**Fig.02**).

After this I determine the source of light within the scene and start to add lighting to define the depth. I always try to avoid using white to lighten surfaces or black to darken them. In this case the colors are richer because I used orange and yellow to lighten the red suit. Although this isn't applicable in every case, it does depend on the final result you are going for, the scene lighting and the character you are painting (**Fig.03**).

I added highlights and contrast in some areas such as the hair. I also added some provisional color to the gun, which would be refined later (**Fig.04**). In **Fig.05** you can see how I added some detail to the gun and a pattern across her suit.

Once the figure is more or less defined I then move onto the background. I usually leave this until last because it's the least interesting part and I really don't enjoy doing it. I work on it slowly, mostly using big color blots to define shapes and lighting in a general way. In **Fig.06** you can see that at this stage the background and the figure didn't share the same color palette, but I corrected this later.

> ## IF YOU DON'T LIKE SOMETHING, DON'T TRY TO JUSTIFY IT. INSTEAD, DO IT AGAIN UNTIL YOU'RE COMPLETELY SATISFIED

As I move forward with the background I find shapes that I like more than others. For example, in the upper left corner of this image I drastically changed the initial shape. It is very important not to get too attached to anything in your illustration. Also, if you don't like something, don't try to justify it. Instead, do it again until you're completely satisfied (**Fig.07**).

In **Fig.08** you can see that I added some more detail to the background and adjusted the color of both the background and the girl using the Color Balance filter in Photoshop. I also introduced the helmet and corrected the girl's proportions using the Liquify filter as they didn't look altogether accurate. As well as these changes I decided to add a rim light around the girl to separate her from the background (**Fig.09 – 10**).

Finally, I added the 1984 logo, some more detail to the girl's suit and a little color correction. As a final step I added a texture layer in order to give the impression of an old, dirty picture.

CONCLUSION

Most of the time I try not to have too many layers in an illustration and so I usually collapse them when I am satisfied. It's almost like painting in oils or acrylic in a traditional way. I also try to avoid using many color corrections or effects. I've built a great collection of brushes in Photoshop, although I always end up using the same three or four for everything with the brush opacity and Flow settings always at 100%.

CHARACTERS

WARRIOR

By Jesse Sandifer
Software Used: Mudbox

Introduction

This illustration of the Turtle Barbarian was created for the Warriors Autodesk Mudbox 3D Challenge on **www.cghub.com**. The brief was completely wide open and organic, and simply required participants to create a warrior using Mudbox. What came to mind immediately was a ferocious character with a foreboding demeanor. I also wanted to create a non-human hybrid, which had features resembling alligators, snapping turtles and other dangerous reptiles. After gathering references of these types of animals online, I decided I would use a lot of rough, plate-like armor to accentuate the character throughout, as well as tough, leathery skin for most of the flexible areas.

The Model

I began by coming up with a couple of loose concepts to help me with the character sculpting. I rarely do finalized concepts for my sculpted characters, as the forms and details are generally better resolved while sculpting. The idea in these concepts is just to doodle and develop some general ideas (**Fig.01 – 02**).

To get started on the sculpting phase I created a quick, box-like human mesh in 3ds Max and then exported it over to Mudbox as an OBJ file (**Fig.03**). The reason I used a human-shaped mesh is because it gave me the general proportions, position of limbs and a neutral pose to start with.

From there I mainly worked on getting the overall warrior silhouette and stature lined up using the Grab brush. Once I was happy with the basic feel of the base mesh I subdivided it once and started roughly sculpting using a mix of the Sculpt, Wax and Scrape brushes. I like the Wax brush as it feels sculptural and intuitive. The Scrape brush is great for flattening out lumps so it's good for preventing things from becoming too bubbly or lumpy (**Fig.04 – 05**).

My first area of focus on any character is usually the head, as it's the main indication of personality and attitude (**Fig.06**). From there I work my way down the torso, branching out into

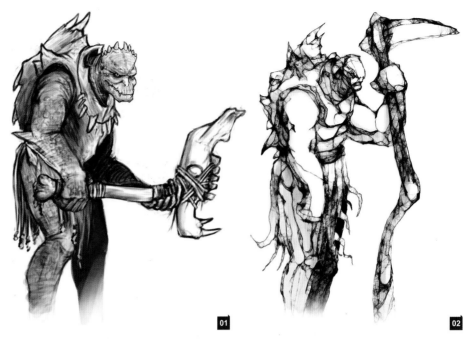

01

02

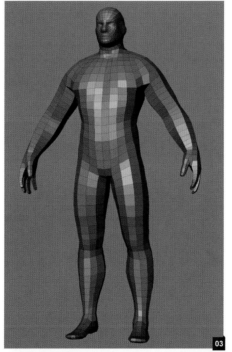

03

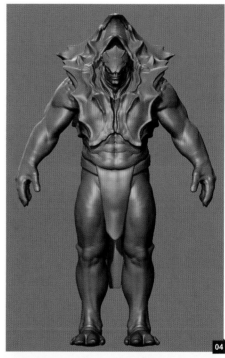

04

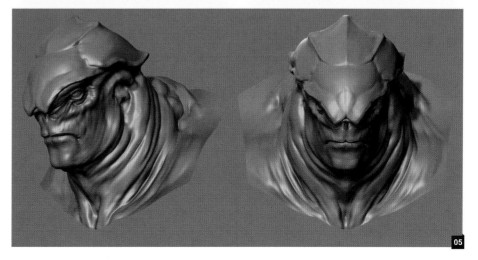

05

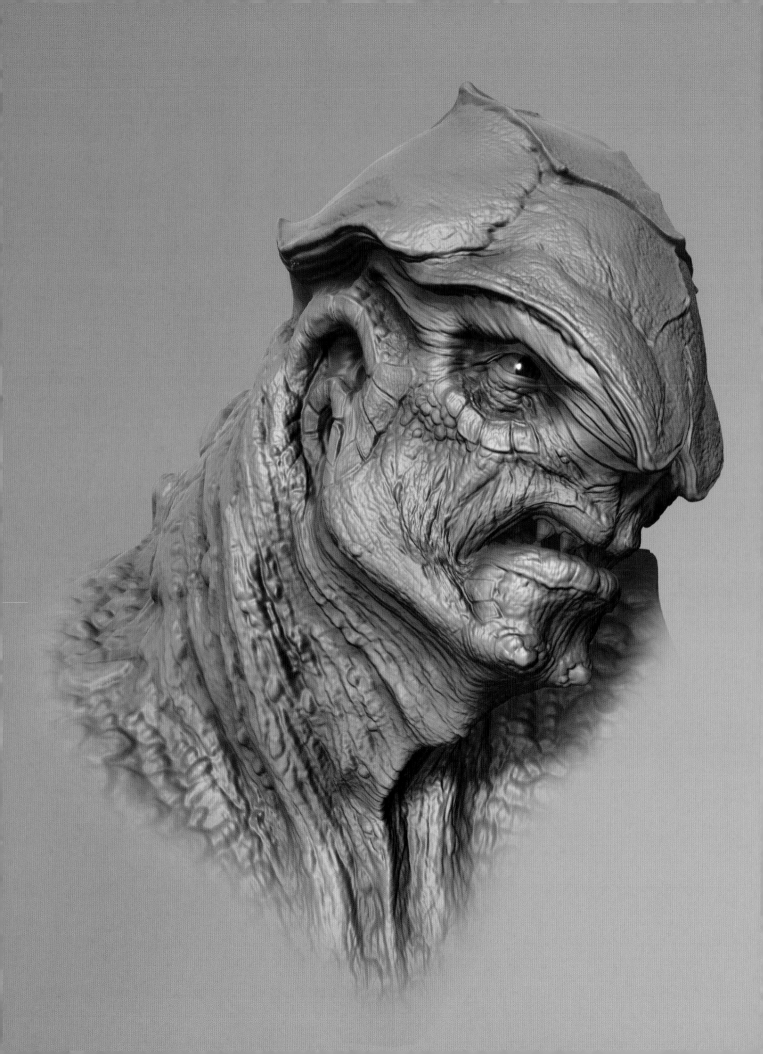

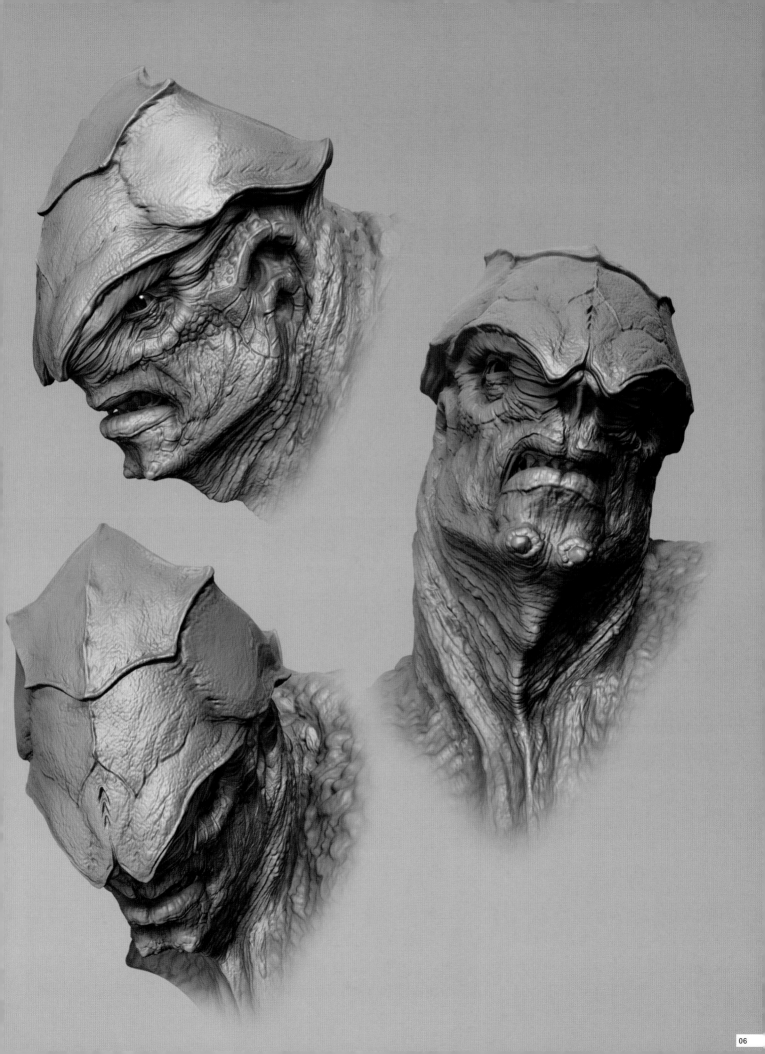

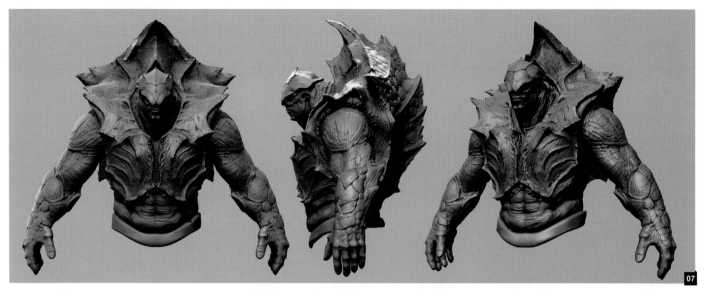

the arms and then the legs. I actually designed him to be broken up into those same pieces just in case I wanted to have him printed in 3D in the future.

> ## I KNEW I WANTED IT TO BE "OTHERWORLDLY" AND INDICATIVE OF HIS WARRIOR STATUS

While sculpting I tried to find a good flow for the scaling, shell and armor that made up the proportion of his surface. It was then a matter of filling in the gaps with believable folds, wrinkles and anomalies that tied everything together (**Fig.07**). During this detailing stage, I really focused on trying to represent reptilian skin successfully, reminiscent of snapping turtles and alligators, whilst at the same time I aimed to create a new breed of creature with some unique features. The lengthiest part of this whole process was in creating all the details (**Fig.08**).

Then it was time to create the weapon. I knew I wanted it to be "otherworldly" and indicative of his warrior status. I figured he had previously killed some sort of huge beast and fused some of its bones together to create his bladed scythe-type weapon (**Fig.09**).

After I was happy with the final sculpting, I worked on getting UVs set up for the base mesh. I generated my UV layout within 3ds Max and broke the character up into several tiles. The head, torso, arms, legs, belt accessories/

cloth and weapon all had their own individual maps. This way I was able to maximize the map resolution, which ended up being 4096 x 4096. The new UV meshes were then imported back into Mudbox at the base level. I didn't really have an idea of color at this point, but I

knew I wanted it to be rough and have lots of dark areas playing against lighter colors on the armor. I experimented with more radical color designs including dark blue skin and tons of splotchy spots, but in the end I tried to just keep it simple with the final result (**Fig.10 – 11**).

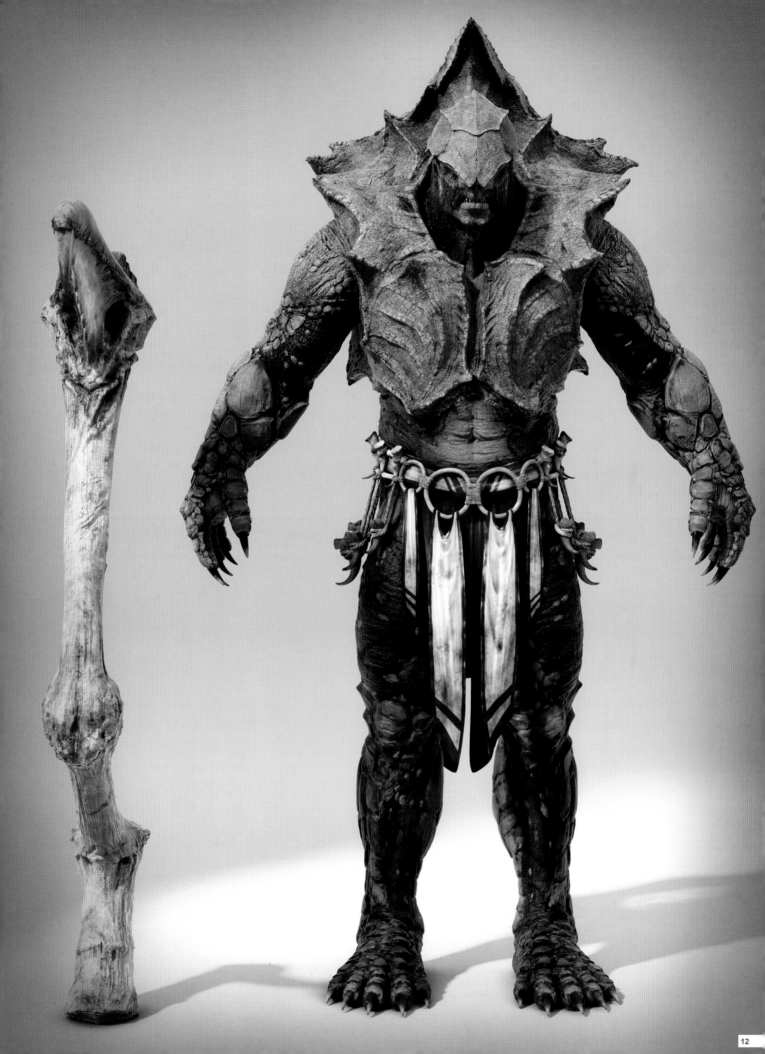

In my opinion Mudbox has an advantage over the competition in regards to its texture painting features. The use of layers, blend modes and the ease of going back and forth to Photoshop for custom changes is simply awesome. I never need to worry about UV seam issues either. For this image I also employed the use of Projection maps for a lot of the armor and scales. To help indicate his status as a warrior I set some deep reds against some off-white in his cloth and accessories (**Fig.12 – 13**).

After texturing I exported all the maps, including Displacement maps, over to Photoshop for some very minor color correction. I posed him in 3ds Max using a plugin called Puppetshop. I nailed down a camera angle that I liked and worked back and forth, adjusting his pose to be as strong as possible for the final illustration. I set a strong directional light to add drama and focused on his face. A couple of fill lights were added as well as a strong rim light to highlight his silhouette. I ended up winning second place in the competition, which I was very excited about. Offload Studios contacted me afterwards and offered me a free 24 inch print of the guy! So I have to say, it was worth it (**Fig.14 – 16**).

© JESSE SANDIFER

GRANDMA

BY ARDA KOYUNCU

SOFTWARE USED: Maya, ZBrush, Mudbox and V-Ray

INTRODUCTION

Hi, my name is Arda Koyuncu. I am a 3D character artist currently living in San Francisco. I always thought there were dark elements to fairy tales and with this in mind I wanted to create all the characters from the famous tale of *Red Riding Hood* in a twisted way. In my re-imagining of the story Grandma is the evil mastermind. I wanted to use steampunk elements in the image to enhance the creepy look, with machines made from dark and dull colors.

THE MODEL

Once I had settled on the concept I spent some time collecting reference images. When I felt I had enough resources to start work on the model I started creating a body base in Maya. I tried to keep the topology as clean as possible, but since I planned to make major tweaks in ZBrush later I retopologized the model as I went along (**Fig.01**).

The first thing I do when I import a mesh into ZBrush is to make sure that I create a solid structure and silhouette. I avoid focusing on any one part in particular and try to develop the whole model at a similar rate, which helps to tie the different forms and shapes together. When I feel happy with the major forms, I export the mesh for retopology.

When sculpting both major and minor areas it is important to consider factors such as age, gender, character and profession. Here is my attempt at sculpting a hand suffering from rheumatoid arthritis (**Fig.02**).

The face is one of the most important areas of focus for the majority of characters. Whilst sculpting the sagging and wrinkles on her face I made sure that I didn't entirely lose the female form and character, despite the fact that women tend to lose their feminine look as they age. I also sculpted a rough hair mesh to make the process easier (**Fig.03**).

When I started working on the wheelchair I began with primitives and made sure the

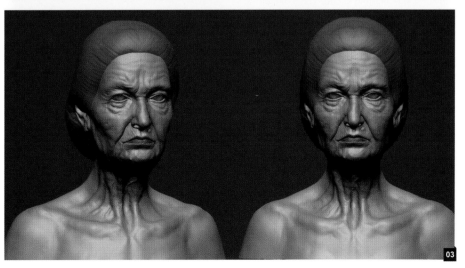

shapes worked well together. Once happy I proceeded by refining the shapes. Most of the chair is modeled in Maya, but I sculpted the leather seats, wooden ornaments, wear and fine detail in ZBrush, and retopologized it as I went along again (**Fig.04**).

TEXTURING

I wanted the fabric, chair and basically the entire scene to look worn but not too old. Whilst I was playing around with the shaders I had an idea about which colors to use as a base. For the wood, iron and leather materials I used high resolution images that I projected onto the model in Mudbox.

When creating the shader for the clothes I used the Additive (shellac) mode of the VrayBlendMaterial (**Fig.05**). To blend these I created two VrayMtls, one for the pattern and the specularity and the other one for the velvet effect.

I used the fabric shader to procedurally tile the pattern. To do that, I created a seamless pattern in Photoshop. Then I adjusted the color and plugged the Out Color value to the shader's diffuse channel. I also included the reflections in this shader as well. For the reflections I created a samplerInfo node and plugged its facingRatio to the uCoord and vCoord of a ramp. Using the ramp's values I adjusted the reflection on the surface.

For the velvet shader I used pretty much the same trick, but this time I adjusted the diffuse aspect of the material instead of the reflection using a samplerInfo node and a ramp. For the Subsurface Scattering shader I once again used a VrayBlendMtl in Additive mode. The reason for this is because I could not achieve a decent specularity with VrayFastSSS, so I used a VrayMtl to get the effect instead. I created a VrayMtl for the specularity and a VrayFastSSS to get the color and scattering, and blended them in VrayBlend Mtl (**Fig.06**).

LIGHTING

When I began lighting the scene the first thing I made sure to do was to set up V-Ray for linear workflow. After experimenting for a while I ended up using four V-Ray rectangular lights. V-Ray lights are pretty straightforward and work

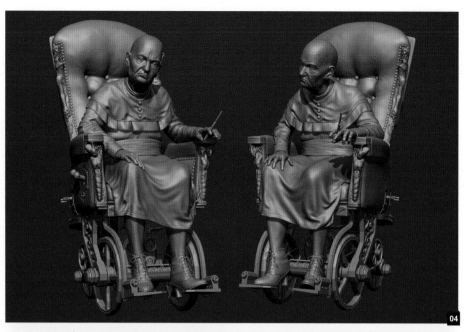

CHARACTERS

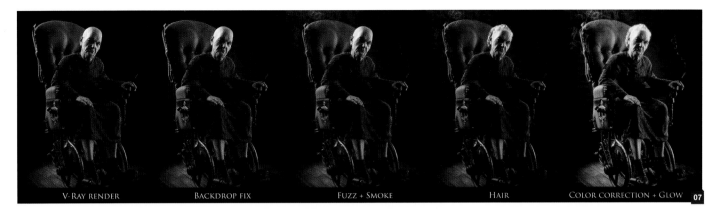

V-RAY RENDER BACKDROP FIX FUZZ + SMOKE HAIR COLOR CORRECTION + GLOW 07

pretty well by default so I did not really tweak them that much. I mostly worked on the light color and intensity.

When I felt comfortable with everything I started working on the fuzz for the clothing and the legs. For this I created a separate scene with the same V-Ray and lighting setup. I then selected the surfaces I wanted to grow fuzz from and adjusted it using Shave and Haircut. Once everything was rendered I combined it all in Photoshop. I adjusted the backdrop by adding a smooth purple gradient to compliment the green chair and emphasize the character a little more. I also added the smoke effect and hair in Photoshop courtesy of some high resolution images that I painted over to get the desired effect (**Fig.07**).

ARTIST PORTFOLIO

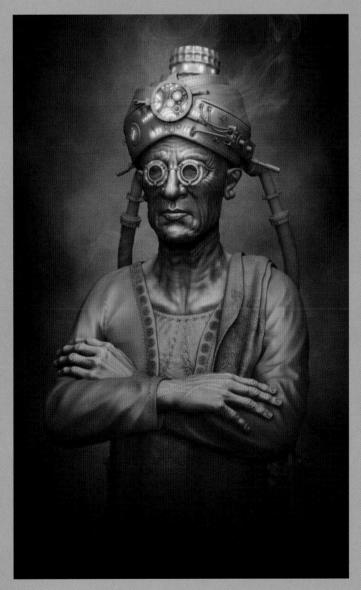

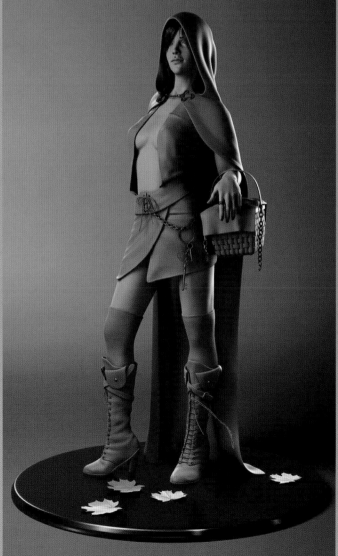

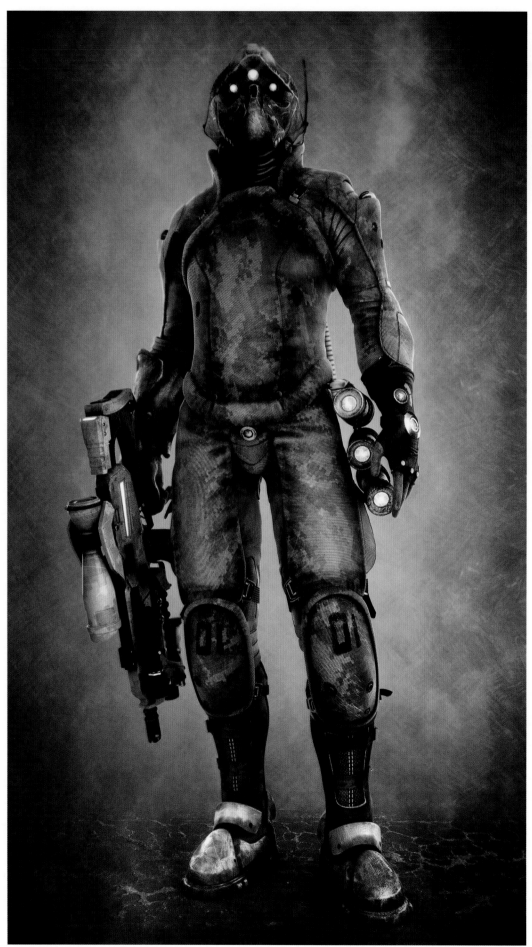

EARTH POLICE

By Caio César Brachuko Fantini

SOFTWARE USED: Softimage, ZBrush, 3ds Max and V-Ray

THE MODELING

This image is based on a concept from the *Exodyssey* book. The original concept was created by Barontieri (Thierry Doizon) and Feerik (Joël Dos Reis Viegas). I began with the character's head, using a cube in ZBrush and adding more divisions until I had the general shape of the helmet (**Fig.01**).

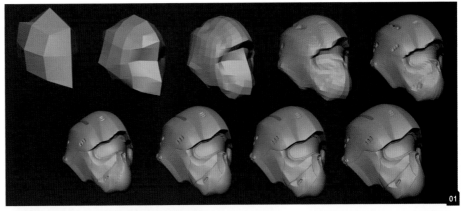

For the hard surfaces I used the Clay, Pinch and HPolish brushes. ZBrush is great for getting the right volumes without being limited by topology, which gives you plenty of freedom to swiftly reach your goals. I used the same process for the body (**Fig.02**). I made a simple base in Softimage and modeled a basic version of the clothing. After defining the volumes and forms came the process of reconstruction. I rebuilt all the pieces inside ZBrush using the topology tools, then made final adjustments inside Softimage so the model would be ready to animate (**Fig.03**).

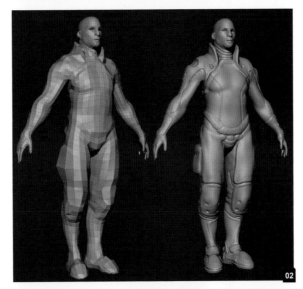

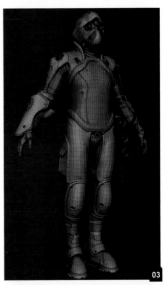

I ended up designing some details that you couldn't see in any of the concepts in Softimage (such as the mechanical part on the character's back). After reorganizing the topology and preparing it for animation, I took it back into ZBrush to add some finer details such as the clothing folds and more detail on the metal sections (**Fig.04**).

The gun was another object that I designed and created entirely in Softimage (**Fig.05**). I found some references of real weapons and tried to come up with a more elaborate design. I thought it would be interesting if it had a very large telescopic sight mounted on it.

TEXTURING

With all the modeling finished I laid out the UVs and got ready to paint some textures. I started with the gun because the textures for the character would be the same as they are in the concept. The textures for the gun were painted in ZBrush using polypainting. I also created Cavity and Occlusion maps to merge with the textures in Photoshop. Alongside this I painted some peeled paint and added some

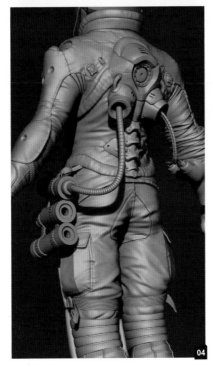

camouflage in Photoshop. I used the Overlay blending mode to add the camouflage (**Fig.06**).

The character was originally painted in ZBrush only using polypainting. I tried to make it look as much like the original concept as I could. I didn't get too bogged down with details at this stage because I knew I was going to update it later in Photoshop (**Fig.07**). After painting the model I exported the following maps: Cavity, Ambient Occlusion, Displacement, Texture and Normal to add more volume to the painting.

> " I FIND THAT THE
> SPECULARITY IS
> VERY IMPORTANT
> OTHERWISE THE
> ITEMS DON'T LOOK
> AS THEY SHOULD "

In Photoshop I usually apply specific blend modes to the maps I place over the main texture. The Ambient Occlusion map is set to Multiply mode and the Cavity map is set to Color Burn with the opacity at 5-10% depending on the circumstances. The Displacement map is set to Soft Light or Overlay, but the opacity is always adjusted until I am happy. The Normal map is converted to black and white and applied as a High Pass filter (Filter > Other > High Pass) and set to Overlay.

I then add some metal and dirt textures from photos to make the Color map more realistic (**Fig.08**). I then use the Color map to create more, like the Specular and Reflection maps.

I used 3ds Max and V-Ray to render the image. VrayMaterials were used for every material, although I adjusted all of their settings to

CHARACTERS

produce the effect that I wanted. I find that the specularity is very important otherwise the items don't look as they should.

LIGHTING

I like to set the shaders up with the final lighting setup, so I adjust the lighting at the same time as the shaders so the two are developed in unison. I used a three point rig and V-Ray lights for this image. Two lights were used to provide the overall volume of the model, and another strong backlight was used to add a nice rim light that makes it easier to read the silhouette.

To pose the character I used the Transpose Master inside ZBrush and then exported the mesh back into 3ds Max and re-applied the textures (**Fig.09**). For the final image I made three passes: a beauty render containing the texture and lighting, an Ambient Occlusion pass to create more shade in the areas of contact and a Z-Depth pass to generate camera depth blur. To finish I added a floor and background smoke alongside some minor color corrections and contrast adjustments.

ARTIST PORTFOLIO

ALL IMAGES © CAIO CÉSAR BRACHUKO FANTINI

Northern Warrior

By Borislav Kechashki

Software Used: ZBrush

Introduction

I was really excited about the idea of making an armored bear, so from the very start I had plenty of ideas in my head. I began by collecting all kinds of reference that could be useful. I knew I was going with a polar bear so I started gathering images of real polar bears, plus different types of armor I found interesting. I also looked for different types of artwork, both 2D and 3D, that could serve as an inspiration.

Concept

As it is a creature living in a cold and unfriendly environment I thought it would be cool if the armor is like the protection used by hockey players, so I was inspired by Casey Jones and Jason Voorhees. So that was my starting point and the main inspiration for the armor. I began by doing some fast sketches just to focus the idea before going to ZBrush, although I try not to spend too much time working in 2D because I'm not that good at it (**Fig.01**).

> I TRIED TO CAPTURE ❝❝ALL THE DISTINCTIVE❞❞ FEATURES OF THE ANIMAL, LIKE THE PROFILE OF THE HEAD, THEIR UNIQUE EYES, BULKY PAWS AND THE OVERALL BODY PROPORTIONS

Modeling

When I was happy with the concept I moved into ZBrush to continue concepting directly in 3D using ZSpheres and DynaMesh. At this point I tried not to go into the details at all, playing mainly with a large Move brush on a very large scale, just trying to make the forms and silhouette more interesting. By looking at a lot of real polar bear photos I tried to capture all the distinctive features of the animal, like the profile of the head, their unique eyes, bulky paws and the overall body proportions (**Fig.02**).

It's good to know from the very start what the final pose will be and the feeling you want to achieve as this will help you plan your modeling

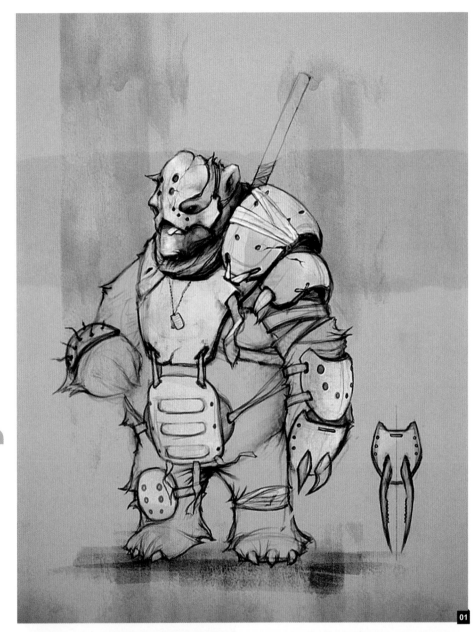

01

02

Edge Loop

Extract

E 5mt S 5mt
Thick 0.04

Loops 4
GroupsLoops Polish 50
Triangle

03

and pose more efficiently. I also did some really fast mock-ups of the main armor plates to see how they changed the overall silhouette. I did that by masking where the plate would be, extracting it, adding some more loops and then polishing it (**Fig.03**). As always, I worked from larger to smaller forms.

When all the main forms were there and I was happy with how they worked together, I decimated all the different elements and moved into 3ds Max to retopologize. Although this step is not really necessary I prefer working with better topology and polygon distribution. It will be a lot easier when making UVs if you use this approach. I still find 3ds Max a lot easier and more precise for making hard surface models, so I made the armor plates there. I started with a clean and simple retopology over the decimated meshes from ZBrush using the Graphite tools and then, using the Shell modifier with a spline for the profile, made the separation of the different elements more precise (**Fig.04**).

For some of the plates I made very fast UVs, just separating the elements that were made from different materials so I could polygroup them by UV later in ZBrush (**Fig.05**). I also retopologized the bear itself (**Fig.06**).

When I was done with that I brought all the newly created meshes into ZBrush and projected the details onto them before I continued sculpting. At this point I pretty much knew what the final pose would be so

DECIMATED MESH FROM ZBRUSH RETOPOLOGIZED MESH

☑ Bevel Edges
Bevel Spline: None

04

Polygroups
Auto Groups
Auto Groups With UV
Uv Groups
Merge Similar Groups
Group Visible
From Polypaint PToler
From Masking MToler

05

I transposed the model, because posing it later on with all the fine elements and hard rigid parts would eventually lead to stretching and unwanted overlapping. It's important when transposing a model with hard surface elements to keep them from deforming. This is easily done by isolating them before or after the topological masking (Ctrl + drag over the model) and by Ctrl + clicking on the canvas to mask or unmask them fully (**Fig.07**).

When I was designing and detailing it I tried to keep in mind that the armor should look believable and functional, and to think about how the different parts attached to one another and the bear. Another thing for better realism was to change the fur behavior around the armor to make it look like it is actually being affected by the pressure. For all the straps I used extracts from the bear's mesh, using the same method as described earlier.

At this point I polymodeled all the weapons, cords and tiny elements that make the armor look more functional. The cords are just splines with thickness made over the decimated model as a guide. For the dog tag's chain I constrained a sphere to a spline using a Path

Constraint, and then adjusted the Snapshot tool until I had the amount of balls I wanted.

I mainly used the Dam Standard brush to make a final pass and to add all the scratches and damage on the armor. I also used it with the SnakeHook brush to make the clusters of fur on the body. To keep all the holes on the plate consistent I made two alphas, starting with a plane in ZBrush, and using the radial symmetry to sculpt the detail I wanted. I then grabbed the alpha and placed it using DragDot (**Fig.08**).

TEXTURING

For the texturing I first quickly mapped the body using the UV Master so I could adjust the texture in Photoshop later if needed. I began by filling the bear with a slightly modified SketchShaded2 material. I only changed the Cavity parameters and the specular curve, just to enhance the hairs a bit more. The texturing itself was quite simple. I worked from large to small details and used a lot of cavity masks with a brush employing spray stroke and different alphas to add a bit of variety.

At some point I opened the texture in Photoshop for some color correction then moved it back to ZBrush to polypaint from the texture. Texturing the plates was really simple; I just masked the cavities, inverted them and then painted some dirt in the cracks. The UV splitting of some of the plates came in really handy here because I could easily polygroup them by UV and then precisely isolate the half I wanted to paint on. I also made a couple of dirt alphas from photos to add some more variety and noise to the textures.

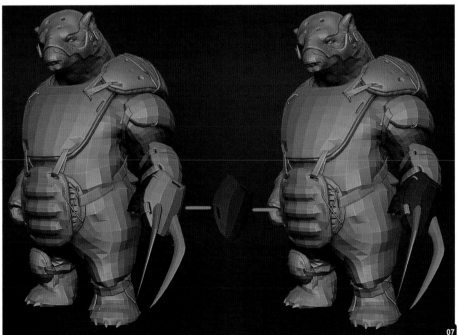

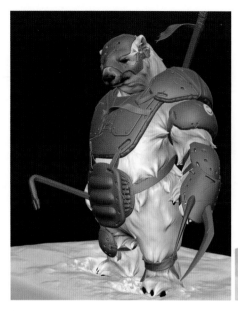

09

RENDERING

The first thing I always do before beginning the rendering of the different passes is save my final view on a file (under the ZAppLink properties), so if ZBrush crashes I can always return to the exact view. I began by rendering a BPR render with all the armor filled with the mah_modeling_01 MatCap and the bear with my modified SketchShaded2 material with no shadows or AO (I prefer having them on a separate pass so I have more control over the intensity and color) (**Fig.09**).

I rendered the whole model with flat color and with Diffuse on, which I multiplied later over the BPR render. Because I needed very precise masking for compositing the different elements I did some render passes that I used later on for selections (**Fig.10**).

Using a flat color material and with Inactive Subtool Dimming put down to 0.1, I rendered all the masks for the armor, all the straps, the bear itself and the snow base. I created three new lights in ZBrush: two rim lights and one fill light, which I rendered on a basic material filled with a black color with a slightly modified specular intensity and curve.

From this point on everything in Photoshop was just about experimenting with blending modes and adjustment layers, using the masks created earlier to have greater control over the different passes. At the end I added some photo effects like vignetting, noise and chromatic aberration to make the image look a little less CG.

10

my little

Lemmy

Requires 2 x bottles of Jack Daniel's (not included)

MY LITTLE LEMMY

BY SERGE BIRAULT
SOFTWARE USED: Photoshop

INTRODUCTION

Hyperrealism and photo reproduction is not usually my goal when painting an image. It's not a very creative process and you're not free to do what you want. However it is a very good exercise and I learned a lot whilst painting this picture; for example, I discovered a new way to paint skin.

My model was my beloved Chloé. She's a big fan of Motorhead, so I decided to add a funny element in the form of a Lemmy doll who is the front man of the band. It was interesting to add a fictitious part to a very realistic painting. The idea was to add a bit of advertising parody relating to a well know pony toy.

WORKING WITH PHOTO REFERENCES

In order to do a very detailed picture you will need to work on a large scale and resolution, at least A3 format and 300 dpi. If your computer is not very powerful, don't forget you can assign more RAM to your software. If you are trying to achieve realistic results, take your time. You cannot paint a photorealistic painting in a few hours. I spent more than 50 hours on this one.

Using a photo reference is not simple because you quickly realize you have to push the realism more and more. The most difficult step lies in finding good contrast, which is far more important than color. An effective and simple technique is to desaturate your photo. It's the easiest way to compare your painting to your reference.

My favorite tool is the Soft Round brush. With low opacities (under 20%) you can create very soft gradients. Picking colors from the photo is not a good idea, especially for skin tones. Skin tones are too complex to use this approach. As usual, I created a lot of layers and then merged them once I was satisfied with the result.

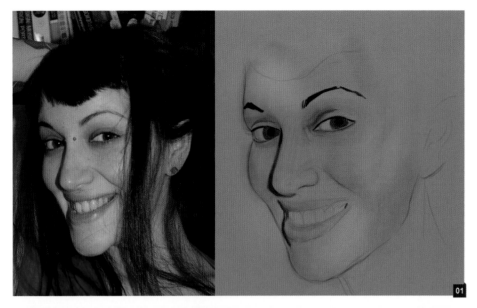

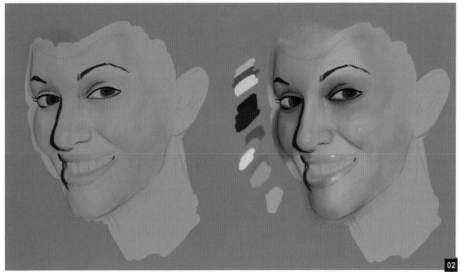

THE FACE AND THE BREASTS

The sketch was very simple and I just tried to create good proportions. I adjusted the original sketch as I developed the image; for example, the left eye was not in the right place (**Fig.01**).

I created a tint area with a basic brush then tried to adjust the contrast. In **Fig.02** the skin tones are a little bit strange so I added red, blue and green. Olive green has been used in paintings for a long time to achieve the correct skin tones. Bouguereau, for example, achieved incredible flesh tones with this color.

The eyes and the shadow of the nose were the darkest parts of the face, so I started with this and then I worked on the mouth and teeth. The eyes and teeth are very reflective and as the lighting was very strong, the reflections were close to white (**Fig.03**).

Once you've found your darkest and brightest tones, you just have to adjust your middle tones. However, this is a long process (**Fig.04**).

The final step for the skin is the texture. I find that a very good brush for painting this is the Dry brush. With a low opacity and various tones it's very simple to create realistic skin, but it does take time (**Fig.05**). The breasts were done using the same technique. The last thing I did at this point was add the shadow cast by the hair.

THE T-SHIRT
To help me paint the T-shirt I took several photos. I didn't copy one specifically because the focal point of my painting was quite different to that of the photos. I needed a lot of layers here so I could add details little by little. Strangely, it wasn't an easy step. The creases on the T-shirt and deformation of the pattern weren't simple and required several attempts before I was satisfied (**Fig.06**).

THE HAIR
Realistic hair doesn't take too long to do (about eight hours) and it is quite easy. Just create a

CHARACTERS

dark area and paint the hairs one by one. Yes, I know it's boring, but I have never found a better way of doing it (**Fig.07**).

Usually the basic Soft Round brush is good for painting hair, but this time I tried a pencil Ditlev brush (you can easily find them to download on the internet). The result is less linear and crisp, but that doesn't matter as much when the brush is so small. Every hair is created using a brush of a one or two pixel width. The tones are very dark so a white Overlay layer is useful when adding in some detail (it also adds contrast).

THE HANDS, ARM AND TATTOOS
The hands were a nightmare (the right one in particular). I did them the same way as the face, but I restarted four or five times. Even with good references, hands are one of most complicated parts of the human body to paint (**Fig.08**).

The tattoos were done on several different layer types set at different opacities and the darkest areas were created with a deep blue rather than a black (**Fig.09 – 10**).

The Little Lemmy

I started Lemmy by searching for some references of his face on the internet. As he's quite famous it was easy. The idea was to paint him as a caricaturized toy. Lemmy has a lot of well known features: his beard, his hat and his warts, for example. The plastic face was done quite quickly; I just had to adjust the contrast to make it work with the rest of the picture (**Fig.11**).

Adjustments and Text

I wanted my picture to have an old-school touch so I changed the tones a little bit whilst trying not to affect my contrast, which I was happy with. Chloé is not only beautiful, she's a great designer too so she helped me with the text and chose the font (**Fig.12**).

Last Words

This picture was more about technical stuff compared to a creative process, but I'm quite happy with the result. I created a lot of photorealistic images with my good old airbrush when I was younger and I wanted to see if I was able to do the same with digital software. I posted it in some of the CG forums and people still think it's a photo, so the result seems to be convincing!

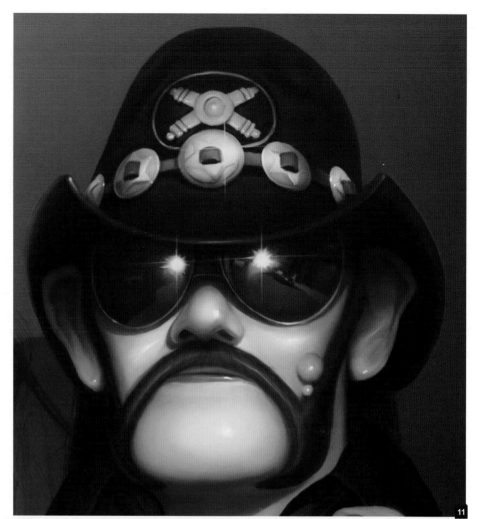

Characters

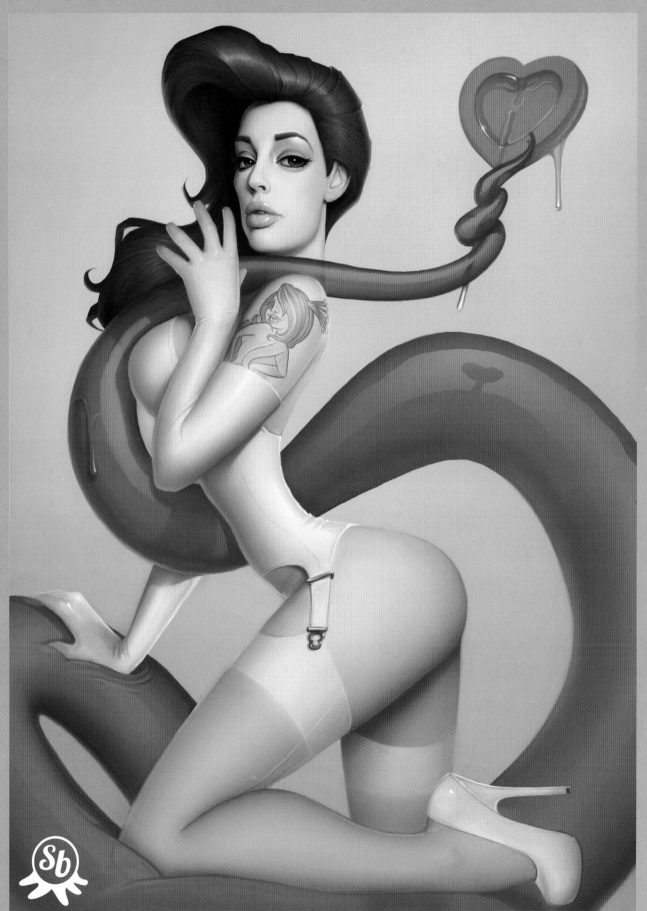

© Serge Birault

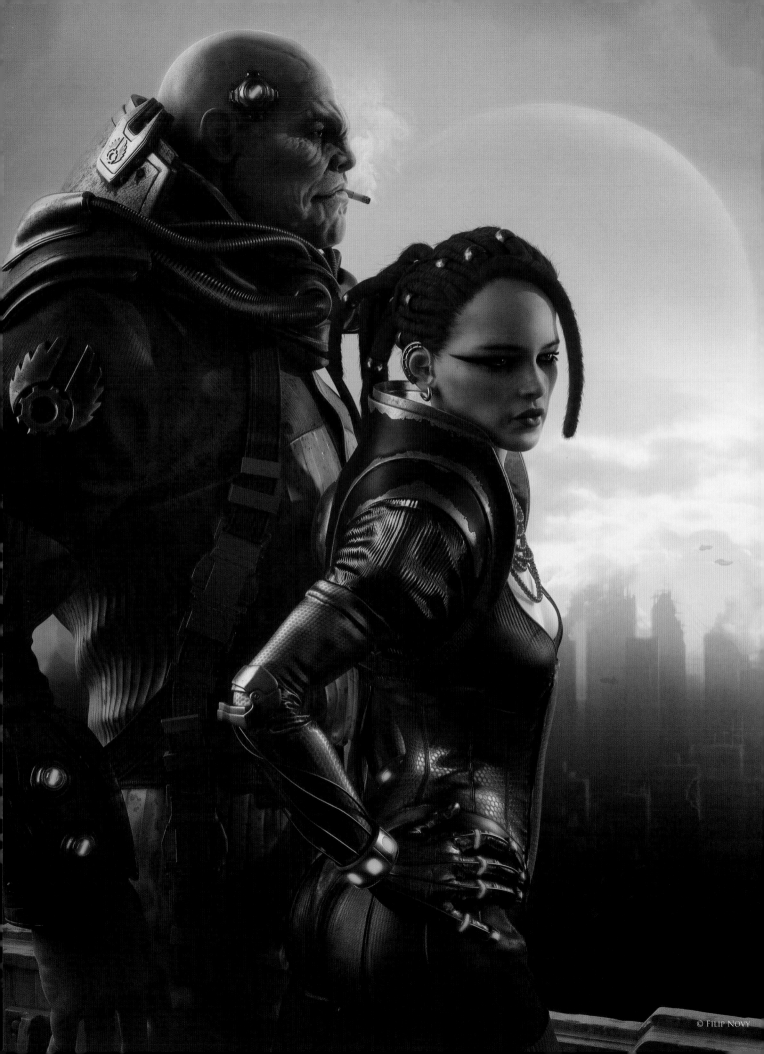

© FILIP NOVY

JUST THIS LAST JOB!

BY FILIP NOVY

SOFTWARE USED: 3ds Max, ZBrush, Photoshop and mental ray

INTRODUCTION

I started working on this image sometime back in 2010. My original intention was to create a sci-fi portrait, but as you can see the scene eventually evolved into a much bigger project. Although I usually try to work with sketches and designs, on this project I let my imagination flow and the scene literally formed itself. Fortunately this was my own personal project and this meant there was no pressure on me to finish it, so I had as long as I wanted to make sure I was happy with it.

Because I didn't have a set concept I could add and alter things whenever I wanted to. This was good as it gave me the opportunity to try out new things, which made the project more fun to complete.

> " I HAVE LEARNED IN THE PAST THAT IF YOU NEGLECT THE SMALLER STEPS AT THE BEGINNING YOU WILL PAY FOR IT LATER IN THE PROCESS "

STYLIZATION AND MODELING

Although my aim was to stylize the characters and avoid having them look too human-like, I did want to make them look technically realistic. When designing the appearance of the two main protagonists I tried to avoid genre clichés. I tried to think more about their personality, history and motives, and keep that in mind for their design. It was important to me that Gregor and Fixie had their own personalities that were obvious to anyone at first sight. This is why they both have distinctive traits. Gregor eventually turned into a stubby frowner and Fixie became a freckled athletic swashbuckler (**Fig.01**).

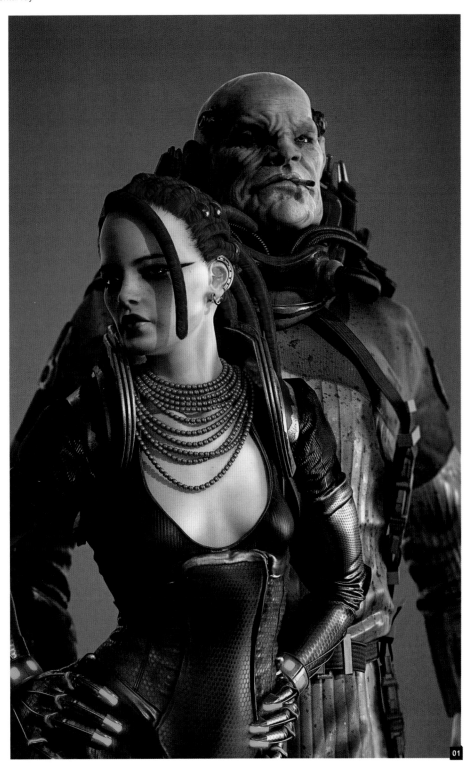

Whilst modeling the characters I began with the cruder forms, which I gradually softened and added more detail to. It was important to have a functional base before moving on to the details. I have learned in the past that if you neglect the smaller steps at the beginning you will pay for it later in the process when you create unnecessary work for yourself.

Most of the character models were created in ZBrush. I used ZSpheres to create the base mesh from which the rough model was created. From this point I used the Move and Clay Tubes brushes to get the shape I wanted. The whole process was very intuitive and creative, and didn't involve any unnecessary hold-ups because of topology. Once the basic shape was functional I thickened the mesh and began to

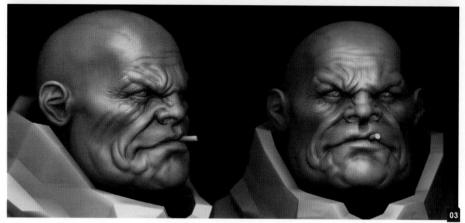

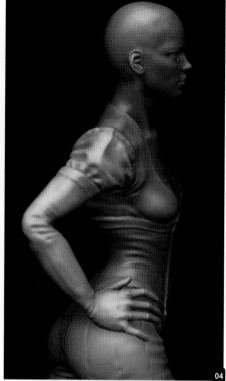

refine the model. Usually I use the Clay Tubes brush, which I gradually alter as I develop the model (**Fig.02**).

The moment it wasn't possible to add any more detail to the model due to missing polygons, I retopologized the model directly in ZBrush. I then projected the resulting model onto the base and could continue with the sculpting. One of the most complicated parts was to pose the characters in a natural fashion. Because I knew this would be tricky I began posing the

characters early in the process in ZBrush. Thanks to ZBrush I didn't have to deal with technical issues like rigging and could pose the characters with the Transpose Master. This wonderful tool enabled me to move the characters into their final pose, but also meant I could return to a T-pose whenever I needed (**Fig.03 – 04**).

TEXTURING AND SHADING
The bases for most of the maps were generated in ZBrush (Cavity map and Normal map), to

which various layers, details and colors were added in Photoshop in order to reach the desired result.

When I started to think about the materials and textures I decided that I would adopt the same approach as I did when modeling. By this I mean that I would adapt everything to create a visually appealing result, rather than focusing on making everything look very realistic.

The most complicated material in the scene is, without doubt, the skin and its settings, to which I dedicated a significant amount of time. You can see all of the different maps in **Fig.05**. In this image you will be able to see the Overall Diffuse, Reflection, Epidermal, Subdermal, Normal, Bump and two Specular maps. You can also see the final render before I did any post-production (**Fig.06**). I also used masks for the Subdermal and Epidermal maps. By using reflection color textures I was able to isolate the color of the Specular highlights on the skin and adjust them. I mainly used azure blue and light pink at this point as I found they worked perfectly. I also combined the Specular, Reflection and Bump maps with procedural maps to get the very fine detail.

I used mental ray Arch & Design materials, which are really excellent, highly versatile

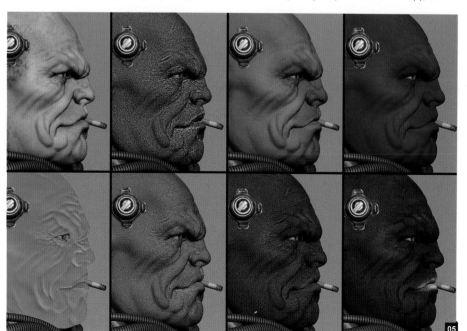

CHARACTERS

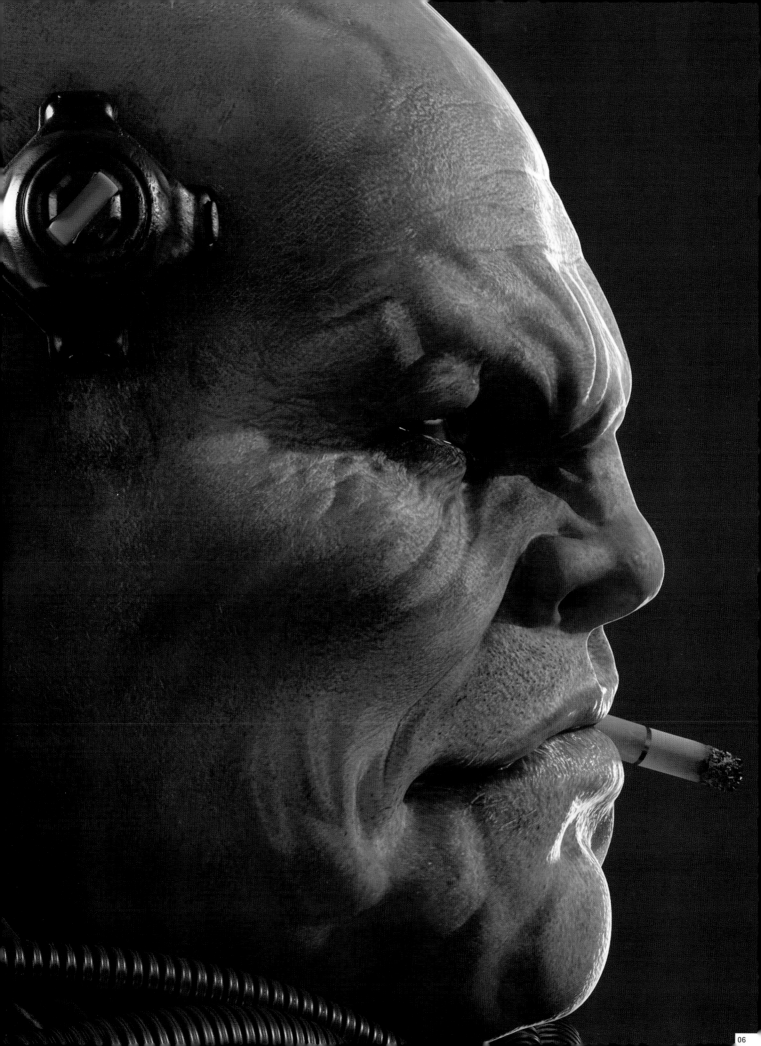

and permit me to create any surface I want. Creating correct textures for the other objects was not that complicated. For the majority of the other items I only needed to apply Diffuse, Specular and Reflection maps as Glossiness Samples were used for the metallic surfaces (**Fig.07 – 08**).

TWEAKING, DETAILING, BACKGROUND AND POST-PRODUCTION

I love the part where the work is more or less finished and I can begin to tune all the details. Towards the end of the process I go through all the materials and add details here and there, adjusting the color and light intensity. My aim was to have the image function as an individual illustration and not simply a model presentation.

" ONE OF THE MOST IMPORTANT THINGS " TO ME WAS THE OPINION OF FAMILY, FRIENDS AND COLLEAGUES

I began thinking about the background early in the process, but without spending too much time on it. In the end I chose the simplest method that I could think of. I was happy with the character, but the city in the background needed to convey a similar feeling so I had to make sure it was done well. Using photos of houses as references I created some simple box-like models in 3ds Max, which I duplicated. It was important that I put these together carefully as they needed to look as though there were streets in between the buildings.

The 3D models served as a good base and most of the background was created in Photoshop. The main colors and overall atmosphere was very important, as they needed to show both detail and depth. Because of this I suppressed the housing detail with fog (**Fig.09**). The far distance is entirely painted in Photoshop.

Given the amount of time I spent on this image one of the most important things to me was the opinion of family, friends and colleagues. They always come up with new ideas and constructive criticism. Without them this image would not be what it is today.

CHARACTERS

© SIMON DOMINIC

FANTASY

An important consideration with any artwork is to have the viewer experience an emotional response to the content of the piece. That response could be anything; pity for a character, awe at a landscape or revulsion at a death scene, but this reaction must be present for the artist to claim success. This is particularly relevant to the fantasy genre where the content has the potential to be very alien to the viewer, sometimes literally.

The way I deal with this is to introduce familiar imagery into my artwork, often environment-based and inspired by the countryside around where I live. By doing this I feel like I'm introducing an element of plausibility, which anchors the viewer's perception and encourages them to be accepting of the artwork's less conventional aspects.

Of course, there are many other ways of establishing viewer involvement and as is often the case in art, it's up to the artist to investigate the options and develop their own approach.

SIMON DOMINIC

si@painterly.co.uk
http://www.painterly.co.uk

LA PAUSE

By David Arcanuthurry
Software Used: ZBrush and 3ds Max

INTRODUCTION

The idea for this image came from a discussion with my good friend Nicolas Reytet (aka Waugh) about the little people of fairyland. I've always loved the imaginary little world populated by goblins, laminaks, gnomes and elves of all kinds. The artist Jean-Baptiste Monge inspires me a lot when it comes to creating an image based within this fantasy theme. I have a lot of books with his work in them and I think he might have been touched by a fairy when he was born!

For this project I started by doing some sketches (**Fig.01**), which is something I like to do because even if the end result is quite different from the original sketches, they provide me with a guide for the construction of the image. After I had done that I went into the forest to take some photographs that I could use as references (**Fig.02 – 04**). The photos helped me when I was thinking about the composition of the final image.

MODELING

There were no special techniques used when I was modeling the scene. When I started the character I went to my library of basic meshes, which I often use as a starting point when I begin modeling. I then simply reworked the model in ZBrush by adjusting the proportions. I usually start using the Move and Scale tools after masking some parts of the mesh with the Lasso tool. As soon as I had the desired result I imported the model back into 3ds Max.

Once I was in 3ds Max I began work on the accessories and clothing. I selected parts of the mesh that interested me and once they were detached I applied the Push modifier. I modeled the fungus using standard primitives (spheres, cylinders, etc.,) and then went back into ZBrush where I imported the model with the clothing. I then applied Group Split and continued to work on the volume in a low level of subdivision in each of the subtools (**Fig.05**).

TEXTURING

For the UV mapping I used the UV Master. It's

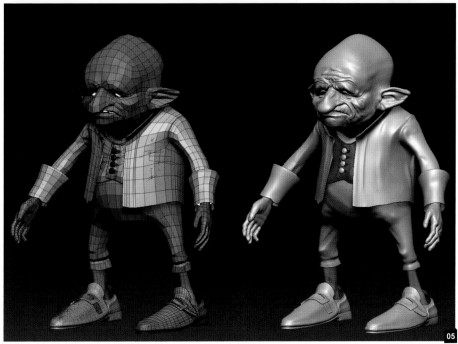

a simple and effective tool that provides good UVs. The next step was to address the textures. I wanted to achieve a realistic look as if I had met this little guy during a walk in the woods, so I used the polypaint feature in ZBrush along with my store of reference images. The textures were also slightly retouched in Photoshop to resolve some defects and add detail. This also allowed me to generate a map to use as a mask in ZBrush for the detailing work. This technique allows you to quickly achieve a good level of detail and consequently refine the image using alphas. I used the same techniques for the other elements in the scene as it was useful in obtaining each and every map (**Fig.06**).

For the character and fungus materials I used V-Ray SSS2 as it creates good results with very few input maps. I also made some color corrections to some of the maps. For the other elements in the scene I used a V-Ray material with different maps in the input (Diffuse, Bump, etc.). I always use Color Correction to contrast or decrease some of the values. For the ground I used a VraydispMod associated with a map made in Photoshop that allows the possibility of adding more detail when rendering.

At this stage of the project the scene seemed a little empty. Because of this it was necessary to add some elements to make it look a little more real. I wanted something that resembled the woods near my home and to achieve this I created some grass and pine needles from standard primitives, and then populated the scene using Particle Flow, which is quite simple. I used the shape instance with the needle as a reference and the ground plane as the object

position. After I had done that I added some random rotation to create a little chaos (**Fig.07**). To manually adjust the position of the particles I used the script Pflow-Baker.ms.

As I knew I would use an intense depth of field, I only modeled the background elements roughly. I also placed some of these items in the far background to simulate depth.

LIGHTING

For the lighting I didn't do anything innovative. I wanted to achieve an atmosphere that made it feel as if you were in the undergrowth. To do this I placed a V-Ray light in a position that worked with my Environment map. For the background I used a standard omni light with a low coefficient multiplier and also turned off Projecting Shadow. I put a VrayHDRI map in the GI and reflection/refraction environment slots (**Fig.08**).

The setup in V-Ray was really basic, just like my PC. I do not have powerful hardware so I didn't push the settings too much (**Fig.09**).

COMPOSITING

To me, compositing is one of the most important steps in this type of project. Along with lighting it is the step that adds a new dimension to the image. This is a very important part of the process, which can improve the look and mood, but if is not done carefully you can end up destroying the image.

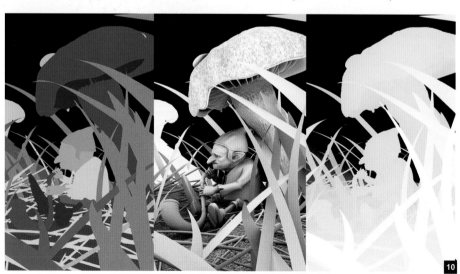

For most of my projects I use Photoshop to complete the image. After compositing all the different elements (**Fig.10**) I carry out color corrections, Curves adjustments and play with the Levels before applying a Depth of Field filter using the V-Ray Z-Depth map. For the final touch I use the Magic Bullet LooksBuilder (**Fig.11**).

CONCLUSION

Originally I created this image as a test for a project that I wanted to share with my friend Nicolas. It allowed me to test and validate different points of the workflow and was both good training and a lot of fun. One day I hope to meet this guy during a walk in the forest!

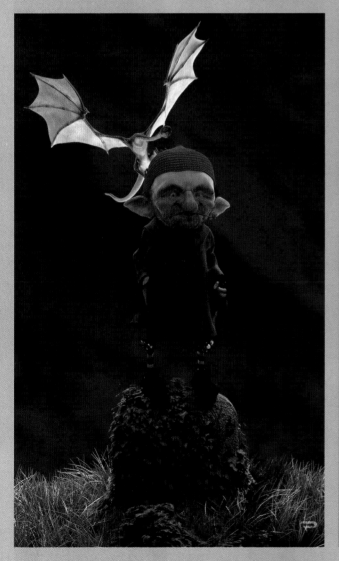

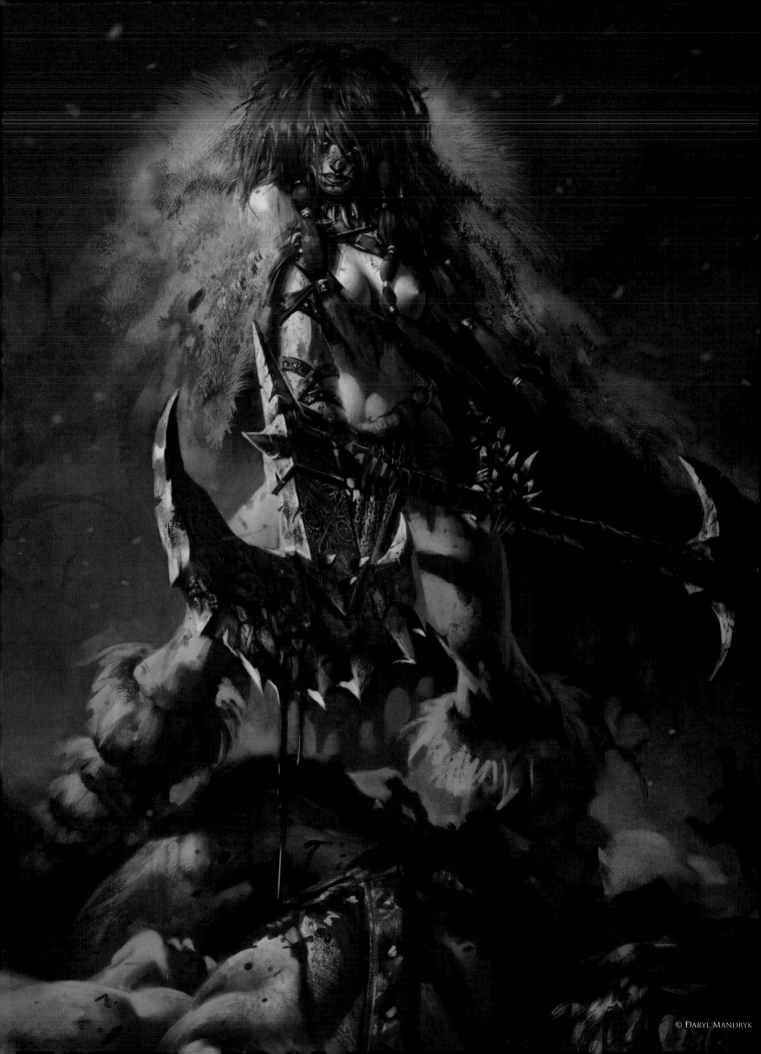

© Daryl Mandryk

Red Sonya

By Daryl Mandryk

Software Used: Photoshop

Concept

Usually when I start a character painting as a personal project I don't have a clear idea of what I want the image to look like when it is finished. Often I'll just start doodling and the ideas slowly start to form into something coherent over time. You will be able to see this process at work in **Fig.01**, where you can see that I just started sketching loosely, trying to figure out what I wanted to paint. At this stage I was not at all worried about it looking good; it was more about creating a loose roadmap so I could picture a destination in my mind. I kept the work black and white at this stage as I would add color later on.

> " I WANTED TO ESTABLISH A GOOD POSE AS EARLY AS POSSIBLE, SO I SPENT TIME TWEAKING HER STANCE AND TRYING TO MAKE THE WEIGHT DISTRIBUTION LOOK RIGHT "

Painting

Once I had settled on a direction I began to flesh things out a little bit, adding some color

using overlays and color layers, as well as refining the figure. I wanted to establish a good pose as early as possible, so I spent time tweaking her stance and trying to make the weight distribution look right. Although it's possible to make changes to the pose later on, it's much easier to do it at this stage as there is less to re-paint. In terms of color, this was

really just a base to work off and you'll see that I pushed and pulled the colors around throughout the process until I got something I was happy with (**Fig.02**).

I continued working on the posture and decided to turn her head to have her engaging with the viewer a little more. I also started to flesh out

her costume design a little bit (**Fig.03**). She's a barbarian so I wanted to avoid anything too refined and dainty looking. I wanted to make sure that the costume design reflected the attitude I was trying to portray. I also wanted to make sure that, compositionally, the costume elements worked together and reinforced one another. This become clearer as the painting progressed.

I often use a Frazetta trick when doing a painting by flipping the painting upside down. When I do this it should still look pleasing in an abstract way. I did this as well as mirror the image many times throughout the painting process. This helps you see the image in a new way with fresh eyes and helps you spot problems that would have previously gone unnoticed. I'm careful not to flip too much though, as this can lead to you subconsciously balancing the composition too much, removing some of the dynamic tension (**Fig.04**).

> **THE RED SUGGESTS ANGER, ACTION AND DANGER, ALL THE QUALITIES I WANTED THE CHARACTER TO CHANNEL TO THE VIEWER**

The character was then scaled up to fill the frame more as I wanted her to feel imposing and indomitable, and she was just too small in the previous composition. Now she felt larger than life and much more heroic. The colors were also starting to gel at this point. I wanted to offset the reds of the character with a cooler background, helping to project the character forward. The red suggests anger, action and danger, all the qualities I wanted the character to channel to the viewer. I still hadn't committed to the lighting one hundred percent, which is why a lot of the painting is still looking very loose. Once I was really satisfied with the lighting I started to paint the details (**Fig.05**).

Slowly I started to refine the painting, especially in focal areas such as the upper body and the head of the axe (**Fig.06**). I tried to bear in mind where I wanted the viewer's eye to go, as these were the most important parts of the painting

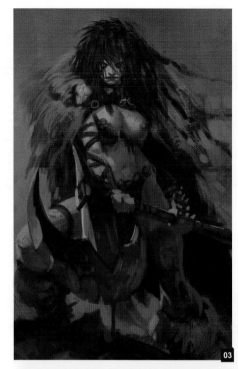

03

04

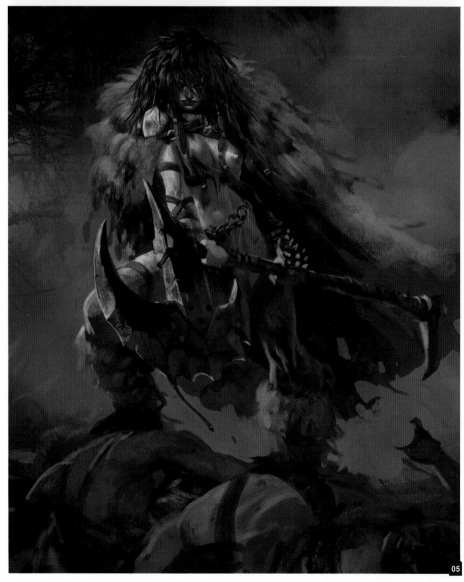

05

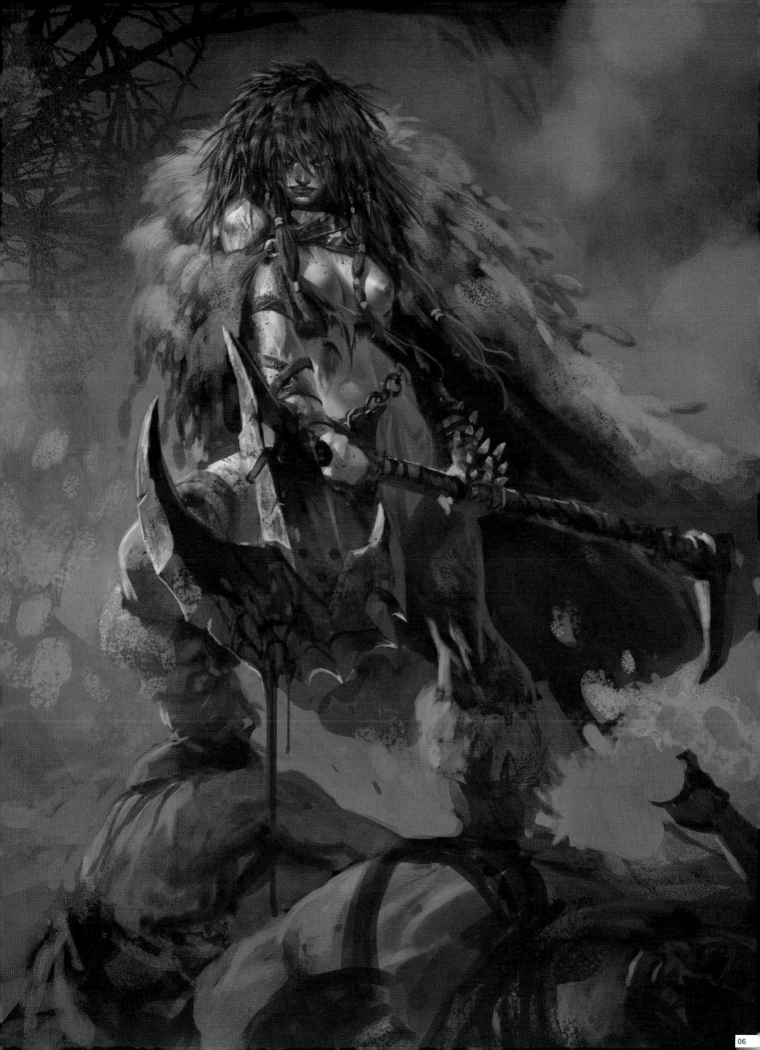

and should receive the most detail. Areas that were previously just blobs of paint had to be thought through a little bit more. What kind of surface am I painting? How weathered is it? How is the lighting affecting it and is it casting shadows? These are all things that ran though my head as I painted the image.

I made more adjustments to the color, tone and pose at this stage in the painting. I felt the right knee was competing with the axe too much and that moving it back would make the pose feel more dynamic. This also helped bring the axe forward in space towards the viewer. I started to play with the background elements, adding in some simple branches as compositional elements, trying to create some interesting angles between the tree branches and the axe (**Fig.07 – 08**).

The almost finished piece that you can see in **Fig.09** contains more little details. You can also see that at this point I had paid more attention to the materials. At this final stage it's all about nailing the focal points, and adding small details and touches here and there to make it sing. I was painting much more slowly at this point, constantly evaluating every stroke and trying to make the details really count. I also subtly adjusted the value and color balance of the painting in an attempt to strike the exact mood I was looking for. After several hours of detailing and minor adjustments, I called it a day.

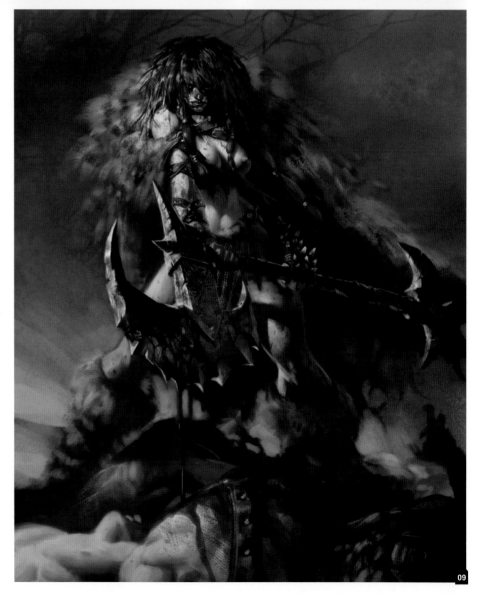

FANTASY

FANTASY

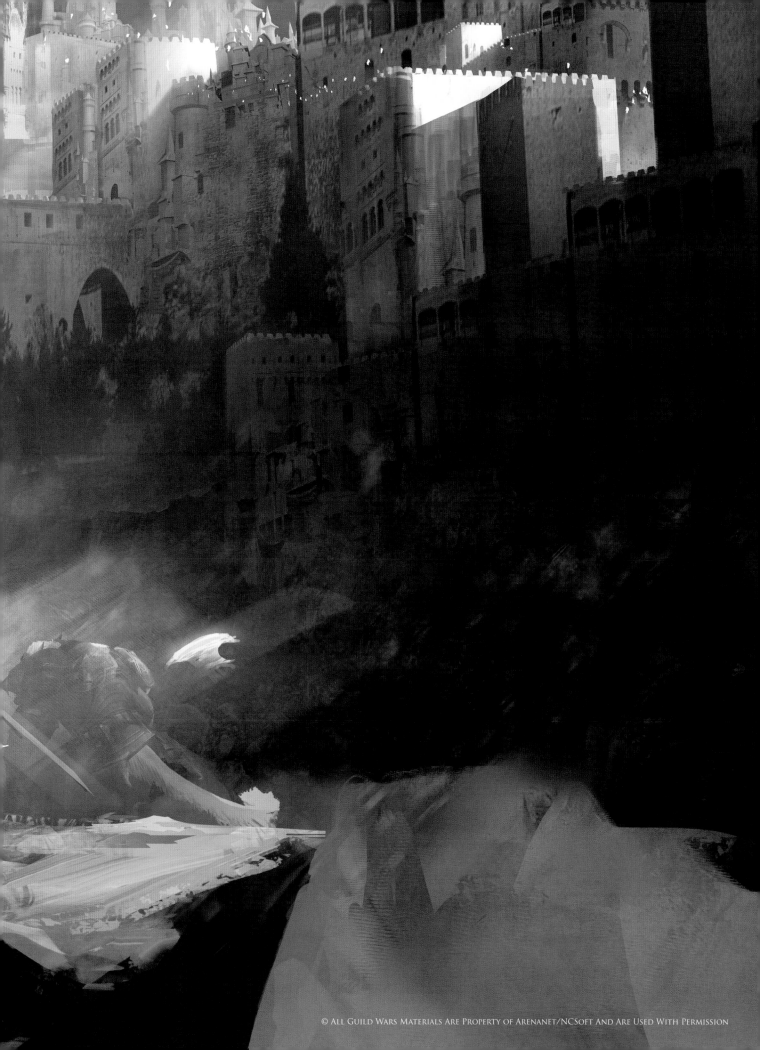

Arises

By Levi Hopkins

Software Used: Photoshop

Introduction

As a senior concept artist on *Guild Wars 2* I spent my time on a variety of exciting projects. The piece in this article was actually created for the *Guild Wars 2* cinematic. Often when I wasn't designing props, architecture or environments, I was tasked with creating paintings for the in-game cinematics. The creation of *Guild Wars 2* in-game cinematics consisted of a multi-layered painting created by the concept artist, which was then shipped over to the cinematics team. The cinematic team would then use their insane motion-graphic skills to create basically moving paintings. Creating cinematic paintings can prove difficult at times because you can never flatten your image. You have to maintain a large number of layers that can later be moved around by the cinematics team. Any sort of color adjustment, contrast tweak or layer mode has to be applied to each individual layer.

> **" AS WITH MOST OF MY WORK, I NEVER HAVE A GO-TO PROCESS THAT I USE TO CREATE AN IMAGE. "**

My Painting

This specific piece was created for a set of three different shots involving a massive dragon flying over the land, leaving destruction in its wake. In reality I made six full illustrations for about ten seconds of screen time! Each shot had a before and after state as the dragon passed through the image. I was given a loose storyboard to set me on the right path.

As with most of my work, I never have a go-to process that I use to create an image. This keeps everything exploratory and allows me to stumble upon happy accidents and new techniques. For this piece I started by taking the previous background layer from the painting I did for the first shot in this sequence (**Fig.01**). I ran a simple Motion Blur filter on it to knock out all the detail, but maintain the values and palette already established (**Fig.02**). I often like to reuse older paintings and add them into

a new piece on layers in a variety of modes, along with brush strokes, to create an abstract base I can work from.

The next step in this piece was to begin with the foreground elements. In accordance with the established storyboard I would need a couple of characters placed in the foreground to view the oncoming destruction. To do this I simply painted an abstract chunk of land and a simple, loose silhouette for the first character (**Fig.03**).

> ❝ THE FUN THING ABOUT THESE CINEMATICS IS THAT THEY ARE SUPER-STYLIZED SO YOU CAN HAVE FUN WITH SHAPES AND PAINT STROKES TO CREATE EVERYTHING ❞

After I had the base set up I began to render the first character, added a second one and then developed the chunk of land supporting them

(**Fig.04**). I also threw in some brush strokes to block in an effect that could allude to a dragon flying by. I then decided to block in loosely what I imagined the dragon to look like (**Fig.05**). The fun thing about these cinematics is that they

are super-stylized so you can have fun with shapes and paint strokes to create everything. I also had to keep everything on layers so I could easily hop around the painting and be able to turn elements on and off. This helped maintain

06

my interest and prevented me from spending too much time rendering any one element.

Now that I had the foreground elements blocked in, I moved on to the most important aspect of the piece, which was the city-like elements in the background. I continued with the abstract method of establishing the piece by blocking in

selections with the Lasso tool. I then sampled some of the motion blurred background and darkened it (**Fig.06**).

Now that I had a very loose idea of what I wanted, I began to use a simple square brush to block in larger shapes and add textures. Then I used the Warp tool to drop everything

into perspective (**Fig.07**). Due to time restraints, I also employed some photo references as textures to quickly achieve some finer details.

With a background base established I decided I needed a bit more overall depth. A quick way to achieve this was to copy all of the painted city elements, paste them into a new layer, lighten

07

them, and then drop them a layer back (**Fig.08**). I then painted into certain areas and added some more elements to really lock in the depth.

Since I had added a bit more depth, I now wanted to bring some of the city elements closer to the foreground. This also helps lead the eye from the foreground all the way to the background. I quickly blocked in a few shapes with a brush and then pasted in the previous detail to continue building the city out to the right (**Fig.09**) and the left (**Fig.10**) of the canvas. Of course, I also added the mandatory fantasy birds in the background for scale.

At this point in the process I stepped away from my computer, grabbed some snacks, ran some laps around the office and then came back to the painting to correct any issues I may have previously missed. After some slight polishing I decided this piece was ready for the pre-destruction phase of the shot. I've included a quick glimpse of the "post-destruction" painting after the dragon has flown through the image (**Fig.11**). Once again this was done with a mind-numbing amount of layers and effects, but in the end it all paid off when I saw it in motion.

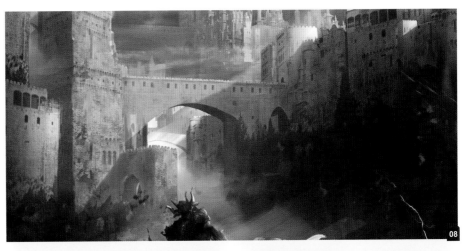

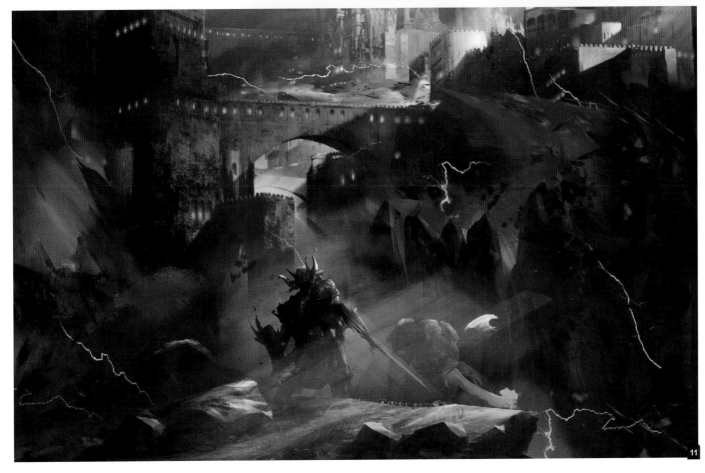

Haunted Land

By Robh Ruppel

Software Used: Photoshop

Introduction

I'm so glad the judges picked this piece for *Digital Art Masters: Volume 7*. I've been experimenting with non-photorealistic rendering lately and I am happy for the opportunity to talk about the process I use.

Design

For me it all starts with a good silhouette (**Fig.01**). Shape is important because it defines the boundaries of an object. The idea behind the design phase is to do it in the most interesting way possible. I began by exploring several shapes on a page and then adding, skewing and adjusting them until I had a shape that had a stark, interesting readability. Then I designed a simple shadow shape that described the form. To do that I made a few contours and wrapping lines to better define the plane intersections of where and how the branches attach to the tree.

> ## It's easier to keep it in grey as well. That way I'm concentrating on readability and clear silhouettes

You can't paint what you don't understand. The marks you make need to mean something. They need to represent something concrete. Even though I'm doing a simplified design it still has to be accurate! This is particularly appropriate with this graphic style because it has to carry a lot of information. That's part of why I like working this way. There's less rendering involved, but a whole lot more planning and designing needed.

Painting

Once I have a shape I like I place it into a composition. I keep everything flat and on its own layer so I can move the pieces around while composing the scene (**Fig.02**). It's easier to keep it in gray as well. That way I'm concentrating on readability and clear silhouettes.

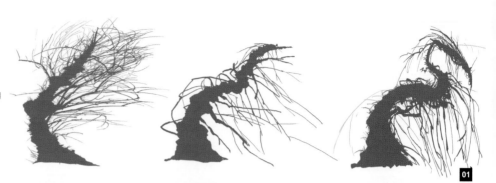

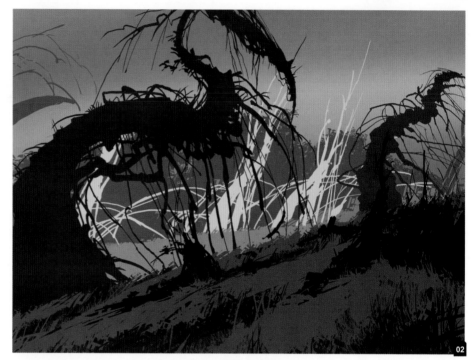

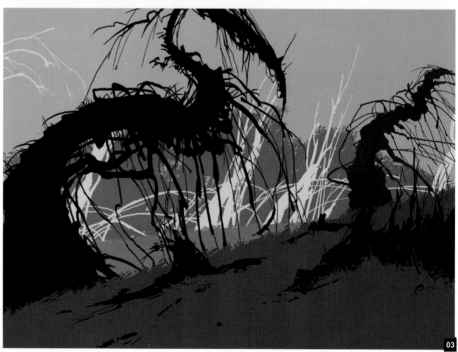

Fantasy

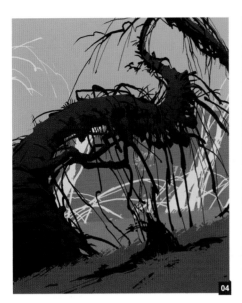

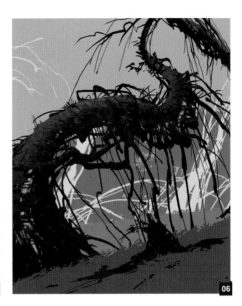

Next I applied flat color to the basic scene to design a good color scheme (**Fig.03**). I played around with this until it felt right. I ended up with a red/green complimentary scheme on this one.

The simple light and shadow pass was based on my contour lines so that, while invented, the shadow was still accurate to the form (**Fig.04**). Then I did a simple pass on the light area

(**Fig.05**). There's a lot of erasing and trying things when using this process as this comes from the imagination and not from any reference or CG render.

Next I added the glowing energy inside the tree (**Fig.06**). It was an important story point so the sooner I added it in, the better it would relate to the whole image. It's important to put these

major visual "tent poles" in early, otherwise they may not fit once you've worked out the rest of the painting.

I then moved on to the background trees, using the same thinking I applied for the main trees (**Fig.07**). I started adding and refining these at this point because I felt that they would be important when shaping the rest of the image.

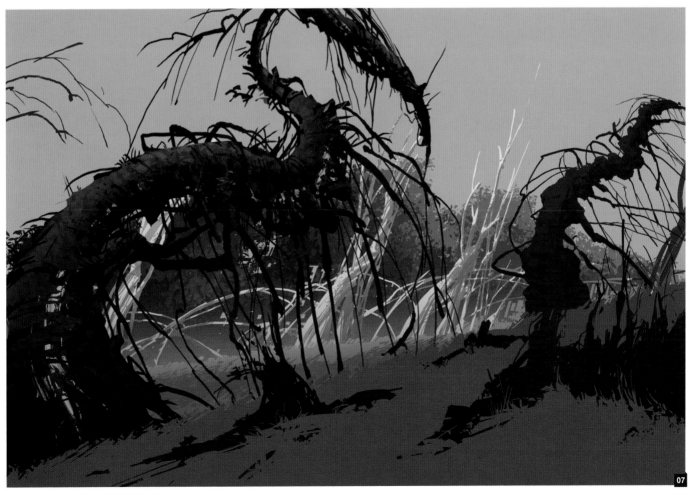

Next I moved on to the foreground. I looked for patterns that felt like clumpy grass, but weren't too obviously grass. It took a little experimentation with a scatter brush to get the right look (**Fig.08**). There's no right way to go about this. It was a "try it and see" approach. That, coupled with some random erasing, yielded what I was after (**Fig.09**).

The sky needed to be a little more brooding so I made a few paint marks and added Motion Blur to soften them. That, plus a little gradation, kept it from flattening out too much.

The final step was to emphasize the center of the image so I added a Levels layer, bumped up the contrast and then masked out the sides with a reverse circle gradient. This gave me a nice hot spot with a little extra contrast to draw the eye towards the middle (**Fig.10**).

My thanks go to Kendall Davis and his *Last Sleeper* project for wanting try out this more graphic approach to concept design!

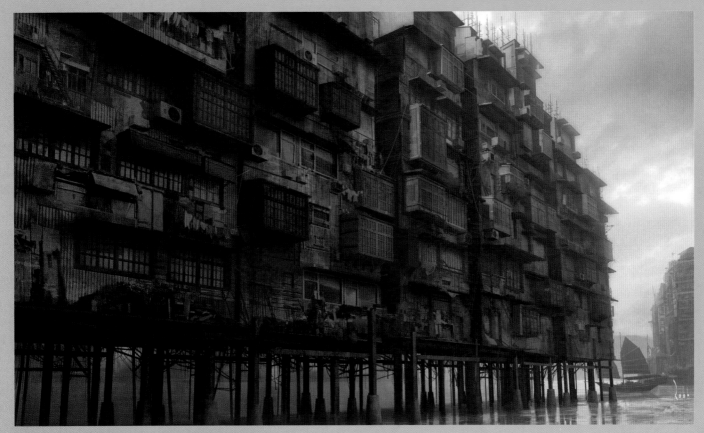

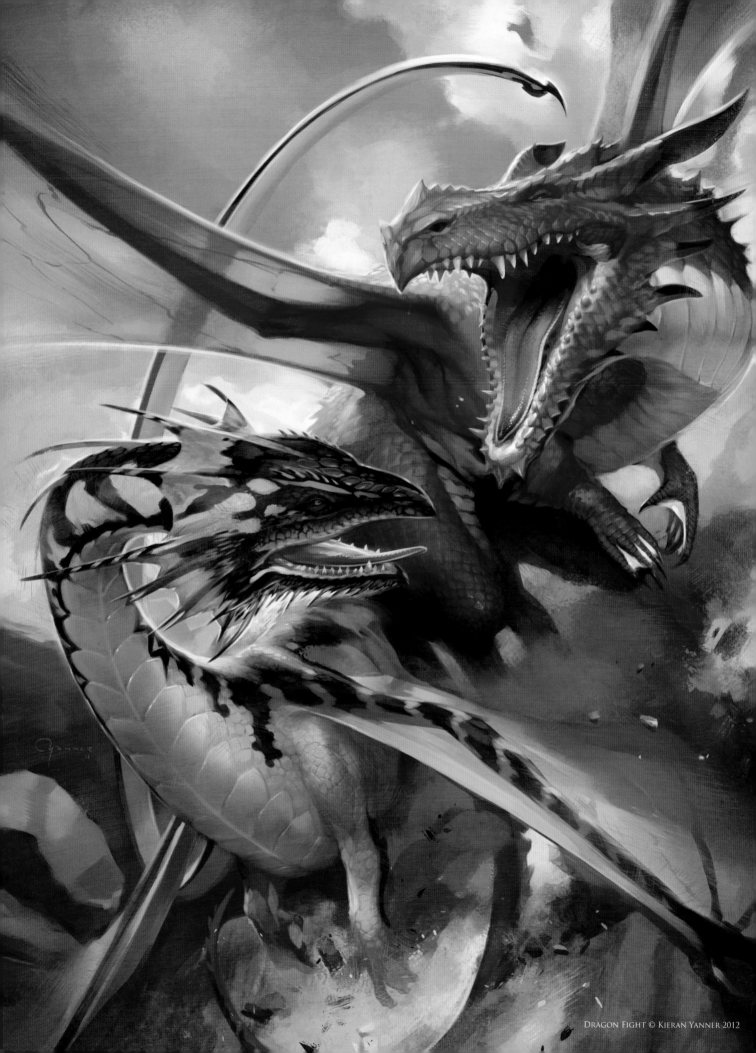

Dragon Fight © Kieran Yanner 2012

DRAGONS

BY KIERAN YANNER

SOFTWARE USED: Photoshop

INTRODUCTION

Before I started work on this image there were a couple of requests from those that commissioned it. The first was that I used warm colors and the other was that the piece should feel like a promotional image for a summer blockbuster. It was originally developed for *Kobold Quarterly*'s Summer 2011 edition.

THE PAINTING

I developed several ideas using dragons as my concept. They were the first things that came to mind when the phrase "summer blockbuster" was used. Two dragons battling it out in an arid desert-like scene was the chosen concept.

I intentionally chose this palette for several reasons, not least of which because it invoked oppressive heat. My other motives were that red is an aggressive color and a nostalgic reference (red dragons are a standard fantasy classic).

When I approached the composition I wanted to ensure the dragons "popped" and the entire image flowed, directing the viewer's eye around the piece. The way I felt I achieved this was through the curvature of both dragons and the positioning of their tails. I also directed the focus through the shape of the wings, which cross the focal points, and the flow of the cloud

formations in the background. The aim was to use an array of lines to hold the viewer's gaze on the main subject.

My overall approach varies from project to project; however, my main focus is in establishing the initial idea. Sometimes this can be through a very rough color sketch, a more detailed black and white sketch, an ink sketch focusing on heavy contrasting shapes, or composing reference shots (though the latter can sometimes produce a stiff or restrictive

process). Ultimately I employ the mindset of "whatever works" to get the idea down as quickly as possible (**Fig.01**).

I often prefer to work by initially refining larger shapes. The hope is that it enforces a quick interpretation of the image and yet still holds up at a smaller size.

I'll either use a soft smudge brush to blend the shapes or one of the many filters available in Photoshop for simplifying details (**Fig.02**).

Sometimes I will experiment with either a textural or more detailed rendering at this stage. I always add new ideas in a separate layer and if I think they work I keep them in the image. The trick is to just get down any fleeting ideas that may sit well in the composition if left, and by putting them on a separate layer I can turn the layer off and reincorporate the ideas at a later date.

At this point I will have collected or shot as many references as possible. Google and Flickr are my staple libraries for online images (I'm sure many of you share this preference), and reference books and my Canon camera are the tools I turn to when I need references.

As I moved further along, I continued to push the contrast within the background and rendered it towards a more satisfactory level. I also added contrasting elements and patterns to the dragons (**Fig.03**).

To me, the clear focus was the gaping mouth of the red dragon and as a result I returned to this area to continue refining it. The scaling was inspired by a combination of crocodiles, dinosaurs and horned lizards. The blue tongue was intended to give an exotic twist and to contrast against the strong red surrounding it, which narrowed the focus to the mouth (**Fig.04**).

At this point I started to incorporate an ambient and reflective light to help push the

dimensionality and, again, add detail to the red dragon. I also moved to the secondary dragon to begin fleshing out its face and scales (**Fig.05**).

The way the image was cropped along the bottom began to grate on me, so I decided to lengthen the piece. The image would eventually be re-cropped to fit the dimensions of the

magazine cover and so this area would be primarily obscured by text, so the crop would be of little significance.

I also began to work in more movement to the background and show an increased interaction between the dragons and their surroundings. I used a combination of Chalk brushes and some harder, blockier brushes to do this (**Fig.06**).

FANTASY

At this stage I reached the final push for adding in details. I fashioned a more exotic pattern across the yellow dragon to help draw the eye along the wings and tail, and more contrast and detail were added to both dragons. I came to feel that the yellow dragon should perhaps look as if it had the potential to win this battle. Its spines, scorpion-like tail, poisonous frog-like pattern and overall color all helped suggest an underestimated deadliness (**Fig.07**).

FINAL TOUCHES

I brought in a layer of atmosphere and began to selectively fan out edges. More details were added to both dragons and I also worked in changes to the jaw of the yellow dragon. As I carried out a final pass, I created a textural layer that helped create motion and softened some of the elements (**Fig.08**).

FANTASY

PLANESWALKERS PANTHEON

By Brad Rigney

Software Used: Photoshop

INTRODUCTION

Hello again! A lot has changed since I last had an image published in *Digital Art Masters* (Volume 4), but the gratitude I feel when my hard work garners attention is the same. So I would like to begin by thanking 3DTotal for the honor of being chosen to appear in this book and included amongst such talented individuals; it is truly a privilege!

Alright, let's get right down to the nitty-gritty. My nephew is a marine and at the end of their training they must endure one final test before earning the honor of becoming a marine. It is called "The Crucible". For 54 straight hours, recruits' endurance and teamwork skills are pushed to the limit. Through perseverance and courage they will finish as platoons and earn the title Marine. The image *Planeswalkers Pantheon* was my Crucible. But instead of 54 hours, my trial was 6 months.

> I CAME OUT THE OTHER SIDE OF THIS A DIFFERENT ILLUSTRATOR, WITH A DEEPER INSIGHT INTO MY GOALS AND CHARACTER DEFECTS, AND THIS KIND OF SELF-KNOWLEDGE IS INVALUABLE

True to the actual test the marines endure, I had a platoon; my wife, kids and Jeremy Jarvis, Art Director for Wizards of the Coast. I simply cannot talk about this work without mentioning their involvement. I watch my kids during the day and work on my contracts at night and on weekends. I simply cannot do what I do without the support of my amazing family, and giving this commission everything it deserved meant getting four hours of sleep a day and throwing my wonderful wife to the wolves to fend for herself every night, weekend and holiday. It was exhausting mentally, physically and, at times, emotionally. And I'd do it again a thousand times over. Why?

I came out the other side of this a different illustrator, with a deeper insight into my goals and character defects, and this kind of self-knowledge is invaluable. I wish I had the luxury of detailing everything I learned working with Jeremy on this, but it's safe to say that he enabled me to push my abilities to the limit and come face to face with some artistic demons. Rocky had Mickey, Luke had Yoda and I had Jeremy.

Getting out of your comfort zone, remaining hungry for constructive criticism and having a willingness to change and sacrifice more of your personal life than you ever imagined is what creating art is all about. Chances are if you're reading this book you are already pursuing art and hunting for hard knowledge on how to improve. Try to bear in mind that there is no express lane to your goals, or any program or tutorial that is going to give you the incentive

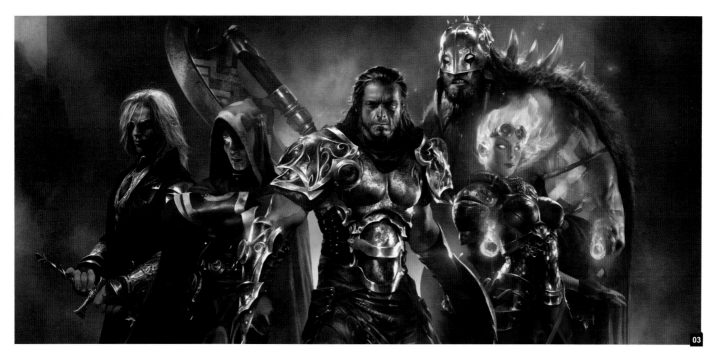

to invest your blood, spirit, flesh and time. That can only come from you. And like you, I too am on a quest to improve.

So, with this in mind, which artistic demons did I mean? I used to hate relying on photo references and withered at the idea of doing composite paint-overs. To me it never seemed like art; it seemed like cheating. This piece forced me to change my tune, at least when it comes to commercial art. The client isn't paying for your personal artistic dogma; they're paying for an engaging representation of their intellectual property. It's not about your voice, it's about their baby. That's a philosophy I've always had, but never fully given myself to until this work. These are the Planeswalkers, you see. You get out of their way.

CONCEPT

The concept for this piece was pure: illustrate The Planeswalkers Pantheon. Make each character shine on their own, but also shine together. Needless to say, when Jeremy offered me the commission I was completely blown away by the gravity of the assignment. I still am to a degree. Me? Illustrate the Planeswalkers... *together*? I never thought I would be trusted to illustrate characters so well known, so loved and so iconic; *trusted*, being the operative word.

PAINTING THE PLANESWALKERS

The commission was in two stages and was to first feature a full-body illustration

of Gideon Jura leading a small group of five Planeswalkers (Sorin Markov, Garruk Wildspeaker, Jace Beleren and Chandra Nalaar), who would be surrounded by the remaining nine. As you can see in **Fig.01**, in my infinite genius and eagerness to get going, I went ahead and started them from the waist up.

This ended up plaguing me until I bit the bullet and reconstructed them (**Fig.02**), repairing and polishing each character so they each shone as powerful individuals without outshining one another (**Fig.03**). I'll talk about that more a little later, since these five aren't the only characters involved, but the formula is more or less the same.

With "The Tight Five" (as they were eventually dubbed) completed and ready to roll it was time to set Gideon and friends center-stage

and retro-fit the remaining nine Planeswalkers around them in a "U" shape, with Elspeth Tirel and Liliana Vess flanking Gideon Jura and acting as anchors around which the other Planeswalkers would orbit (**Fig.04**).

This took six months to complete and the characters you see here are life-sized (e.g., you can match your head size to theirs when viewed at 100%). Because of this it's basically impossible for me to cover each character in-depth, so I'll cover one character in general terms to give you a sense of what it took to paint each one.

The character I'm going to talk about is Liliana Vess. She is beautiful, cunning and deadly. In the *Magic the Gathering* "Multiverse", Liliana Vess is a century-old necromancer who forged a pact with demon lords in order to be restored

to her zenith of power and beauty. She raises the fallen to do her bidding, corrupts the living and draws power from death. My kind of gal!

Liliana, at heart, is a predator; a man-eater. It was essential to transmit this in her body-language and attitude. When I think of predators I think of exotic big cats and serpents; of hypnotic eyes following their prey's every move, waiting to strike from the darkness. Garruk Wildspeaker also embodies this, but on a more barbaric, primal level with fur, tusks and muscle! Liliana, however, is more subtle, more insidious; like a stalking black panther or a slithering cobra. I mention all of this because I tried to immerse myself in who these characters are when I illustrated them.

> " IT WAS AN
> UNBELIEVABLY
> TIME-CONSUMING
> AND PUNISHING
> PROCESS, WHICH
> WAS GUIDED MORE
> BY INTUITION AND
> REPEATED FAILURE
> THAN TACTICAL
> DELIBERATION "

I thought about what it is that attracts the die-hard fans to these personalities. From that point I created a phrase or word that embodied the essence of what the character should project and tried to make them tangible.

The hard-numbers and technique was the same for each character. After studying the reference sheets provided by Wizards of the Coast, I illustrated the character in primitive shapes with a large, wet-edged brush at around 50-60% opacity and 50% flow, attempting to establish their attitude and presence.

Then I began to wrangle up references to correct mistakes and develop the character. I used anything from movie-stills that possessed strong lighting arrangements to a hand, set of eyes, or an entire model striking a pose I liked – although often the appearance of the model was irrelevant; it was the attitude they projected or that invisible something you don't see, but sense.

After this I started laying in the flesh-tones, armor highlights and garment colors with smaller brushes (some textured, some not) at a lower opacity. The variables on which brushes I used at what time are also too numerous to mention here; this part of the process was very fluid and I simply didn't keep track of specifics. I went in with the Smudge tool set at around 80% and sculpted the pixels into place, blending, reworking and refining as I went along. This technique is more akin to sculpting than drawing. I've used it for over 10 years and it would take another 99 pages of this book to describe it accurately. It's something I've taught myself, as I have with all things related to art as I have never been trained.

The result for each character was commonly what you see here in **Fig.05** and typically what got sent in for approval; a murky, unrefined mess that possessed a couple of focal areas of detail so Jeremy could get a sense of the direction I was heading in. This is the point where his eagle-eye started pointing out the pit-falls that I had been unaware of, like misplaced emphasis or loss of focus. After I cleaned up the trouble spots and got approval, I prepared to enter the ring and fight with everything until I had produced my best.

From here I repeated the process, refining and tightening as I went, investing hundreds of hours on each character at 400-500% magnification until they were finished. It was an unbelievably time-consuming and punishing process, which was guided more by intuition and repeated failure than tactical deliberation. I do not recommend it, but I do adore it.

After finalizing Liliana (**Fig.06**) I moved backward to Ajani Goldmane, Koth, and then

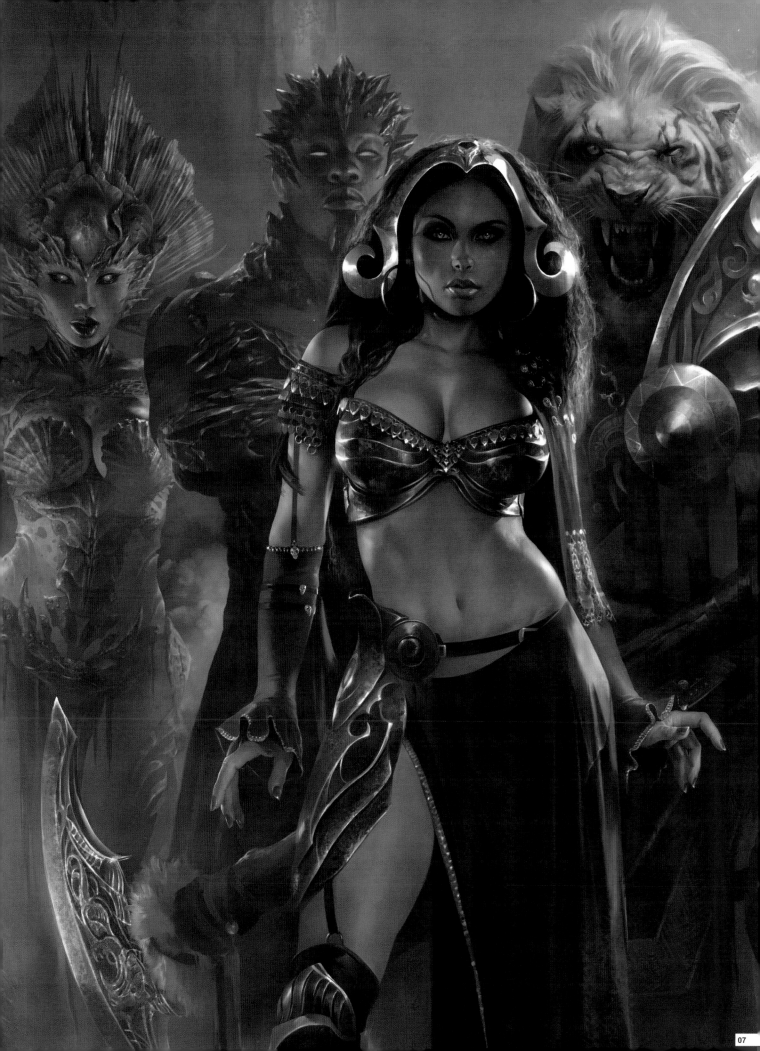

finally, Kiora Atua. **Fig.07** shows how I used light fogging to stagger and separate the characters, while being careful not to wash them out.

I used this exact same formula on the left hand-side of the canvas, starting with Elspeth Tirel, then moving backwards to Tezzeret, Sarkhan Vol, Nissa Revane and Karn (**Fig.08 – 09**). As you can see by studying these images, a lot of re-organizing took place to balance the position and presence of each Planewalker in order to get a strong composition in both localized areas and overall. After all the characters were completed I cleaned and tightened the background elements, being careful not to over-describe the location or de-mystify the characters.

If you want to take a look at a larger version of my image, head over to: **http://cryptcrawler. deviantart.com** and browse my gallery to find the image. It's only at about half the actual size, but you'll be able to check out each Planeswalker a little more closely. Thank you for your interest in my art; I hope you enjoy looking it as much as I did painting it. Until next time!

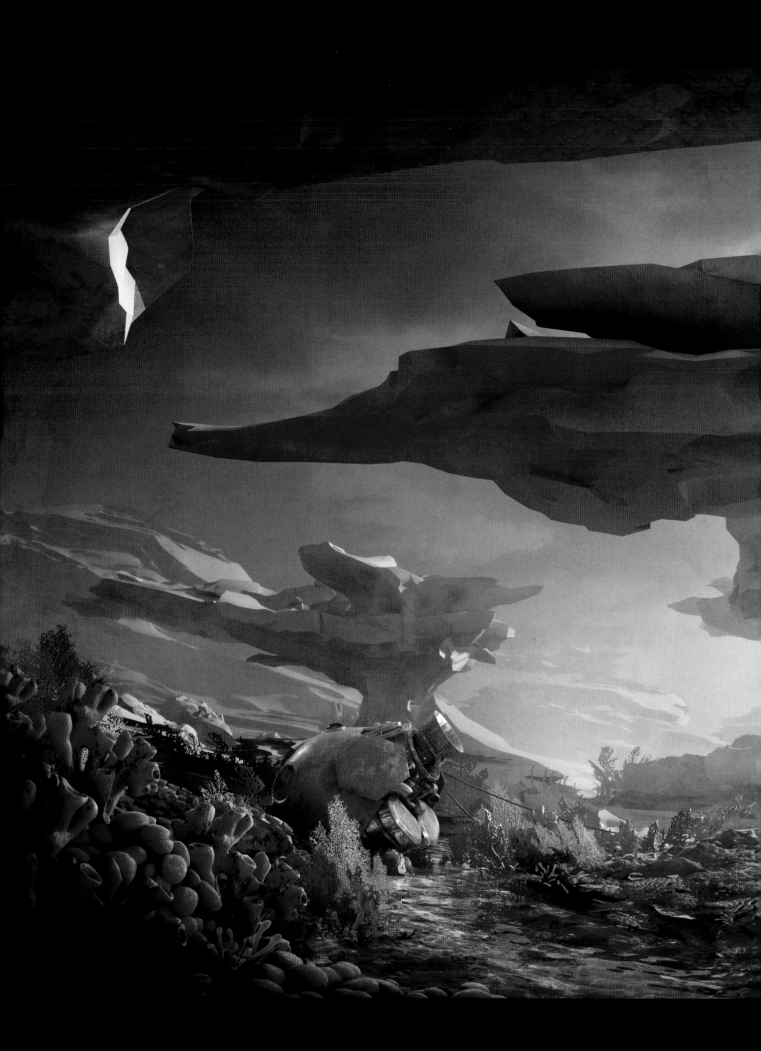

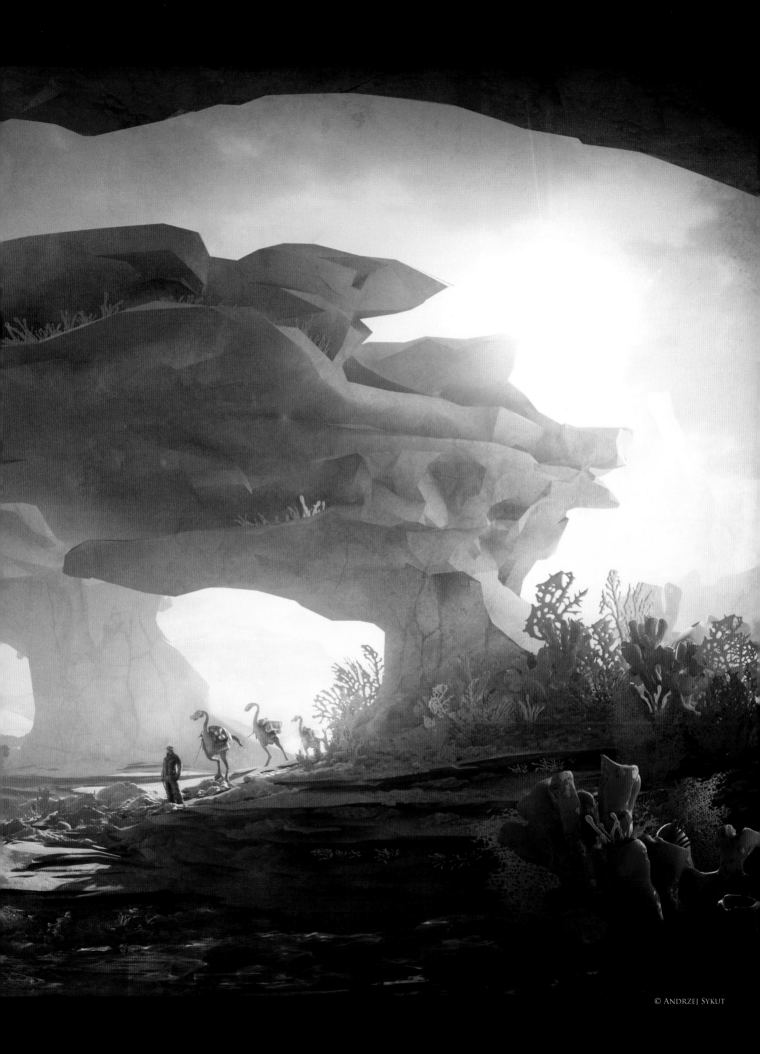

© Andrzej Sykut

THE JOURNEY – GOOD TO BE BACK

BY ANDRZEJ SYKUT

SOFTWARE USED: ZBrush, 3ds Max and V-Ray

INTRODUCTION

It's good to be back in *Digital Art Masters*! When working on personal images, finding the time is the biggest problem. If I want to finish anything I have to work fast. That means taking every shortcut available, skipping anything that isn't essential and, most of all, planning well and dividing the work into smaller, manageable chunks that can fit into various spare moments during the day.

The idea comes first. It doesn't have to be very detailed, but it has to be somewhat solid (I like to have at least some backstory to the image). Details will be worked out as I go along. It's vital not to get hung up on details at the expense of the big picture. It's as important to keep things fluid; anything I add to the image can spawn new ideas and it's almost as though the image starts to have a life of its own.

MODELING

What I like to do is create a simple 3D sketch of the scene as quickly as possible using low resolution geometry, primitives and old models. Anything is fair game when doing this. With some objects roughly in place I have the ability to test various camera positions and light situations without waiting too long (the scene isn't detailed so the render times are short). This is the creative part of the process that is the most fun.

I had a sketch I was happy with in around two days (**Fig.01**). The main stone structure was a quick ZBrush sculpt and the ground was re-purposed from one of my test projects. The

light and atmosphere was almost the default V-Ray Sky and V-Ray Light. To achieve the fish eye effect I used a V-Ray camera. The row of boxes in the foreground was supposed to be a caravan of sorts; maybe not camels, but some alien-looking pack animals. I had no idea about the kinds of animals they were to be at this stage. The patches of green were supposed to be teeming with vegetation, but again, were unspecific at this time.

The low resolution render was taken into Photoshop where I did some rough color corrections and quick post-production. From this point on, after every few hours or any significant change, I would undergo a quick render and drop it into Photoshop to see how it looked with the addition of a few post effects.

This was a critical moment! I'd had my fun and it hadn't even involved that much effort.

The ideas were mostly there, the composition worked, and the image mostly matched what I had in my head. It was way too easy to think that was enough and move on to the next thing.

Everything was a placeholder at this point, and was liable to be replaced by a more detailed version. Surprisingly much of the background survived almost intact all the way through to the final image. I wanted to approach it in a more painterly way, akin to the way some painters detail and polish only the important areas and focal points, leaving the rest as rough brush strokes. It's kind of hard to do this in 3D, as unfinished 3D usually looks… well, like unfinished 3D (not good).

Since the background already worked with nice shapes due to the atmospheric perspective and lighting, I could then focus on the foreground, leaving the rest alone. This way I hoped to

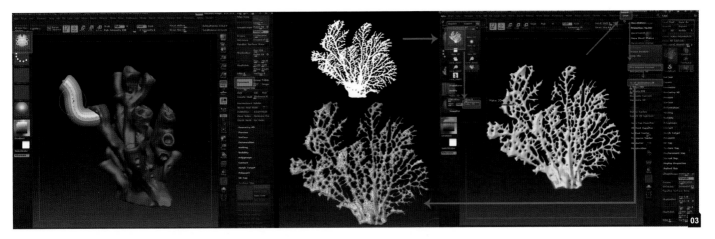

achieve a nice gradation of detail fading off into the distance. The detailing was not that difficult, but it was time-consuming. As the scene size grew and interactivity dropped, it became tedious. The progress is shown in **Fig.02**.

I started by detailing the plants. Most of the vegetation was made in ZBrush (**Fig.03**). The sponges were done using the Curve Tube brush combined with DynaMesh, followed by some further sculpting and Decimation Master. The coral, amongst other plants, was made by extracting a black and white silhouette from photos and using it as an alpha, followed by the Make 3D command and some sculpting. Some plants were placed manually, while most were positioned using the Advanced Painter script.

Somewhere during the early stages I decided to push the caravan back further into the image. This introduced some story changes and instead of making its way into the image, the caravan was now heading towards the viewer, but without any real goal.

This is also when I introduced the crashed spaceship. The image was going to be an addition to my series entitled "The Journey" and I wanted to incorporate some of the key elements of this series. The ship relates directly to the very first image in the series and as for the character, the poor guy is a permanent work-in-progress.

> " THE TEXTURING WAS GIVING ME SOME TROUBLE AS I WANTED TO RETAIN THE SIMPLE LOOK FROM THE FIRST SKETCHES, WITH LOTS OF FLAT GEOMETRIC SHAPES. USING PHOTO-SOURCED TEXTURES DIDN'T REALLY WORK "

The last things to be modeled were the bird-like pack animals (**Fig.04**). I built a very simple rig for them and burdened them with packs covered by simulated cloth. It was faster to pose the character and run the simulation, then manually sculpt the folds on the packs.

TEXTURING

The texturing was giving me some trouble as I wanted to retain the simple look from the first sketches, with lots of flat geometric shapes. Using photo-sourced textures didn't really work – they were just adding unwanted noise to the scene. It transpired that the detail was in the models and the few textures that were used are mostly black and white masks, serving to add spots of high contrast colors to the base materials (**Fig.05**). The only objects to use

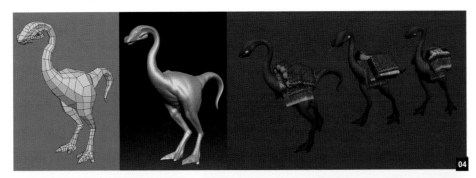

detailed textures were the story-based ones such as the character, animals and ship. It does work, however, as the higher amount of detail naturally draws the attention, which is important in an image full of wildly colorful things

LIGHTING AND RENDERING

The lighting started simply, with me using the V-Ray Sun and Sky, but in the end became more complex. Both the ship and the caravan have their own additional three-point setups, providing rim and fill light to slightly separate them from the rest. There's a directional light providing caustics underwater and an omni light providing subtle caustics on the rocks above the water level. There are a few lights adding detail and directional lighting to the foreground objects, and, finally, some blue lights creating the bio-luminescence (**Fig.06**).

Most of the rendering challenges were solved a while back and during this stage I just

needed to type in the resolution and decide which V-Ray passes I would need. I used some MultiMatteElements, VrayReflection, VrayZdepth, and VrayExtraTex with Vray Dirt as a texture, plus some additional light passes for foreground objects.

When it came to compositing, most of the challenges were solved in the earlier previews (**Fig.07**). What remained was to copy adjustment layers into the final image and add some detail, including smoke, subtle texture overlays, some grain and other little tweaks.

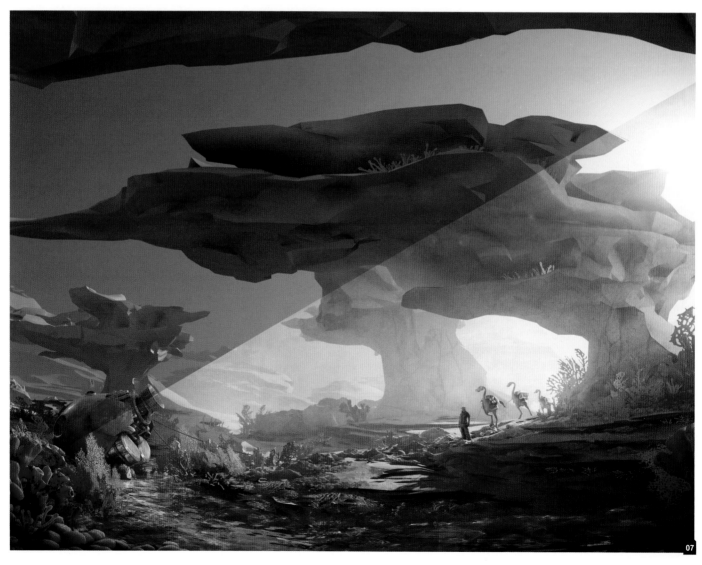

FANTASY

FANTASY

LITTLE RED RIDING HOOD

By Blaz Porenta
Software Used: Photoshop

INTRODUCTION

From early childhood, every cartoon I watched and every fairy tale I read made me want to portray it in a sketch or painting. Painting fantasy images (especially characters) was something I could easily lose myself in for days – and not much has changed! So when I got the opportunity to redesign an existing fairy tale character for a project, it was a dream commission and something that I wouldn't mind doing over and over again. Thanks to the 3DTotal team for giving me the chance to share how I created this image!

> ## CREATING A GOOD HORROR PAINTING IS QUITE SIMILAR TO SHOOTING A GREAT HORROR MOVIE

IDEA

We all know the story of *Little Red Riding Hood* and today's vision of it. It is portrayed as a children's bedtime story where even the big, bad wolf often looks like a friendly puppy. I decided to go with a grim and darker interpretation of the story, as this is how I believe that *Little Red Riding Hood* was supposed to be read.

Creating a good horror painting is quite similar to shooting a great horror movie. Gore and sharp teeth help of course, but building a tense atmosphere brings it to another level. In movies this can be achieved with long silences or screeching violin music just before the scary face pops out of the closet, but in paintings we use composition, character placement, color schemes and the relationships between dark and light areas. Showing less is sometimes more! Creating a claustrophobic environment and selecting the very moment before contact is made are just some of the ways that help you achieve the scary mood.

PAINTING

I usually start painting in grayscale to establish tonal values and the right amount of contrast, but this time I jumped straight into color since

it was more or less a monochromatic piece anyway (**Fig.01**). I hid most of the wolf's body in the dark, showing only his hunchback silhouette emerging from the foggy background and illuminating his werewolf-like face and hands from below, which is a classic horror device. Although there is no logical explanation for the strong light source in the bottom left of the image, it helps create a strong atmosphere. I knew that as long as I applied this light to

everything else in the image, it wouldn't matter why it was there; the viewer would take it for granted.

At this stage, good composition is the number one priority. It is true that working digitally makes any changes easier in comparison to working with traditional media, but getting to a point where half of the painting is already finished and you need to cut it to pieces and

reposition everything can be really frustrating. I've been there too many times, so establishing a strong foundation with quick brush strokes and working full screen was important to avoid unnecessary detailing during the early stages.

Once I was happy with my sketch, I moved on to sculpting the characters out of the background (**Fig.02**). Starting with the wolf I kept in mind that most of his body would stay hidden in shadows and wouldn't require much more work at this stage of the process. As previously mentioned, less is sometimes more and leaving some parts of the image to be filled in by the viewers' imagination can make the mood even scarier.

In my next step I redesigned some parts of the girl and her outfit, added the wolf's other hand and worked on his silhouette, giving him bristled hair along his back (**Fig.03**). I also started defining the surroundings more, smudging fog parts with some hard textured brushes. I love using textured brushes from early on in a painting as they give it a more finished look. This way I don't even need to define everything as the textures themselves give you hints.

When I felt everything was sitting well, I started working all over the place. Jumping from one part of the image to another, developing it as equally as possible, allows me to spot flaws in a painting and makes them easier to correct, especially in terms of the composition (**Fig.04**).

05

I also started defining skulls and bones at the bottom of the canvas, creating ground textures with all kinds of scattered brushes, as well as painting hair on the wolf's back and hands. To paint convincing hair or fur, we first need to understand how it sticks together, and how it is layered and affected by light. Here is a quick step-by-step that shows how to approach it when painting (**Fig.05**).

I also felt it was necessary to change the little girl's face. I decided to do so because I felt she already knew something bad was going to happen and I needed to catch that exact moment when she was turning around. This gave me a much better interaction between her and the monster behind, although she can't see him clearly yet due to her hood. I believe this kind of detail always helps build a stronger story in paintings. You shouldn't be afraid of making any changes during your painting process, as long as they help improve the final image.

Now that I had a strong core to the image I could play with the environment and light effects (**Fig.06**). For the branches in the upper part of the image I helped my cause with some custom brushes generated from references I photographed. This is a quick way of creating a believable and complex treetop base, but it will need further work to avoid looking like a lazy photo placement inside the painting. Using these kinds of brushes only provides the silhouette so you will need to add the highlights and shadows to create the final form.

For the lower branches I used more organic shapes, resembling thorned tentacles reaching for our little girl and closing her path. I also used

a lot of layers set to Overlay with orange hues to increase the contrast and make the painting more vivid.

LAST TOUCHES

In the last stages I played with the contrast some more, added the moon in the background and placed a couple of canvas textures on top of the image (**Fig.07**). Once again be very

careful how you use these textures. They are great for random details here and there that would be hard to achieve with plain brushes, but can quickly become overwhelming and prove a distraction. Use them in carefully chosen places and as subtly as possible. They should serve only as a cosmetic touch up and nothing more.

06

07

FANTASY

SICK OF HIDING

BY ANDREW THEOPHILOPOULOS
SOFTWARE USED: Photoshop

INTRODUCTION

My name is Andrew Theophilopoulos and I am a senior at the Ringling College of Art and Design, studying Illustration. I am also a freelance visual development artist at Digital Domain's Tradition Studios in Port Saint Lucie, Florida. The painting you see here is the result of my first assignment for school immediately following a fantastic summer internship at Digital Domain. The original concept behind this painting was simple. I wanted to depict the interaction between a character and its animal companion.

MY PAINTING

In this case I started traditionally, drawing thumbnails on every piece of paper I could get my hands on. The forty or so thumbnails were all smaller than an inch each, which allowed me to quickly cover a lot of ground extremely effectively, throwing out every bad idea in a matter of seconds. At this point there was no character design, no reference, nothing besides the shapes of the elements I planned on using. I continued these one inch thumbnails until the composition seemed right. Using elements like the tails, vines and rocks I could lead the viewer's eye around the tiny composition. I now had an inch tall scribble that still fits perfectly on top of the final painting (**Fig.01**).

> ❝ WITH THESE SETTINGS YOU CAN TAKE ADVANTAGE OF HOW MUCH PAINT IS ROLLING OFF YOUR BRUSH, JUST LIKE TRADITIONAL PAINTING TECHNIQUES SUCH AS SCUMBLING OR GLAZING ❞

At this point it was time to jump onto the computer (**Fig.02**). I use a Mac Pro with a Cintiq and Photoshop CS5. Within CS5 I use a single brush with the same settings from start to finish. I use the good old Round brush, with the pen pressure set for size and opacity, of course.

With these settings you can take advantage of how much paint is rolling off your brush, just like traditional painting techniques such as scumbling or glazing. For example, you can vary the tonal range just by controlling how much pressure you use without ever switching to a new color. If you need a low value, but a big stroke, simply adjust your brush size quickly with the control option shortcut. The reason I use the Hard Round brush is to specifically control every edge (hard, soft or lost) simply by color picking an area to either smooth it out or keep it crisp. I don't use the Soft Round brush because it dictates how soft my edges are. Every edge is unique in its own way.

Once I'd scanned my thumbnail the next step was to scale the image size up to the final dimensions and begin drawing over it. This is a technique I learned at Digital Domain over the summer. Basically, you create a white layer on top of your thumbnail in Photoshop at a low opacity, simulating a virtual piece of tracing paper. Then you start drawing on top of this layer, bringing in the details and fleshing out the world on top of the now fifteen inch thumbnail. At this point I was working out a pose for the characters while staying within the shape I gave them during the thumbnail stage. I continued adding tracing paper over and over until I'd settled on a tight final drawing (**Fig.03 – 04**).

Once I had done the final drawing I changed the color of the lines to something that fitted in with my color scheme, just so I didn't pick up any muddy black and mix it into the painting. I then started painting under the line layer with the colors I would use for the rest of the process (**Fig.05**).

Think of this step as the block in stage. It's the most important part of the process because the colors chosen here will dictate the rest of the painting. For the first time I used the website **www.colorschemedesigner.com**. After settling on a color scheme, I grabbed the colors from the website and pushed them towards those I needed for a tree, a rock or a person, etc. Once my color and values were decided on I made a new layer on top of everything and began rendering (**Fig.06**).

> ## CONSTANTLY QUESTION EVERYTHING ABOUT YOUR PAINTING AND DON'T STOP UNTIL YOU FINALLY HAVE ALL THE ANSWERS

For me, the painting process is about getting rid of the lines, working edges and filling the world with everything you imagine would be there.

I think of it as making a Rockwell out of your world; getting into the mind of your character, developing their emotions and the relationship they have with their surroundings. In this case the four of them have spotted movement in the distance, and one girl has immediately snapped into her camouflage as the other sighs, slowly becoming engulfed by her responsibilities. She longs to be seen (**Fig.07**).

Constantly question everything about your painting and don't stop until you finally have all the answers. Norman Rockwell was a master at bringing beautiful, inspiring worlds to life (**Fig.08**). He mastered the personality of not only his characters, but the worlds his characters inhabited. Ultimately, this was my goal, which took 20 to 30 hours overall. I hope you enjoy it!

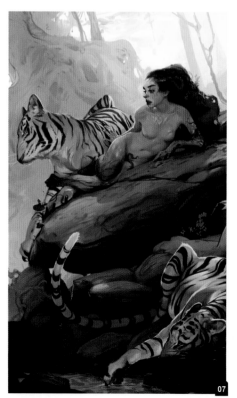

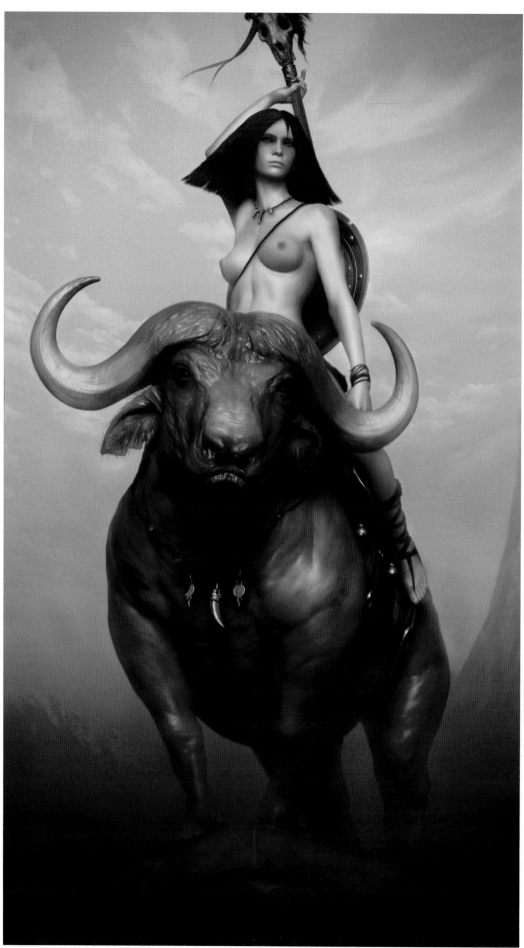

DAWN

By Alessandro Baldasseroni

Software Used: ZBrush and 3ds Max

Inspiration and Concept

I've always been fascinated by fantasy art.
I remember how, back in the day, I used to
buy all sorts of art books (and I still do) from
masters of the genre. I'm talking, of course, of
people like Vallejo, Rojo, Brom, Frazetta and
last, but not least, Catherine Jeffrey Jones. I
was particularly in love with their book covers
and their fine art paintings of the 70s and 80s.
That kind of romantic aesthetic always struck
a chord in me. Catherine Jeffrey Jones in
particular used simplicity of forms supported by
beautiful color schemes and composition, which
motivated me to try this kind of approach, only
in 3D as this is the medium I know best.

Whilst sticking to this style I decided to combine
two basic elements: brute power and grace.
My idea was that they could somehow balance
themselves out in a resting pose. From this
thought process evolved the idea of something
like a priestess or scout riding a powerful, but
static, animal, like a bull or a bison. I did a quick
sketch of how both of the two main elements
should be placed in the composition (**Fig.01**).

> " **IT'S VERY IMPORTANT
> AT THIS POINT
> TO STAY TRUE TO
> THE BACKGROUND
> RESOURCE IMAGES
> FOR THE MAIN
> PROPORTIONS** "

The Sculpting Process

The first thing I did was to collect a bunch of
references of African bison to set up as the
background in ZBrush, which would serve as
a solid reference for the main proportions.
I decided to start the sculpting process by
blocking in the main volumes, starting from a
sphere and proceeding with the new ZBrush
4 R2 DynaMesh feature. The idea was to
progressively expand the mesh as needed
through DynaMesh, which takes care of the
retopology process (**Fig.02 – 03**).

It was very important at this point to stay true to
the background resource images for the main
proportions. I find it particularly useful during

this stage to lock the position of my subtool
on the screen using the ZApplink properties.
This way I can freely sculpt and then call back
the saved view/position so that it aligns to the
background reference.

As far as the sculpting technique goes, along
with the DynaMesh process I usually tend to
use a limited set of brushes like the Standard
brush and the Move and Clay tools for the main
proportions. When it comes to the secondary
forms I use the Soft, Hard Polish and Dam
Standard brushes for the fine detail (**Fig.04**).

Once I was satisfied with the overall sculpting of
the bull it was time to put it into a pose by using

the awesome transpose tools (**Fig.05**). I also built a simple stone base and appended it as a sub-object (**Fig.06**).

Then it was time to move on to the female figure on top of the bull. In order to save time I started from a base body mesh in a T-pose that I have used in various past projects; the idea being that I could customize her clothes and gear later on for my specific needs (**Fig.07**).

All her clothing and gear were built in 3ds Max using simple poly modeling, and then adjusted in ZBrush. Her hair was generated with Hair and Fur in 3ds Max, converted into geometry, imported as an OBJ file into ZBrush and appended to her body mesh. Later on I placed her on top of the bull and posed her in accordance with my concept. I also took the opportunity to add a few items to the bull itself, creating the geometry in 3ds Max and again importing them into ZBrush as an OBJ (**Fig.08 – 09**).

It's also important to point out that for the overall posing of the two elements, I set up a few keys in the ZBrush time line that served as cameras. This way I was able to freeze my final composition frame and adjust the pose and objects according to the camera to maximize the effect of the composition.

Once I was satisfied with the final framing I switched the overall material to something that looked like resin/clay and did a render of the final sculpt with the BPR render. I also did a little bit of compositing in Magic Bullet and Photoshop (**Fig.10**).

Texturing and Rendering

Since my aim was to make an illustration, it was time to move on to texturing and materials.

Fantasy

I also wanted to render it entirely in ZBrush through simple materials and the BPR renderer, making good use of the passes feature.
The first thing I did was to set up the basic color of the sub-objects in polypaint. I didn't really care too much about creating accurate texturing since I wanted the final result to look illustrative and focus more on mood and overall composition, as opposed to realism.

Most of the materials are just the default basic MatCap gray material, with a few exceptions for the metallic parts. Something I found very useful was being able to paint two different materials on the sub-objects, such as a shiny metallic material on the horns and a less glossy MatCap material on the body. I then blended them together with a specific blending radius in the BPR palette, which gave me a lot of control over the overall look of the surfaces (**Fig.11 – 12**).

I also took advantage of the new wax feature in the ZBrush materials in order to achieve a decent subsurface effect on the body of the woman and the bull. The great thing is that it is possible to preview the effect in the viewport and render it with the BPR (**Fig.13**).

Once everything was set up it was time to render with the BRP, taking advantage of the passes feature in order to have more control over the compositing in Photoshop.

The lighting rig involves a basic key light and rim light for some highlights on the back. My rendering parameters can be seen in **Fig.14**.

You can also see the render passes in **Fig.15**. Once I had extracted all the passes it was time to put everything together in Photoshop for the final illustration. I wanted it to consist of warm tones, so I decided to isolate the main render from the background through the

extracted alpha channel in order to work on the areas independently. It basically consists of a collection of manipulated photos of skies that have been heavily retouched and color corrected in Photoshop. I also painted a few elements in the background. The

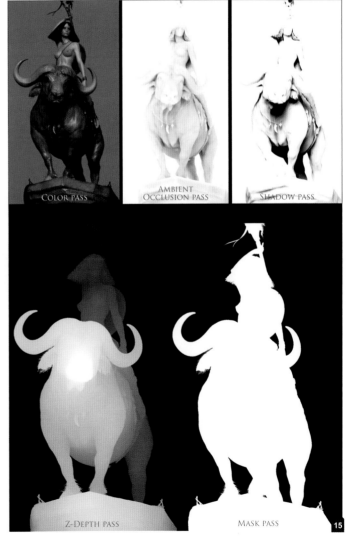

COLOR PASS

AMBIENT OCCLUSION PASS

SHADOW PASS

Z-DEPTH PASS

MASK PASS

same approach was used for the mountains. Everything I had put in the background was then added to a sky gradient folder for ease of access and editing (**Fig.16 – 17**).

> ## THIS WAS ALSO AN OPPORTUNE TIME TO PAINT OVER SOME OF THE ACCENTS ON THE METALLIC PARTS OF THE IMAGE TO ADD SOME SPICE IN TERMS OF VISUAL INTEREST

Setting up the mood of the background really dictates the overall mood of the illustration, so I decided to integrate the color of the main focus (girl and bull) into the warm tones of the background. I started color shifting the shadow and Ambient Occlusion passes, putting them on separate layers and overlaying them on the base color render. Some pure color layers and gradients have been created and put on top of the color render to control the tones and create dark shadows here and there, such as the girl's eye sockets and lower part of the illustration. This helps add depth to the whole composition and focus the viewer's attention on the girl and bull (**Fig.18 – 19**).

FINISHING TOUCHES

I was not completely satisfied with the mood of the overall image, which felt kind of flat, so I decided to introduce some cold and warm contrast. I color shifted the whole image with a few adjustment layers, which included Hue/ Saturation, Photo Filter, Brightness, Contrast and Vibrance. This was also an opportune time to paint over some of the accents on the metallic parts of the image to add some spice in terms of visual interest (**Fig.20**).

To complete the image I introduced a few more enhancements to the color and detail. I exported the image in a TIFF format and imported it into Magic Bullet. I did this to introduce a Film Contrast filter and a vignette. I also took care of a few little details here and there, including reflections on the girl's hair. I also smudged some edges here and there, and applied a bloom effect to the girl in order to draw the viewer's attention to her (**Fig.21**).

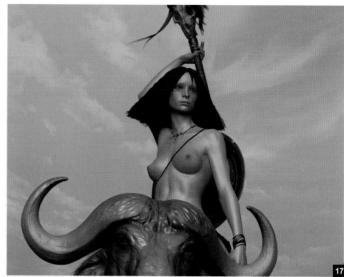

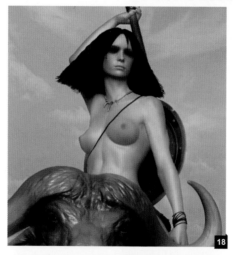

Concept by Tom Gluckmann . Modeling, texturing, shading by A. Baldasseroni.

© CONCEPT ART BY TOM GLUCKMANN. Modeling by ALESSANDRO BALDASSERONI

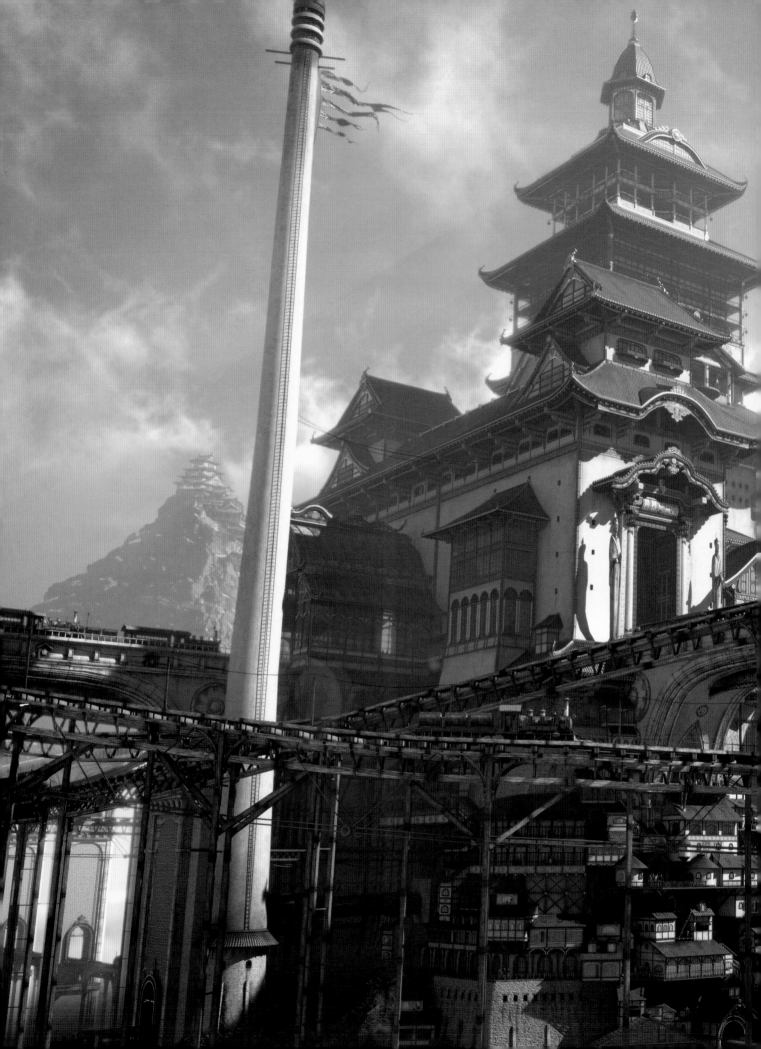

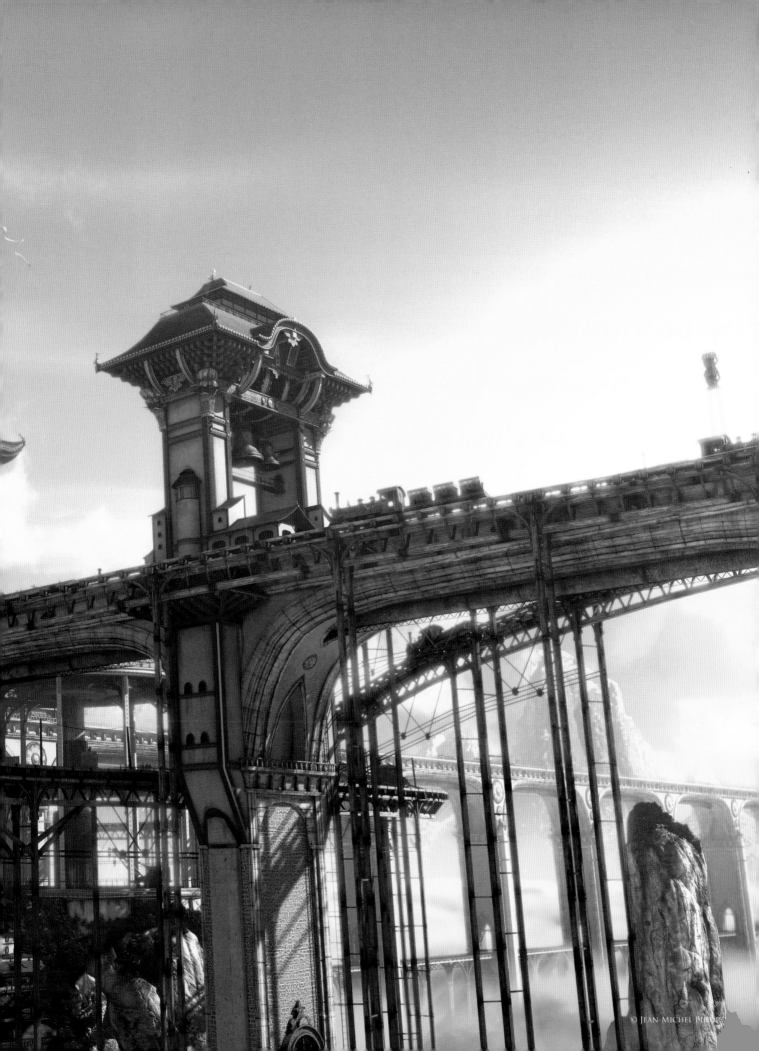

THE TRAIN STATION

By Jean-Michel Bihorel

Software Used: Maya and Mudbox

CONCEPT

This project is entitled *The Train Station*. The idea was to illustrate a fantastic, dreamy place that I wish existed in the real world. It's also strongly inspired by the universe of Hayao Miyazaki and, more specifically, by the bath house of *Spirited Away*.

I started by doing some quick drawings to define the shape of my building. In **Fig.01** you can see the very first rough ideas I came up with. I didn't try to make the drawings any more detailed or aesthetically pleasing because I knew that my drawing skills were not good enough to include the amount of detail necessary. At this point I was happy that I had a good idea in my head.

> ❝ I SPENT A LOT OF TIME SEARCHING FOR REFERENCES, AS I DO FOR ALL OF MY PROJECTS ❞

I then moved on to model a rough proxy of the main structure of the building, in order to find a good set of proportions. I made some quick renders as reference for designing the sub-levels of the scene (**Fig.02**). This allowed me to focus on the more specific areas without losing the coherence of the rest of the scene, as all the proportions were previously set.

It's good if you have no deadline, clients or supervisors to report your progress to. A good, clean concept is always better, and it saves a lot of time and allows you to share your ideas. It was a good experience, but if I had to redo this project I would spend more time on the concept phase. I had the picture in my head from the outset, but it turned out to be of little help as the concept was only partially resolved on paper before I started the 3D process.

REFERENCES

I spent a lot of time searching for references, as I do for all of my projects. This allowed a lot of freedom when choosing the objects I was going to use in the scene, although I didn't want

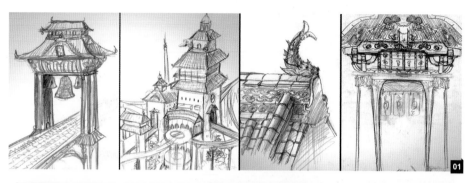

to restrict myself purely to Japanese culture and a single period. This was a commercial train junction, so it would have been influenced by many civilizations passing through with the commerce and trade shaping it into a multicultural area.

MODEL

The modeling process was very basic. Since my proxy model was ready I just replaced it with new geometry, little by little (**Fig.03 – 04**). I tried to keep everything as optimized as possible, as I knew that my final scene would contain a huge number of objects.

I always use as few polygons as possible, opting instead for instancing and ensuring everything is named and grouped. All the trees, trains and even a large number of the bridges were mental ray binary proxies. I strongly recommend you all research this technique as it's the best approach in crowded scenes! My final scene was about a million polygons or so (not counting the mr_BinaryProxys).

TEXTURES

I then generated a lot of UVs, splitting the objects into two groups of tileable textures and ones that required specific textures (**Fig.05**). I then painted most of the textures in Mudbox and Photoshop. I created all my maps at quite a big size to ensure I didn't lose any detail in

close-up shots. Then I converted all the textures to a .MAP format in order for mental ray to render them more efficiently.

CLOUDS

For the clouds I decided to use some Maya fluid containers textured with Perlin noise in

order to get some nice volumetric effects with reasonable render times, and a real interaction with the lights. I was not able to use matte painting to create the near foreground as my camera was moving. For the clouds I used one of the presets that I modified slightly to get the density and details I was after (**Fig.06**).

RENDER

For rendering I used one directional light and an HDRI sky. I generated my sky in Vue because it was hard to find a sky that I wanted to use at a high enough resolution to fit all my shots from the different camera angles. It's very easy to create some nice sky with the Atmosphere Editor in Vue, despite it taking quite a lot of time to render a nice 360 degree environment at a high resolution.

I then baked a few Final Gather maps along the camera path, combining them together and freezing the generation of the Final Gathering (**Fig.07 – 08**). That way I was able to save a large amount of render time. By chance I was able to use the render farm at the studio where I work, otherwise it would have taken a long time to get the sequence renders done.

COMPOSITING

To tweak the final look of each shot I decided to output a few passes to play with in Nuke. A Normal map allowed me to adjust the lighting in the post work, although I would rather use a World Position pass to gain more control over this process. A Z-Depth pass is a great way to achieve depth of field and atmospheric fog quickly, and I strongly recommend rendering the Z-Depth pass as a 32bit float picture. If you do this it contains such a huge amount of information that when you grade it you can output some masks for very small details, such as the houses on the cliffs (**Fig.09 – 10**). The clouds were also rendered separately because they had a slightly different render setting and because it was also easier to tweak them separately. I then combined everything in Nuke to get my final shot.

MUSIC

As this project was for a video, it needed some music. I assigned a track that I liked by *Gökhan Terlemez* over the footage in order to create more of an atmosphere.

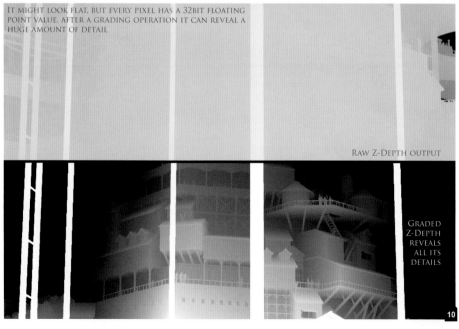

IT MIGHT LOOK FLAT, BUT EVERY PIXEL HAS A 32BIT FLOATING POINT VALUE. AFTER A GRADING OPERATION IT CAN REVEAL A HUGE AMOUNT OF DETAIL

RAW Z-DEPTH OUTPUT

GRADED Z-DEPTH REVEALS ALL ITS DETAILS

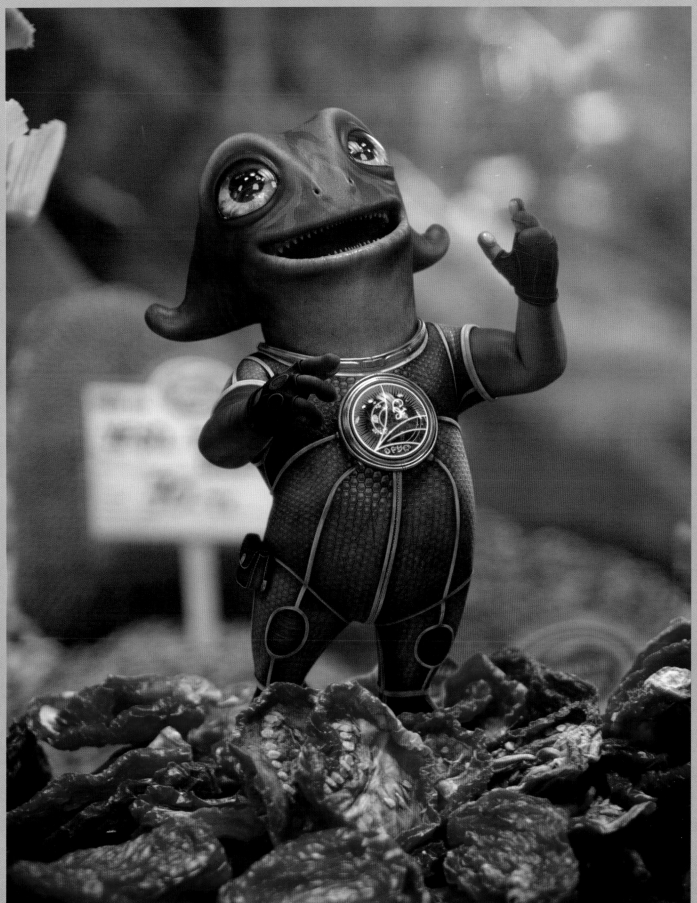

© JEAN-MICHEL BIHOREL

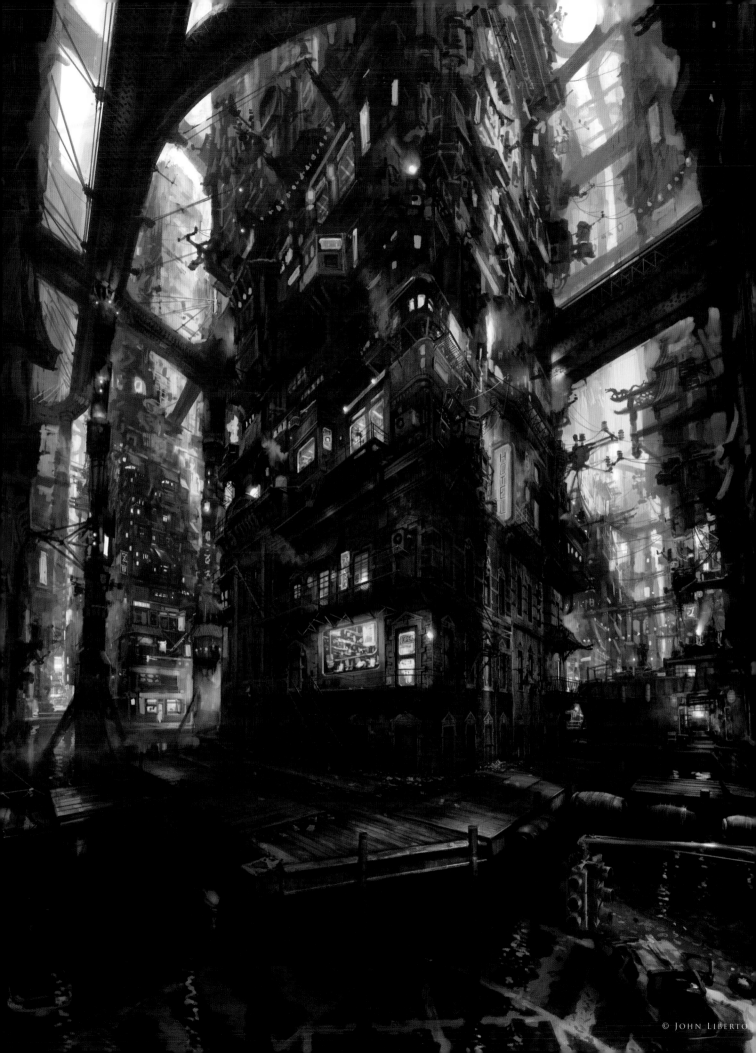

© John Liberto

SCI-FI

Sci-fi is easily my favorite genre because it allows me to paint fantastic worlds and potential futures, whilst at the same time I get to play engineer, architect, designer and even crazy scientist sometimes!

Figuring out the best way to balance function and design while trying to comply to the laws of reality and be believable is a hard task, but once you've mastered this you can start to add your own spice! The possibilities within the genre are endless; gravity-defying speeders cruising around treacherous wormholes or even extraterrestrial robots with beards. The only limitation is the power of your imagination.

JOHN LIBERTO
info@johnliberto.com
http://www.johnliberto.com

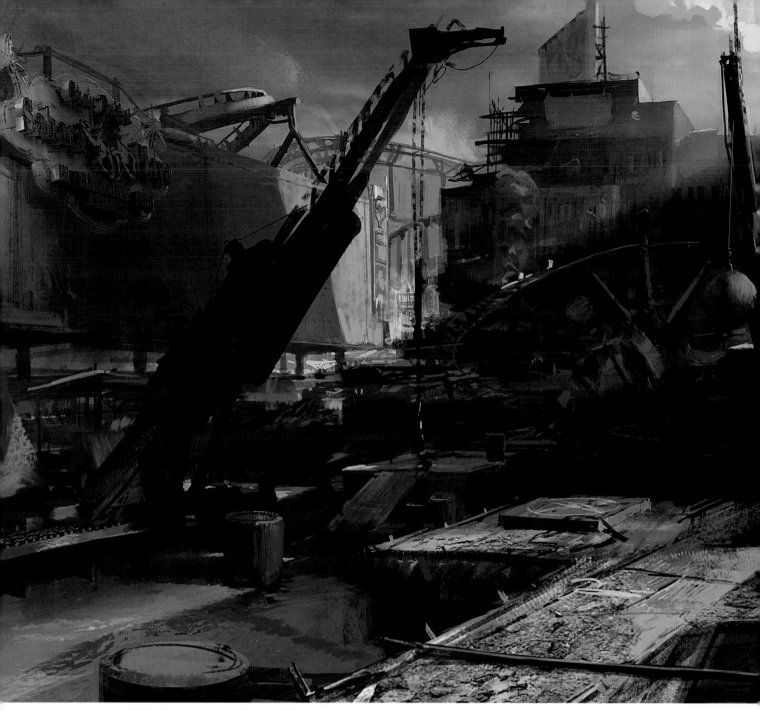

CIRCUS CIRCUS

BY JOHN PARK
SOFTWARE USED: Photoshop

INTRODUCTION

I'm not quite sure how this image came about, but I can tell you that being part of a large art community on the internet always inspires me to create artwork. I guess that's the honest explanation for this particular piece. As a kid growing up, I absolutely loved theme parks and the circus. I love the idea that a theme park feels totally different to the rest of the world and remember always excitedly asking my parents if we were nearly there when we travelled to them.

Part of me still remembers those good old days of going on family trips to theme parks, but what if the theme park wasn't the polished candy cane land that we always perceived it to be? This was the idea behind my painting; to revisit the theme parks that I loved as a child, but after they had suffered years of neglect.

REFERENCES

The visual representation of this piece was inspired from several books I own of abandoned locations. One particular image from this book

stood out from all the rest. It was an image of a merry-go-round ride that was slowly decaying, rusted and brown, as if nature is taking back its rightful place.

The concept of a man-made object being taken over by nature isn't anything new to us, but there is a pure visual appeal of something as magical as a theme park being disassembled by nature. This image had such an impact I couldn't get it out of my head and is why I started this painting.

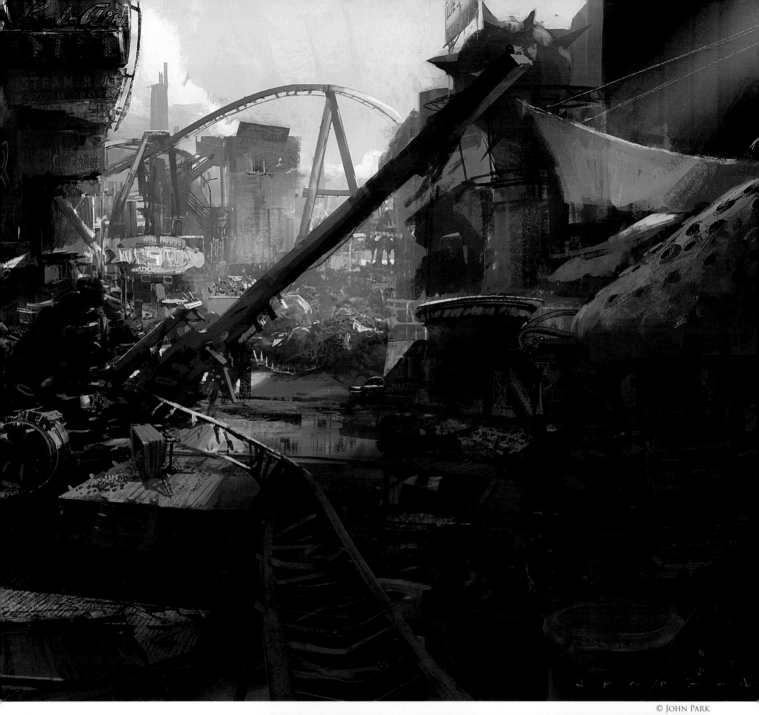

PAINTING

Typically I find composing environments very difficult. I don't think it's the technical aspect, but more the storytelling that is hard to deal with. Trying to fit a few visual elements into an environment is challenging enough, but choosing to do a theme park, where it's just a visual clutter of everything possible, was one hell of a challenge and I wasn't going to back down (**Fig.01**)!

Generally when I start a painting like this, I honestly don't have the faintest idea of how it's going to turn out. I guess that the journeys that scare us are the ones where we don't really knowing where we're going, right? For

this image I started with stabs of color and texture, just to get something going. I then began to establish a sense of space by adding solid structural elements such as buildings and recognizable structures (**Fig.02**). As my mentor always reminded me, make sure your foundation is solid and is clear in all your work (a big shout out to Scott Robertson).

Having done this, I mapped out the perspective, just to check everything was in place, and started to communicate some design elements that could possibly exist in the space. At this point I was really just trying to figure out the design and what looked good and what might tell a decent story (**Fig.03**).

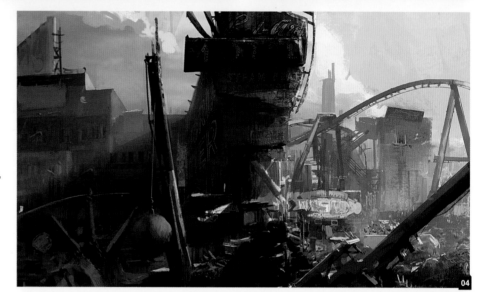

By the time the image was starting to take good shape, it was much easier to see how it would look when finished. Here I began to add more interesting elements and focus on exactly what I wanted in the final composition. It was also an opportune time to refine the lighting in the scene to make sure it was consistent (**Fig.04**).

On a technical note, I generally start an image using a lot of different brushes, but as I refine it I slowly refine the brushes I use and end up using just a few different ones. Occasionally I try to implement some photo textures to help add detail in areas where its lacking. Then I usually go and paint on top of the photograph or adjust it to better fit into the painting, as I did in this image (**Fig.05**).

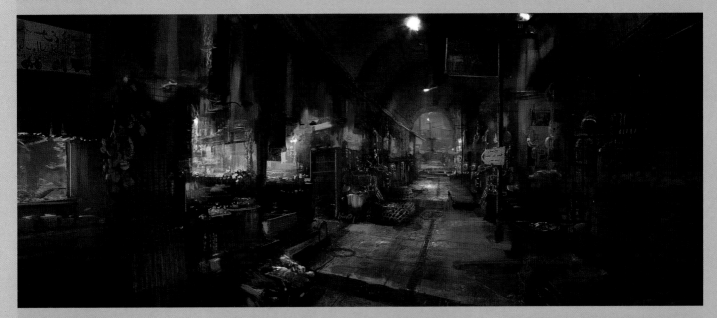

WESTBOUND

BY JUSTIN ALBERS
SOFTWARE USED: Photoshop

INTRODUCTION

I created this piece for an art show my company put on to showcase the personal projects of its employees. I was very excited to participate and happy that something like this could happen! This was the perfect excuse to create imagery that I loved and have it shown to a (hopefully) willing audience.

The post-apocalyptic genre was the inspiration behind this piece. It's my absolute favorite genre to design for. I had this image floating around in my head for a while; a group of survivors who have joined together, who are all decked out in old worn clothing and make-shift gear, who wander the landscape in an old antique robot looking for other survivors and resources. They've stopped at a gas station in the desert somewhere in previously contested territory, to see if there's any fuel left in the pumps that they might use to continue their journey, wherever it ends up taking them.

SKETCHES

There definitely had to be a cool robot somewhere in this piece and I decided to design that first. For this particular design I didn't want it to be a war-like looking mech. Instead it should look like its main purpose is exploration and discovery. I tried to achieve that feeling by combining a submersible design with parts of old 1950s and 1960s cars and trucks. There's a little bit of an old steam locomotive in there too. Also I wanted it to be a little clunky and move like a large dinosaur lumbering across the desert. It should look a little like it is falling apart and the pilot has done the best he can to fix it with whatever parts he manages to scavenge (**Fig.01**).

Next I thought about the characters and what sort of story I was trying to tell here. I knew

© Justin Albers

01

yellow-gold details
sept 23

02

I wanted one character pumping gas, so it made sense that the rest of the crew would be standing watch, surveying the landscape, looking for enemies, checking the radiation levels and trying to figure out what part of the world they've stumbled into. I also wanted to have an eccentric character in a scrappy-looking tech suit decorated with a bunch of random pieces he's scavenged; basically a junk merchant sifting through the wreckage that the crew keeps around because he sometimes finds valuable things.

The next step was to think about the composition. I did several small thumbnails to get started and asked myself, what did I want the main focus to be? Should it be the gas station, robot or the characters? In the end I wanted the characters to lead the viewer's eye into the scene towards the focal point, which would be the robot. In my mind I envisioned

a tiny gas station off to the side with the robot walking around it. Two main characters are cautiously making their way down the road in the middle of the piece, with the gas station sign in the middle. A friend advised me to move the gas station sign over, since it was a vertical element that divided the piece in half (**Fig.02**).

Once the elements were ironed out, I needed to complete a final drawing before I started painting (**Fig.03**). The drawing itself is a little rough and ended up being a strange abomination of a pencil and digital drawing, but I wanted to be sure that all the designs were well thought out so I knew what I was painting.

03

SCI-FI

After checking my perspective and scale references I was ready to move on to color.

PAINTING

It was then time to choose a color palette. I did a few fast studies for color and lighting. Once again, in my mind, I pictured it to be either early morning or dusk to get those really warm oranges and browns in the desert rocks, as well as the nice cool blues in the shadows. I also tried a stormy scene, with dark radiated storm/ash clouds hovering in the distance, but that wasn't quite the look I was going for in this particular piece (**Fig.04 – 06**).

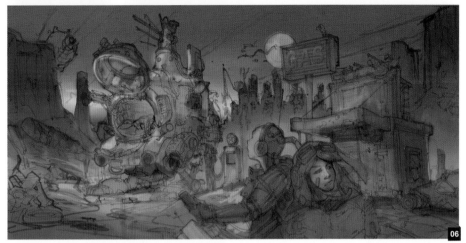

After receiving some fantastic feedback from my co-workers I settled on a scenario where the foreground would be in shadow, the mid-ground would be hit by late evening light and the background would be in shadow with the tops of the mountains illuminated. The front of the mech would be lit, while the side would fade into cool shadow. The characters would be in shadow too since they're in the foreground, creating a focal point around the robot (**Fig.07**).

At this point I was feeling confident about how the piece was progressing so I began to tighten the whole thing up, moving around the piece as a whole and not being caught up for too long in any particular area. I constantly added detail and then faded it back, catching myself ruining my lighting scenario. If I felt like I was losing detail, I went back in on a layer on top, re-drew certain areas and then rendered those out to be sure I wouldn't lose them. I usually stick to just a few brushes when I'm working; one Hard Round, one airbrush and maybe three or four textured brushes (**Fig.08**).

It was suggested to me that by having the characters in the middle of the image they cut the piece in half and made the viewer feel like

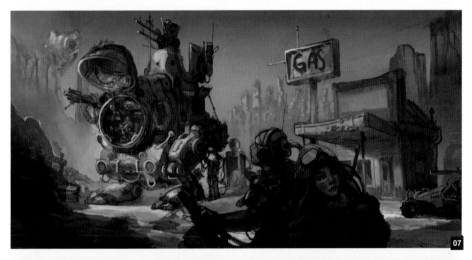

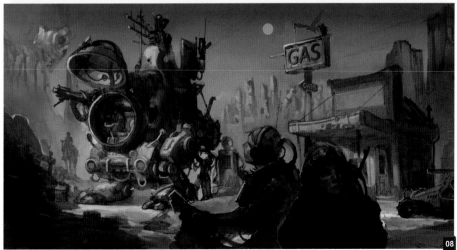

the painting was cropped in a strange way, as though there was something important happening off-screen that wasn't shown. This was something I had been fighting with for a while, so I added some room to my canvas and moved the characters over to the right, framing the scene and leading the viewer's eye into it from that side. Adding to the story and history, I worked in a burned out husk of a battle mech, possibly from a rival faction (**Fig.09**).

I was satisfied with all of the overall shapes and masses, and how everything was organized. Now I just needed to continue to render out the forms and sharpen the edges of the most important elements. I filled in the details of the gas station, indicating some items in the windows and having them boarded up as if there was a last stand/shoot-out there at some point in the past. I also added a cable/hose snaking in from the right side, leading into the scene (**Fig.10**).

I finished rendering the robot, tightened up the foreground elements, detailed the wrecked car and debris on the left side, and completed the rendering on the characters' faces. In addition, I finalized the shapes of the mountains, and tweaked their color and texture. Something was needed to illuminate the main guy's face a bit to set him apart from the dark area around him, so I added some light coming from the radiation meter/Geiger counter he's holding (**Fig.11**).

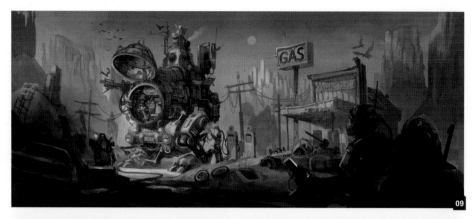

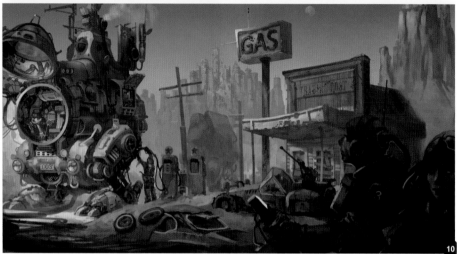

I cleaned up the edges of the robot, the characters and some of the foreground elements, and then added in some atmospheric perspective on the mountains, as well as the destroyed battle mech in the distance, to push those elements back a bit. After doing a few

more slight color adjustments I was feeling content enough to call this one finished (for now). I enjoyed every step of creating this painting and I'm looking forward to seeing how people react to it!

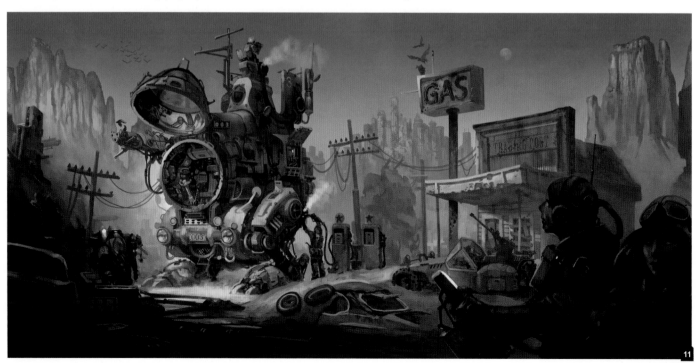

SCI-FI

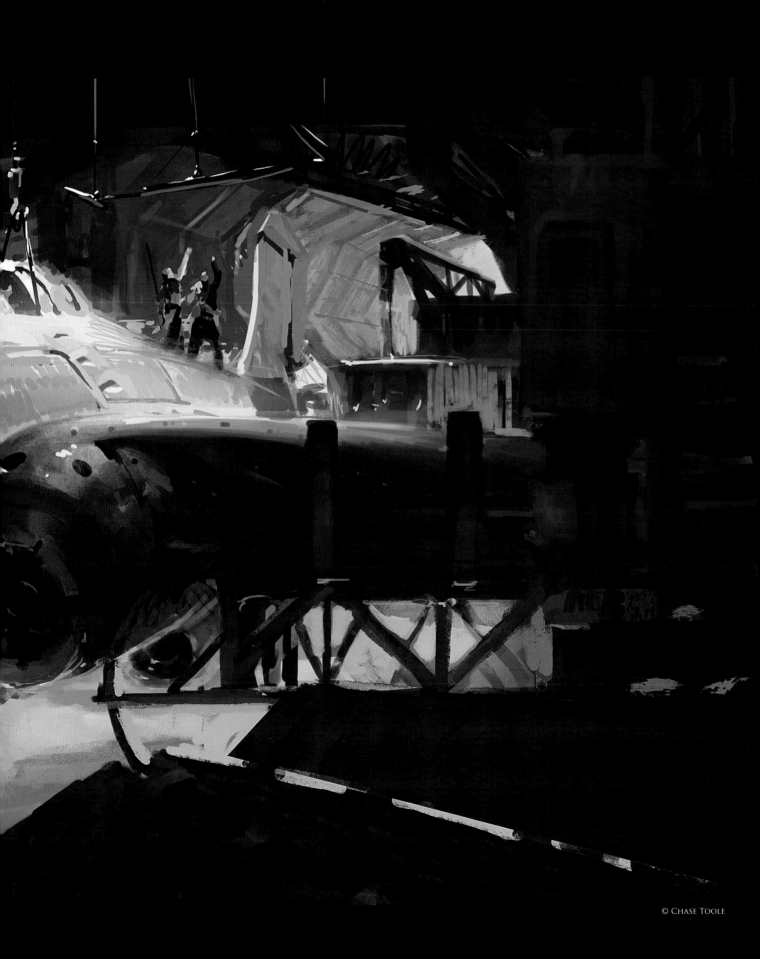

© Chase Toole

DOCK STATION

BY CHASE TOOLE

SOFTWARE USED: Photoshop

INTRODUCTION

Dock Station is a personal development, sci-fi piece. I've always liked the genre, but I feel that I neglect it sometimes. So with that in mind I chose to practice by developing a story with some familiar designs and concepts. Practicing outside your comfort zone can be really tricky because it's not very organic and can feel forced, but as an artist you have to adapt. The trick I've learned is to find the similarities in the work you gravitate towards with the work that doesn't come as easily. After you find that key, practicing across genres becomes really easy and enjoyable.

> « MEDITATING (AKA CHILLING) ALLOWS YOU TO FOCUS ON WHAT IS IMPORTANT AND LETS YOU BLOCK OUT ALL THE EXCESS NOISE »

IDEA

When I begin an image I think about how I am going to tailor my process to the job (do I create line drawings, abstract shapes or find references?). I don't think it's a good idea to have just one way of achieving a goal because that essentially limits the journey. However, one thing that I almost always do is sit back for a few minutes and picture what the overall piece is going to look like. If I can't really see anything right away I might take a coffee break and go sit in my backyard, just recapping what it is that I am trying to achieve. Meditating (aka chilling) allows you to focus on what is important and lets you block out all the excess noise.

I envisioned that the ship was docked over open sky in a floating base where workers could carry out maintenance. I also imagined a warm light radiating from the top of the dock, with a cooler light emanating from underneath. I thought it would be interesting if the station was like a hive that releases waves of fighter planes. That's about it; everything else is in the details and context (**Fig.01**).

I remember seeing some WWII fighters and was impressed by how aggressive and powerful they looked. They don't have the same elegant shapes and proportions of commercial planes or even the newer fighters. They are just an engine with a cockpit. This idea inspired the design (or at least the feeling) for my ship (**Fig.02**). I wanted a bulky, ugly and aggressive

shape, but something that still looked as though it belonged in a battle and not a showroom. I love concepting this way, using memorised experiences together with some knowledge of the subject matter, and combining them to create rich and layered ideas. I mix in references after I have established the basic composition because I don't want the detail of the design clouding my focus (design is very important, but not the point of this exercise, which is why I tailor my process).

> ## " COLOR AND TEMPERATURE ARE GREAT WAYS OF LEADING THE EYE AROUND THE CANVAS AND CREATING DEPTH "

PAINTING

I always like to start in color because I think it's a very powerful tool. I think it should be taken into consideration from the start because thoughtful color choices can really swing the mood in the right or wrong direction. Color also creates interesting challenges that you can address early on. When I started painting this image I rapidly put down some very large, blocky strokes of color with some texture to create the abstraction of what I envisioned

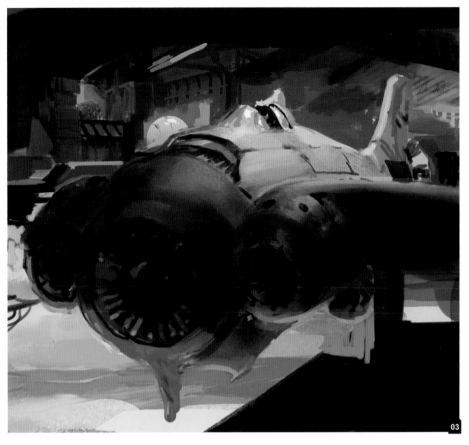

(**Fig.03**). I kept this abstract on a separate layer so I could refer back to it in case I started to get too focused on the details.

Planning out where certain colors are going to be early on is something I find really helpful as

it means I can have some of the under painting show through in the final image (**Fig.04**).

Color temperatures are also something I like to plan out. Color and temperature are great ways of leading the eye around the canvas and

05

creating depth. In this piece I felt it made sense to have the overall painting in a cool light, using warms to pull out certain details and guide the viewer's attention (**Fig.05**).

Generally I try to make the values work in a similar way as I find it's easier to check these compared to color, because I can squint and see the parts that I want to focus on. When

I squint (or blur in Photoshop) at one of my paintings I look to see if the image closely resembles my original idea or some mutation of that idea. If it doesn't I adjust it accordingly (**Fig.06**).

Adding details can get really tricky, because without restraint it can get overwhelming and burn out your eyes. I always try to leave a place

for the eye to rest after areas of noise and detail so that my head doesn't spin. Once again though, this depends on the situation because on some occasions you require chaos and at other times you need simplicity.

When I had achieved the balance I was going for and the detail was in the correct place, the piece was finished.

06

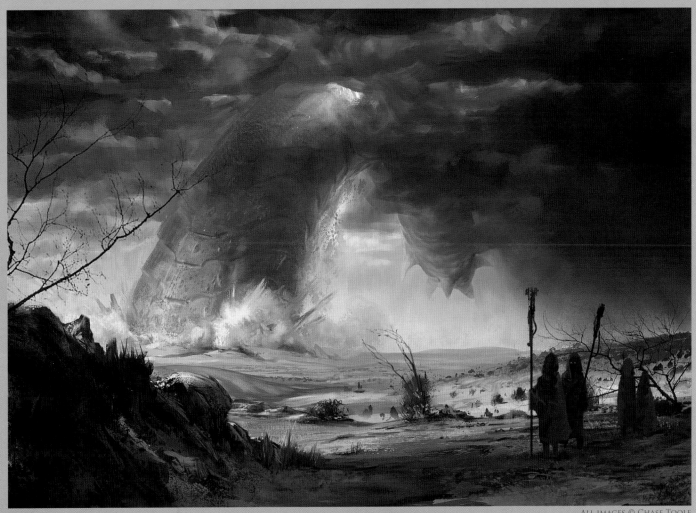

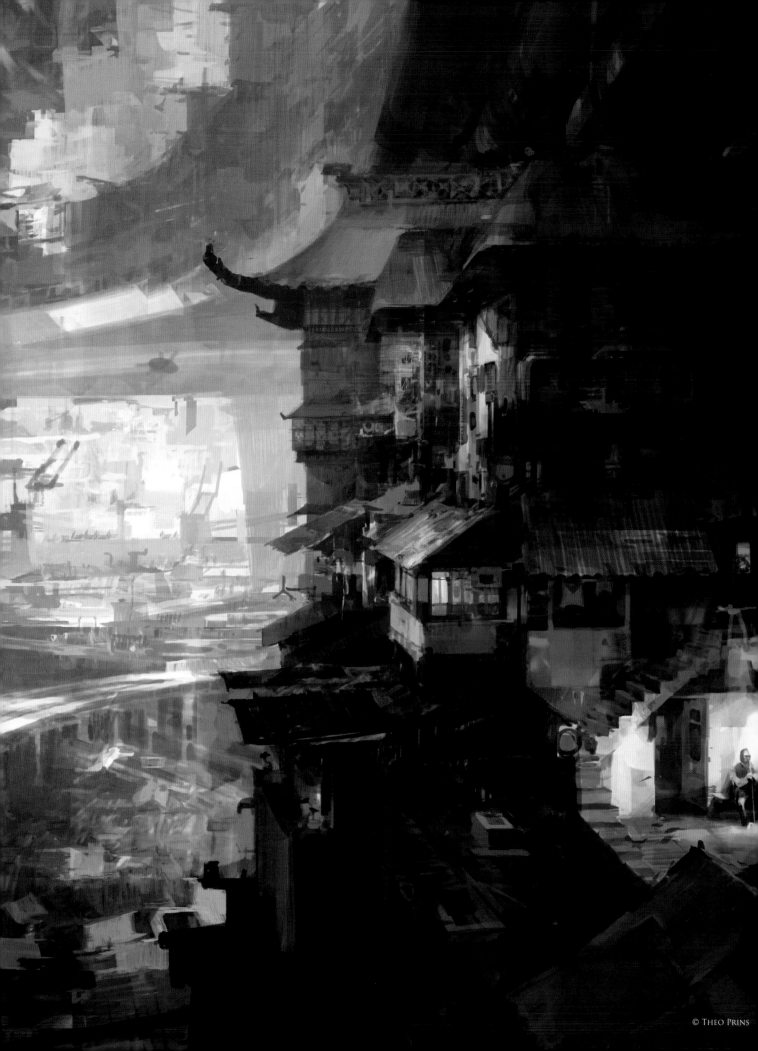

SITTING

By Theo Prins

Software Used: Photoshop

My Painting

When I sit down to work, my hand automatically starts drawing shapes of buildings and cities. It's been an enjoyable habit of mine over the years. Occasionally I view it as a comfort zone, and though that may be true, it's also true that there's always more to explore within the subject matter. I've never managed to be completely successful in portraying exactly what it was I was searching for. Until that happens, I'll probably keep trying. This piece was one of those attempts.

Initially I was working with a fairly ordinary view of a city (**Fig.01 – 03**). After shifting through several moods, from a gray city to a green one and then back again, I arrived at **Fig.04**. In scale it's fairly similar to what we might find in our cities today; skyscrapers with normal proportions, highways and a dense urban sprawl. I liked the textures and color tones, however I was hoping to discover something more otherworldly and extreme in scale. That's when the idea for a new composition came.

> ## BY KEEPING THE PAINTING VAGUE MY MIND'S EYE WAS ABLE TO SEE DETAIL AND COLOR POSSIBILITIES IN THE TEXTURES

I had a sudden urge to strip apart the painting and rearrange the pieces at different angles on a new canvas (**Fig.05**). I see each step in the painting process as the potential foundation for a new idea I may not have imagined by staring at a blank canvas. Even though the result of my initial efforts didn't appeal to me, it led to a new idea and that made it worth painting.

This quick mock-up quickly became the basis for my final image. After a short while I had laid down the basic composition, placing an emphasis on the curve-like flow of the railway tracks below and the highway overpass above (**Fig.06**). By keeping the painting vague my mind's eye was able to see detail and color possibilities in the textures. I then subtly

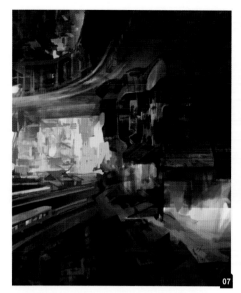

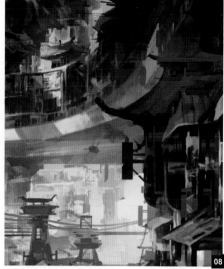

developed these discoveries into the actual painting and kept molding the shapes until solid structures began to appear (**Fig.07**).

The red temple materialized when I began to feel the need for more character and variation in the metal dwellings in the foreground, which had become quite generic. The little man sitting under the light helped create a sense of relative coziness. Perhaps the smell of freshly brewed tea is spilling out of his doorway (**Fig.08 – 09**).

At this point I had also started to become very eager to convert the painting into a stereoscopic 3D pair, which is a whole other story. As a result, I raced to the finish and prematurely detailed the image. My lights and darks became too scattered and messy, and the background became difficult to distinguish from the foreground. After indulging in my stereoscopic version I decided to return to the painting to fix all the bothersome parts. Blurring my eyes to get a sense of the whole picture made it easy to see what was wrong. Whilst painting, I also tend to glance at the navigator every few seconds. This way I'm aware of each brush stroke's impact on the overall image.

I worked on improving the composition by removing clutter and simplifying portions into larger, more harmonious elements. For example, I changed and lightened the entire background. This gave the painting the sense of scale and atmosphere I had been looking for and also more clearly defined the buildings in the foreground (**Fig.10 – 11**). I painted the temple a more solid red, and simplified the

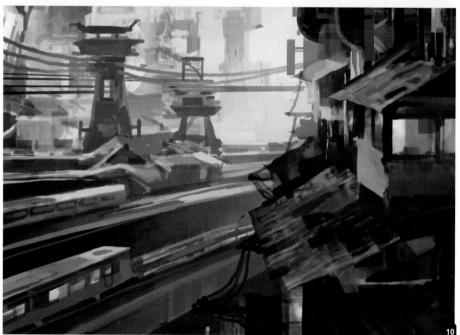

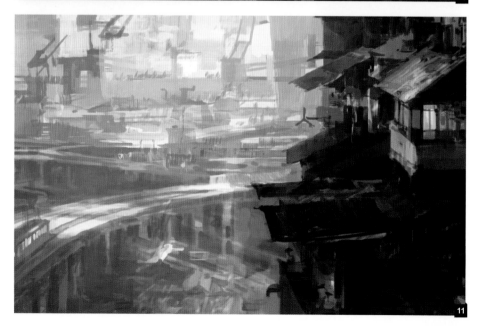

SCI-FI

supports of the overpass as well as the overall silhouette of the structures above it. Again, I had to like what I saw in the navigator (**Fig.12 – 14**).

The final step was to create a feeling of crispness and definition in key areas, including the main illuminated window in the center of

the painting, the edges of certain objects, the buildings, and odd corners here and there. If just the right spots are detailed, it can create the illusion of definition across the rest of the image. For me, the process of finding those spots involves just letting my brush dart around the canvas, adding detail wherever I feel the impulse.

Looking at the painting now, there are still things I'd like to change. One example is the coincidental alignment of the overpass with the large black pipes and the curved roof of the red temple. Sometimes things like this may not grab my attention until I revisit an image several months later. There's always more that could be done, but that's it for now.

ARTIST PORTFOLIO

© THEO PRINS

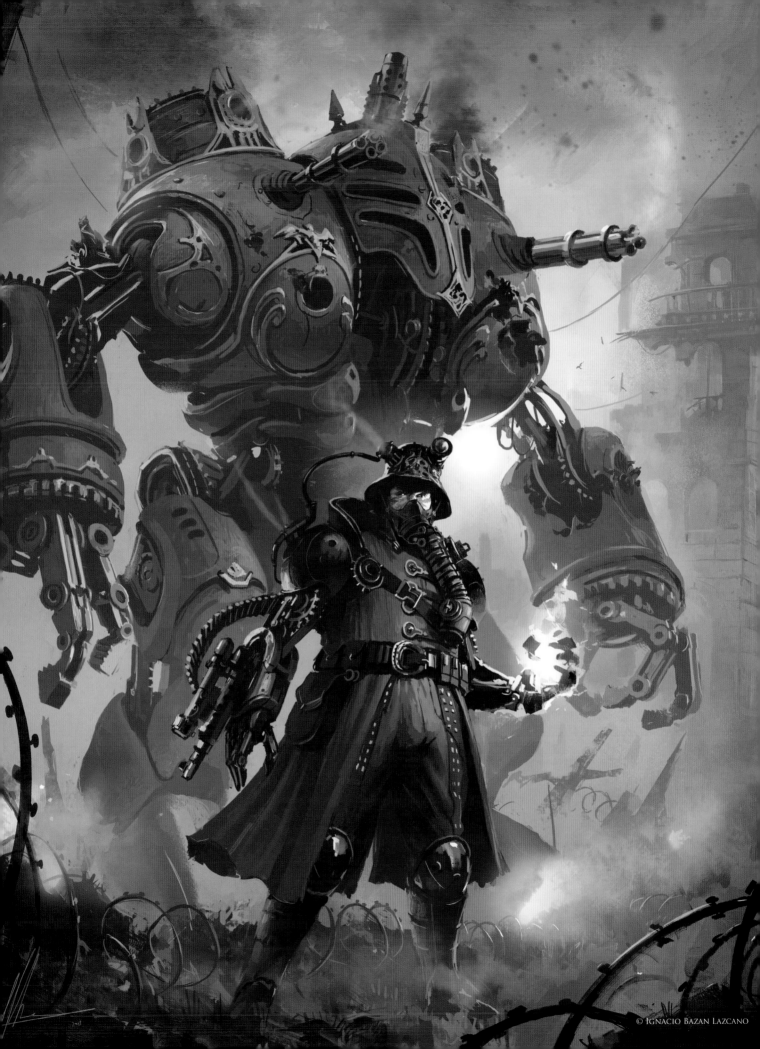

RED STEAM

BY IGNACIO BAZAN LAZCANO

SOFTWARE USED: Photoshop

INTRODUCTION

For over two years I've been working in my free time on a graphic novel. It takes a lot of time and dedication, and sadly I see results slower than I would like to because I only have a few hours a week to do it.

I've always loved drawing historic scenes, characters of the past, ancient weapons and, most of all, rewriting and designing history. My father is a recognized historical researcher and he has managed to convey his love for history to me, which I think has had an impact on my drawings. Of course, he never talked to me about robots or steam war engines; they just came out of my crazy mind and artistic imagination!

I've been amassing ideas for a long time now in the form of drafts and unfinished drawings, most of which are vehicle designs, uniforms and cities. I use these images as an aesthetic guide that helps me make decisions when starting a new drawing.

While I was enjoying one of my few days off I decided to create a new character for my personal collection and specifically for my book.

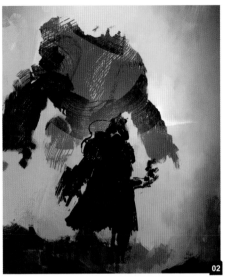

As is often the case, I didn't know in advance what I was going to draw. It is not easy to start from scratch, and often when ideas don't seem to be flowing I turn to pictures and films.

Ideas can come from anywhere and anything can act as a source of inspiration. I am a good observer and I do it all the time, generally getting inspiration from colors. My ideas usually emerge from something abstract, such as the way light appears in a certain situation. I often think that a beautiful illustration can emerge from colorful shapes. When working on the image and searching for inspiration, I came across a couple of photographs containing orange flares that pointed me in the direction I was aiming for.

CREATING A BASE

I started with a color palette and built the foundation of what would become my picture. Just having the color base was enough to prompt me to start thinking about what would be in the scene (**Fig.01**). My idea was to create some sort of cover for a movie or book, something that really struck a chord with everyone who looked at it. I knew that my drawing would have a central character and something in the background.

When I started to assemble the foundation of the painting, I used a photograph that I liked and moved the colors around. I didn't use any

filtering or image distortion, but just created a new canvas and painted it with a mixture of the colors I intended to use.

COMPOSITION AND LINE

The next step was to plan the elements I was going to paint over this color base. Would it be a character in an action pose, a portrait, a landscape? In order to encourage ideas and develop the content I started painting abstract forms until I found something that worked.

For many people this way of working seems very strange and unnatural, but for me to start a painting this way allows me to explore more opportunities.

The next step was to begin defining these forms and the first thing I thought about was a soldier with his war robot. Obviously this phase is not purely random and each stage of development helps me get closer to the idea I'm searching for until I get a definite form. At this point I only had two layers; the first being the background colors, the second containing the figures (**Fig.02**). I then added a new layer and started to add some color and line work to help develop the scene (**Fig.03**).

COLOR

To many people this stage proves very difficult, but luckily for me it is the part of the process that I enjoy the most. At this point I decided to

create the color palette, which requires you to start considering the harmony and balance of the image early in the process. Badly selected colors can change the painting's composition and make it awkward to look at, but obviously it is up to your own personal tastes as to which colors you choose (**Fig.04**). The options are almost unlimited, but for the sake of simplicity I worked with a limited color palette made up of blue, red, orange and green (**Fig.05 – 07**).

> ## EACH ELEMENT OF THE PAINTING (WHETHER IT BE THE TREES, PEOPLE OR BUILDINGS) SHOULD INTEGRATE COLORS FROM THE ENVIRONMENT

Sometimes you will look at a painting and realize that an artist has used grays and greens on an item that is clearly red. It can make you scratch your head and think, how did he make those colors work? If you can add these extra colors to your palette, your colors will become richer. The key is to find the colors that compliment your base color. If done carefully, this mixture of color can even help to convey an object's material (**Fig.08**).

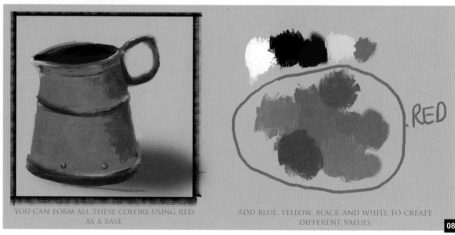

YOU CAN FORM ALL THESE COLORS USING RED AS A BASE

ADD BLUE, YELLOW, BLACK AND WHITE TO CREATE DIFFERENT VALUES

Some artists who are comic fans can be afraid of painting over their line drawings as they don't want to lose the overall shapes. In most cases these lines can be painted over with either light or shade, which also helps achieve a sense of realism (**Fig.09**).

Each element of the painting (whether it be the trees, people or buildings) should integrate

colors from the environment. I usually add the background color into the base that I painted at the beginning. If the robot is red and the background is gray/violet, I will use gray in the red regions to make it look like the character is actually standing in that environment. In general I add the background color to faces that look like they are facing the background. This also helps to demonstrate depth and distance in the

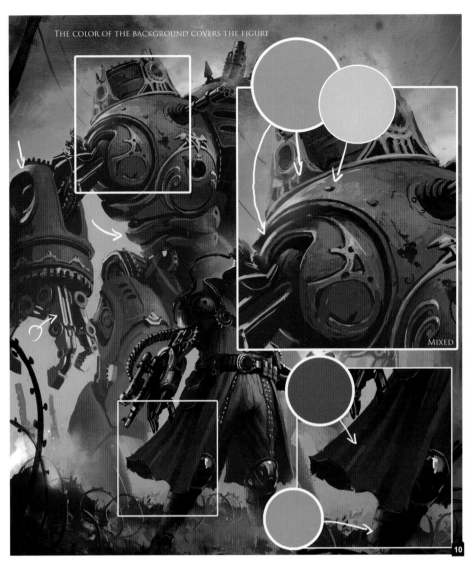

MIXED

10

11

12

image. Quite often you will see a nicely painted background and character that look like they are not part of the same scene or environment. The key is to mix the colors like this to make everything look as if it is part of the same image (**Fig.10**).

DEPTH

To create depth I painted in a fence and repeated it throughout the image from the foreground to the background. Obviously

I ensured that the size of the fence varied according to the perspective. Whenever you duplicate an object several times in different sizes, you tell the observer that there is distance between them. Repeating elements of the same design provides rhythm and is also useful within the composition, helping to make it look less flat (**Fig.11**).

Contrast is another way of creating distance, with lighter colors receding behind darker tones.

I always use black and whites very carefully and you'll not find a pure black or white color in any of my paintings (**Fig.12**).

To separate the robot from the character I used a fog effect, which created some distance between them. An easy way of doing this is to use a mask and then paint white into the selected area. You can then set that layer to Screen or Lighten mode and adjust the opacity (**Fig.13**).

FINAL DETAIL

Once we have the final color palette, and the shape and design of the characters, we can turn to the final detailing stage. To detail this picture I took into account the order of importance so as to draw the viewer's attention to the character more than the robot. The character's chest, side and face are the most detailed areas, followed by robot's left side, other parts of the chest and arm (**Fig.14 – 15**).

BRUSH

13

Special effects (particles, ash, smoke or sparks) will affect color, reflection and shadows. The way that I deal with this is to first define all shapes and add these effects at the end.

One final tip that I would like to offer is in regards to having your image printed. I mentioned at the beginning that I created this as a book cover or poster-like illustration, so I had to consider that it may be printed. When an image is converted from RGB to CMYK, blacks and whites often end up burned and distorted, which can ruin an image. In the case of my image I lightened it to make sure this wasn't going to be as much of a problem when the image is printed. A good way to test this is to simply print out your picture on a printer to see how it comes out (Fig.16).

CONCLUSION

It is good to have your own personal project with which you can free yourself from your daily work. I spend all day working for others, fulfilling other's dreams and while I do enjoy doing it, there is nothing more rewarding than having a small amount of time to work on your own art, and to take advantage of your own ideas. I want to thank 3DTotal for giving me the opportunity to show my work and for providing an outlet for artists to share their work with the community. I hope you like it!

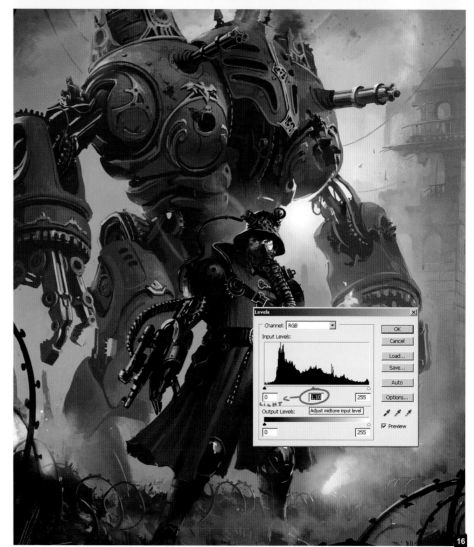

© IGNACIO BAZAN LAZCANO

LAB

By Maciej Kuciara

Software Used: Photoshop

INTRODUCTION

Working in the entertainment industry as a concept artist can be fun, but it can also be quite challenging at times. It's the final quality of those paintings that require you to go outside your comfort zone that will really allow your supervisor to evaluate how good a concept artist you are.

I try to challenge myself with things I haven't tried before as often as possible. Whether it's trying new styles or genres, or simply putting in

place artificial boundaries such as time limits, it doesn't matter as long as it's something that won't make me feel comfortable at all during that time.

The same principles were true for the image I'm writing about in this article. The idea behind the scene I wanted to paint was actually quite simple: a secret, underground government laboratory in which scientists are making final preparations to tests their new, powerful weapon – a giant robot. The challenge I set

myself was to make this idea come to life in the shortest amount of time possible, while preserving a realistic look and quality that made it look as close to a still from a sci-fi film as possible.

COMPOSITION

Having limited time and quite high quality expectations, I had to approach each creative step carefully in order to prevent myself from going back and forth due to unwise decisions. With that in mind I started working on some

© Maciej Kuciara

very quick composition sketches, using only simple suggestive shapes and just three basic values: white, gray and black.

I made quite a number of very quick thumbnails, each taking no more than a couple of minutes. After creating quite few of these I selected the images that you see in **Fig.01 – 03**, which I liked most, and then eventually chose one that I felt looked most like my government lab idea

(see Fig.02). I kept all of these sketches in aspect ratios close to what you would see on a cinema screen.

SKETCH

Once I was happy with the initial compositional sketch, I decided to proceed with a quick grayscale painting to get a more defined idea of what would appear in the scene. At this point I didn't pay too much attention to the accuracy

of straight lines, but rather tried to bring out the basic shapes and suggest the basic lighting. I knew I wanted to use artificial indoor lighting that would bounce from object to object, creating semi-sharp highlights and diffuse bright areas. Because my initial composition sketch already suggested a good balance of values, I knew that I could use dozens of small beam lights everywhere. I didn't have to spend extra time carefully placing highlights and shadows in

order to make the scene readable. The contrast of bright and dark materials in the scene allowed me a lot of freedom.

I decided to put two "bunny-suit" scientists in the front, one on a second plane somewhere in the middle distance, and one last figure in very close proximity to the robot, situated on the construction bridge around the robot's arm (**Fig.04**). The placement of characters helped me to create a good sense of scale in the scene, as well as lay the base for the painting.

Creating the sketch was crucial as it allowed me to check that everything in the scene was well balanced and make sure that I was definitely happy with the results.

Hues

Immediately after I was finished with the sketch I decided to layer the hues. I used three layers set to Color blending mode and then simply used Standard brushes to paint the colors I wanted to see in the final image (**Fig.05**). Because of the way the Color blending mode works, this step was pretty quick but helped to keep the image integrity in the long run. This was also an important step, because it took away the guesswork later on when working on different parts of the painting.

Details

Because the goal was to create a realistic look in the shortest time possible, using photography to suggest more definition in shapes as well as details was inevitable. At this point I started looking through my personal photography, previous artwork and eventually royalty-free stock photography on the web. Then I incorporated the elements that I found and filled in areas that were missing texture with custom brushwork. On several mechanical objects such as the construction bridges, I used a mix of photography and the Line tool to create grid-looking textures. Then with a brush set to Dodge mode, I painted in highlights. To save time I reused some of these elements in other parts of the painting, mirroring them, flipping them and adjusting them to fit.

Having undertaken these steps I didn't have to worry about spending infinite amounts of time on hand-painted detail to capture a realistic look, but instead focused on the big picture.

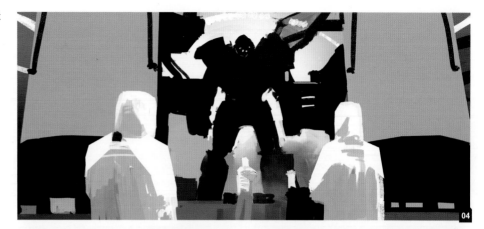

Sci-Fi

Rendering the details was the most time-consuming part for obvious reasons. On the other hand, having undertaken the previous precautions I avoided a lot of headaches that could easily have doubled the time spent on the image (**Fig.06**).

After all the details were done I simply used a soft, white brush to add some extra volumetric light on the robot and two adjustment layers (Levels and Hue/Saturation). Using the latter adjustment I was able to take out some of the unwanted hues by changing the options from Master to specific colors (**Fig.07**).

RESULTS

Not every painting will end with the results you wish for, especially when you have to step out of your comfort zone in order to complete it. Over the last several months I've been testing myself by creating realistic results in a very time-limited environment and needless to say, about half of these attempts have failed. The concepts were not realistic enough, the colors didn't sit well and the lighting was unsatisfactory. It takes time and quite an effort to improve, but it's never a waste when it comes to being more versatile in your work.

ARTIST PORTFOLIO

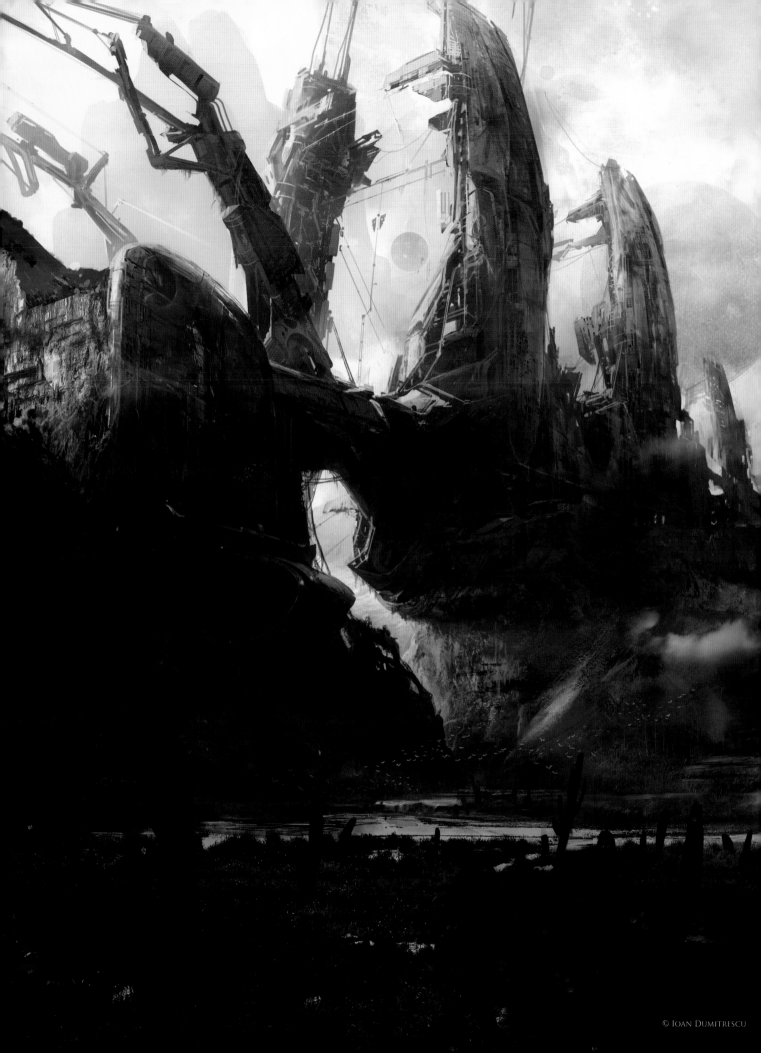

DISCOVERY

BY IOAN DUMITRESCU

SOFTWARE USED: Photoshop

MY PAINTING

Hi, everybody. In this tutorial I will show one of
the ways I build an image from start to finish.
First off all, before laying down any lines, I
started thinking about what I wanted to draw.
Creating a personal image is very different in
comparison to painting for a client. For one you
get to experiment and for the other you have to
achieve reliable results.

I'd had this image in my mind for quite a while
and it had always been an interesting subject
for me to approach and explore. I was thinking
about a huge, derelict, sci-fi construction
that was either alien or human and had been
fighting a losing battle against nature's forces.
Having this as a starting point, I proceeded by
sketching on a zoomed out canvas in order
to focus on the composition and relationships
between the various elements (**Fig.01**).

Try to rid yourself of predetermined ideas or
fears. The only thing you have to worry about
is finding a striking composition. In this case
I had a really clear idea in my head, but I still
wanted to sketch out a few more variants;
maybe they would be of some help or trigger
some extra ideas. I knew that it was important
to suggest the huge scale of the derelict base,
so my solution was to have it occupy the center

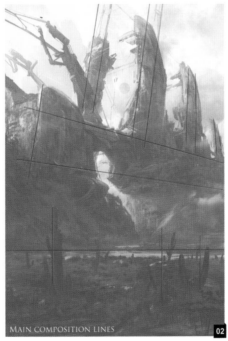

MAIN COMPOSITION LINES

of the image along with a large part of the
composition. The other aspect I liked was that
the perspective went beyond the frame, which
somehow helped increase the scale and keep
the focus on the base (**Fig.02**).

Then it was time for the next phase: painting in
the values. For that I needed to decide on the
lighting and general atmosphere (**Fig.03**).

I decided to place almost everything in shadow
as it would increase the impact of the derelict
building and also help with the story. I chose
to depict the magic hour (first few hours of
sunrise) to achieve this dramatic look, which
meant the light hit the edges of the landscape.
This type of light would also give me interesting

yellows, oranges, purples and greens in the
shadows. It also allowed me to use warm grays,
which created a nice contrast and gave me the
epic feel I was looking for (**Fig.04**).

Now that I had my composition, values, light
and color, I was ready to start focusing on the
design. I started to consider the function of the
base, which helped a great deal. I decided that
it was some sort of telecommunications centre
from which ships were deployed on various
missions. The larger pillars represented some
sort of antenna that helped communications
from a command center on some alien planet.

The first thing I do when I have an idea is
to search for references from either my own

folders or just from Google. To help me to start to think about the shapes and forms, I looked at photos of old plane components. For the landscape I looked at jungle pictures with dense forests and fields (tundra/swamp-like).

I had the idea of merging the natural and the man-made elements more closely by digging into the hill and setting the base of the building into it. I continued to merge them until there was no obvious place where nature ended and technology began (**Fig.05**).

I continued to paint shapes, starting from the largest and moving to the smaller elements. It was quite important to think about the size of the panels to help demonstrate the overall scale. I often bring in photos of forests and scale them down so the trees demonstrate the scale that I am trying to convey, which keeps everything consistent. Now that I had established the general image, I started adding more detail and natural features across the abandoned base.

> " THIS IS THE WHOLE
> TRICK BEHIND
> CONCEPT ART AND
> GOOD IDEAS; TAKING
> ELEMENTS THAT
> YOU FIND IN REAL
> LIFE, AND THAT ARE
> RECOGNIZABLE, AND
> TRANSLATING THEM
> INTO SOMETHING
> WE'VE NEVER SEEN
> BEFORE "

It's interesting to observe real life and see how the process of ageing affects abandoned architecture, military equipment or anything else for that matter. In this case I looked at what happens to metal when it remains in a rainy and humid environment, and how paint starts to wear and chip through the effects of weather and rust. This was taken into consideration for things like the rivets, panels, girders, as well as the main structural elements. I figured that I'd have to divulge some more elements of the story by adding a few signs of disaster, such as holes in the shell of the building and black marks from the smoke of fires long extinguished (**Fig.06**).

Despite all this detail and noise, I made sure the overall shape was still easy to decipher. I kept adding photos in different layer modes, waiting for unexpected surprises or different effects that looked good. From the beginning I had the idea of adding cacti across the bottom plain, which was rewarding for me because having crazy vegetation in places you might not find it on Earth gave the image an otherworldly feel. It also helped to break the horizontals and lead the eye around the image (**Fig.07**).

This is the whole trick behind concept art and good ideas; taking elements that you find in real life, and that are recognizable, and translating

them into something we've never seen before. The two moons and the mountains also helped with this feeling.

The final touches were done to help make the image more epic. I added volumetric light coming from somewhere on the left side of the frame. This type of lighting allowed me to reinforce the edges and highlight the powerful shadowed silhouette (**Fig.08**). To make the viewer think more about the background story, I added huge, cable-like structures rising from the pillars to suggest a connection to another base up in the sky or even outside orbit. Then all that was left was to sign it and call it done!

© IOAN DUMITRESCU

Sector 21

By Rudolf Herczog
Software Used: Cinema 4D

Inspiration

The idea for this scene came to me whilst looking on the internet at photos of old abandoned industrial areas, which are often a source of inspiration for me. I came across an old steel plant and a shot of a huge blast furnace covered with bolts and pipes. I've always loved making scenes that contain loads of detail, so I thought it would be cool to use the furnace as a large, platform-like, hanging structure, and place it into a fairly cramped city environment, blending industrial and futuristic elements. Some parts of the world struggle with very poor air quality, which inspired me to turn the main part of the scene into some sort of air filter. To convey this I added a number of vents to the machine and its surroundings, as well as adding a few characters for the purposes of scale and to inject some life into the environment.

Modeling

With any scene I work extensively from primitive objects and build all the models from smaller parts. I used the same technique here and started out with a torus object as a base, which I covered with extra plating, vents, bolts, etc., as well as pipes made with sweep NURBS (**Fig.01 – 02**).

Covering only the portion of the torus visible to the camera, I then started working on the upper platform. I made a set of railings surrounding the base and added a few ladders, allowing access from the ground. Next I built the body of the structure, which would support the base, and modeled a set of air tanks surrounding it, which were connected with thicker pipes. The idea was that the main volume would form the control center of the structure. I decided to model another smaller service platform halfway up the structure (**Fig.03**).

The next step was to fill the empty part beneath the base. Although the structure was supposed to hang freely, I still wanted it to be connected to the ground. I had left a hole in the ground plane for this, so added a number of thick pipes in the center. I also placed wiring all around

it to suggest it was connected to some sort of machinery beneath. Once that was done I modeled a few billboards and placed them around the structure (**Fig.04**).

Next I wanted to pay closer attention to the surrounding walls. My initial idea was to use huge columns and a more open space, but as the modeling progressed I decided to go for a more enclosed environment instead. I used a number of tube objects for the walls and employed booleans to cut out the doors and fans. I then reworked the large fans used on the base and embedded a few of them into the upper section of the walls. I also covered up the door openings with blinds (**Fig.05**).

I did some more work on the outer walls and then went back to the main structure, adding the beams that would actually support it. During this stage I also set up the camera view, deciding to position it close to the ground to add a little bit of scale and allow the viewer to see the ground, people and most of the structure. I also kept parts of the sky visible for atmospheric purposes.

Once I had attached the support beams to the outer wall I modeled a platform on top of the main structure, a few walkways leading out to the edges and also some additional fans. To fill the scene some more I added some wiring, a few extra billboards and additional detail on both the main structure and the walls (**Fig.06 – 07**).

04

05

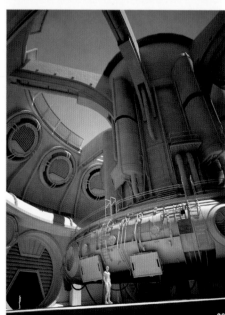

06

SCI-FI

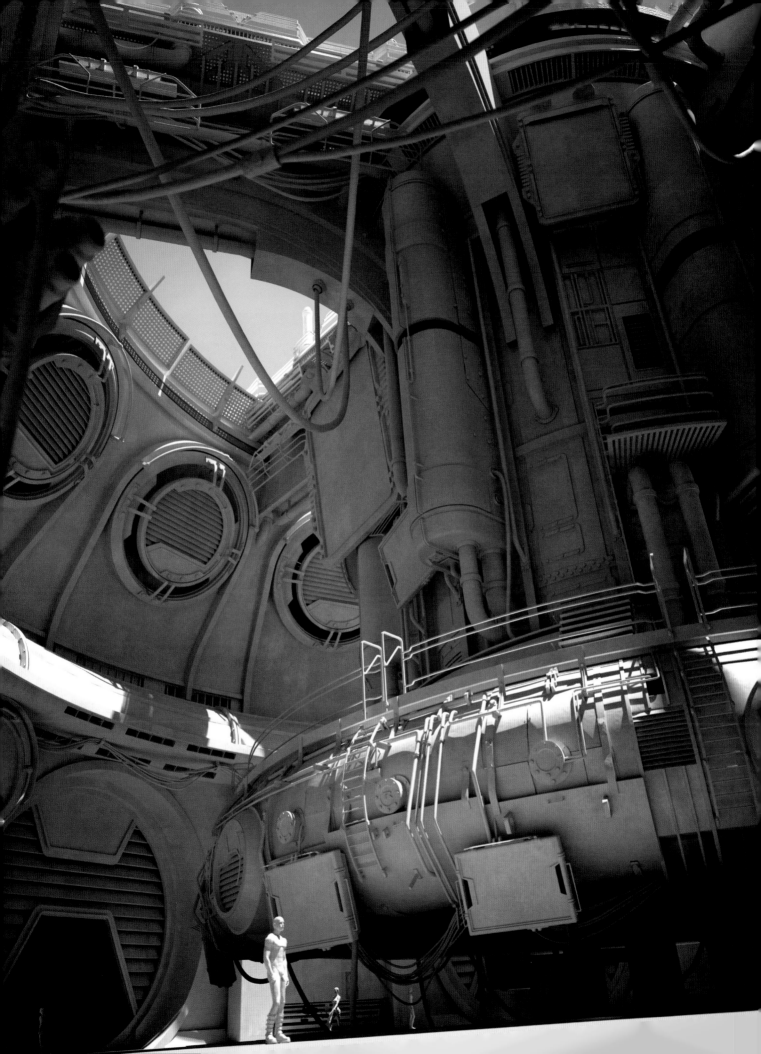

MATERIALS AND LIGHTING

I kept this part very simple and decided to go with a simple, consistent material across the whole scene and do the rest in Photoshop. This is a procedure I've tried before and worked out quite well with one of my previous images called *The Gateway*. I then used a Maxwell Physical Sky and a sunset at midday as the only light source, and let it cook overnight (**Fig.08**).

> " ALTHOUGH I INTENDED THE IMAGE TO BE SLIGHTLY MONOCHROMATIC, I ALSO WANTED TO ADD JUST ENOUGH COLORING IN CERTAIN AREAS TO BREAK UP THE UNIFORMITY "

POST-PRODUCTION

Once in Photoshop I started with some initial color corrections and then applied a few textures to create a little bit more detail, mainly to the base plate. With the help of an alpha mask I also added a sky and clouds in the top part of the image. I then used a copper texture for the areas next to the fans on the outer walls. Although I intended the image to be slightly monochromatic, I also wanted to add just enough coloring in certain areas to break up the uniformity. Once that was done it was time to add some dirt, which incorporated black and white Dirt maps, and apply various layer effects along edges, cracks and expansive clean surfaces, etc. I also made a few imaginary billboard textures (**Fig.09**).

The next step was to add a little warmth to the overall atmosphere courtesy of a few sun rays coming through the opening at the top. For these I used the Line tool to create a few thicker lines, added a fairly large amount of Gaussian Blur and decreased the opacity slightly. I then used layer masks and the Gradient tool to shape the rays. I used the Ellipse tool in a similar way to create a little bit of haze where the rays came through the support beams. To wrap things up I did a few more color and gamma corrections before I baked all the layers and finalized the image.

RVL-28

By Lupascu Ruslan

SOFTWARE USED: 3ds Max and Photoshop

INTRODUCTION

Hi everyone, my name is Lupascu Ruslan and I am from the Republic of Moldova. For me It's a great honor to be featured in *Digital Art Masters: Volume 7* and I am very happy to share my production flow and knowledge (as little as it is), which I hope you will find helpful or, at the very least, not too boring!

The idea for this vehicle design came from a mixture of the *Mass Effect* games, Isaac Asimov, Stanislaw Lem books and, of course, good old movies like *Aliens* and *Star Wars*. All sci-fi imagery is inspired and conjured in our mind by the influences that we see and hear. The trick is converting this inspiration into something good in 3ds Max. I hope that this article gives you a good insight into the creative method used to make this vehicle.

MODELING

I always try to keep the model as simple as possible, usually starting from a very basic shape or primitive, with the aim of obtaining the look I want using simple modifiers like Bend, FFD, Mirror, Extrude, etc. This is why the model looks the way it does during the early stages (**Fig.01**).

I used the same technique throughout the entire process, all the way through to the final model. I must confess I never had a clear idea in my head about how the final image was going to eventually look. For this reason I did a few different concepts, as you can see in **Fig.02**, and after much thought I chose one as the final design.

SHADERS AND TEXTURES

There were no fancy tricks used during this stage either. I just used a simple neutral texture, which was a mix between sand, concrete and metal. I wanted the texture to be quite neutral and so didn't add any oil leaks or dirt, but did include a few scratches here and there. I only unwrapped three parts of the vehicle: the wheels, tires and the front section. Everything else used just a simple texture in conjunction with a UVW map modifier.

LIGHTING AND RENDERING

I tried to cheat at first by exporting the model into Keyshot and making a quick studio render, but the result was unsatisfactory, as you can see in **Fig.03**.

I intended to create an uncomplicated environment and something that would not distract the viewer's attention away from the vehicle. For me, the perfect kind of background is a simple concrete wall and floor. I must confess that this was my third attempt as the first two environments were too heavily detailed and I didn't like them. I like to advise people that if they are not happy with their work they should go back and redo things as many times as necessary until they attain the desired result. If you continue to improve things and adjust them you will eventually achieve the look that you were after.

For the lighting and rendering stage I made everything as easy and simple as possible, using V-Ray with a V-Ray Sun. Almost all the settings were left at their default parameters, including Brute Force and Light Cache. I never worry too much about getting amazing images

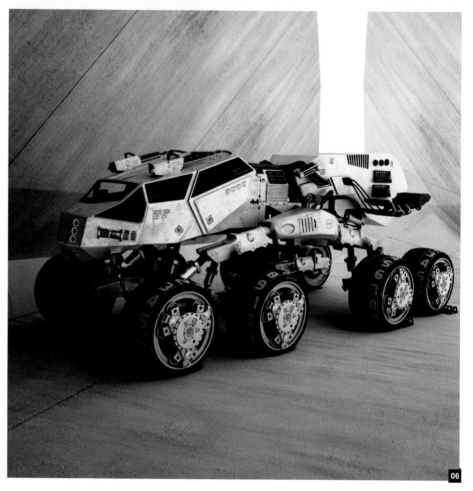

in the Frame Buffer because there is always a lot that can be done in the post-production phase.

POST-PRODUCTION

Usually I adjust very few elements in Photoshop and just play with the levels and sharpness. For this image I used a third party plugin to create the light coming from the headlights. You can see the way I developed the image in Photoshop in **Fig.04 – 07**.

So that is it; neither too hard nor too easy. I hope you like the final result and, of course, if you have any questions feel free to get in touch via email.

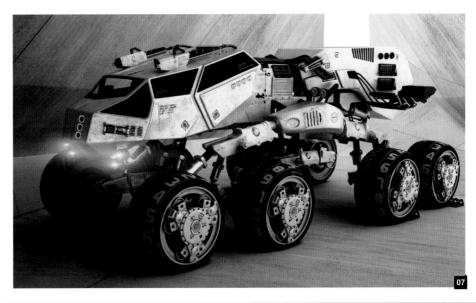

ARTIST PORTFOLIO

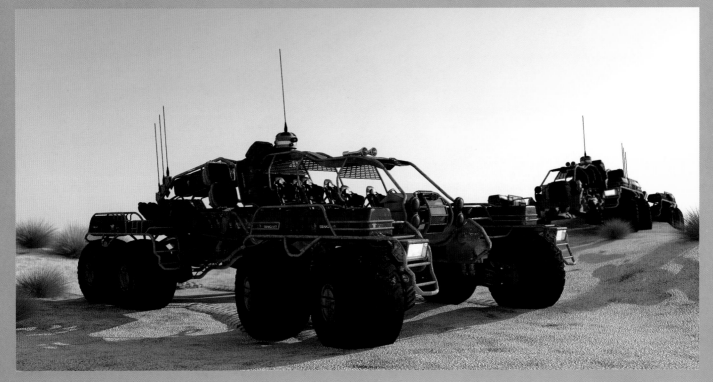

ALL IMAGES © LUPASCU RUSLAN

UBERMESSERSCHMITT

BY TOBIAS TREBELJAHR

SOFTWARE USED: Corel Painter and Photoshop

MY PAINTING

The original plan when starting this image was just to practice exaggerating a classical airplane design and to create a vintage poster with some retro-tag lines. At the time I was feeling kind of guilty for not using the huge sketchbook I was given at Christmas. Because of this I took a break from my usual tiny pencil sketches and started a bigger, more complete drawing.

After a few thumbnails where I tried to nail down a pleasing silhouette and camera angle, I sketched the drawing. The drawing you can see in **Fig.01** is about 20 x 25 inches in size.

The final aircraft design was like a bloated plane where the engine was clearly visible in places, almost like an American hot rod. It was decorated with a savage-looking paint job

01

and equipped with a ridiculously overpowered mini-gun (which would actually block the pilot's view, but it looked good so I left it in). The flying squirrel was just for fun at this point. I changed almost everything about it later, but by the end I liked to think of it as the picture's heart.

Before starting on the final image I usually try out a few different color schemes to see what will work in the composition. I love to use Corel Painter to do this as the colors are incredibly fun to handle (and mess around with). I ended up with a muted, military green and silver for the airplane, contrasting with a bold red backdrop, slicing the workspace in two (**Fig.02**).

The next step was to scan the drawing and put it into Photoshop so I could start rendering. I firstly painted below the sketch with a solid color using the Lasso and Fill tools. In a layer above this I started working in some form and volume, and started painting in some lighting and detail (**Fig.03 – 04**).

I slowly started to notice that the background was looking a bit boring and began to think that there was an opportunity to paint in something awesome going on there. I took a little time to generate some good ideas and to think of a new composition, and then the idea came to me. The re-imagined Messerschmitt should have an interesting backdrop, so I enlarged the canvas on every side and started to block in some new shapes (**Fig.05**).

What was once was a plain red shape now became part of a huge sky vessel. I had to be careful not to add too much detail to the background because together with the saturated colors, it could divert the viewer's attention away from the point of interest. By keeping it simple it had more impact and provided a nice backdrop for the main focal point.

Instead of another flat surface as a backdrop, on the right I opened up a vast cloudscape, which gave my image enormous depth. This distance contrasted nicely with the proximity of the objects on the left. Again, I used Painter to help me choose the colors I wanted to use (**Fig.06 – 07**).

You can do awesome things with Photoshop's Smudge tool, but whenever it comes to doing soft-edged things such as fire or clouds, Painter seems to work better for me.

The bright red ships in the background serve two purposes. For a start, without them the

red space by the main focal point would be confusing and seem strange. The other purpose of the smaller ships is to show depth by way of perspective.

When it came to painting the first of these smaller ships something became quite clear. All of these smaller ships needed to demonstrate the same proportions and design. When something like this comes up in your paintings it is always worth thinking about using 3D. Making a quick ship in 3D was pretty swift (**Fig.08**).

After preparing the painting for the arrival of this new element, I copied the 3D ship several times and positioned the copies in places that seemed to work well with the composition. This process is really helpful because with one click on the Render button you can create an armada of ships with perfect perspective and proportions (**Fig.09**).

I WAS ALMOST DONE AT THIS POINT, BUT THE COMPOSITION STILL SEEMED A LITTLE DULL AND FROZEN

Now my lonesome aircraft was just a small part of a mighty fleet crossing the sky (**Fig.10**).

For the paint job on the red ships I found a nice font that seemed to contrast with the overall war theme. These sorts of contrasts always seem to add some extra fun to an image (**Fig.11**).

I was almost done at this point, but the composition still seemed a little dull and frozen. To add the feeling of movement I added several trails of steam evaporating from the engines. For some of the objects that were moving quickly (propeller, bat's wings, etc.,) I

used some Motion Blur. Not too much though, because these filters can quickly kill the painterly feeling (**Fig.12**).

One thing that can be great for unifying your scene is to let the light bleed into the shadows. To do this, copy and merge the flattened image, and lay it on top of your layer stack. Then apply some Gaussian Blur and set the layer to Lighten. The higher the blur radius and opacity, the stronger the blooming effect will be (**Fig.13**). Be careful not to go crazy though, because if the effect is too strong it can look really bad.

At this point the image was almost finished. After taking a good look at the painting as a whole, I found it kind of sad that there was no sign of human inhabitants. So I made some last minute changes and added a row of windows to the nearest red ship, with some people staring out through the glass (**Fig.14**).

When I got to this point I was happy that the image was finished. I decided to totally change the content during the process and turn it into more of a scene. If you are tempted to do this with one of your practice images then do so with care, as it can prove risky with the overall focus being lost. I decided to take this step however and it worked out well, and was totally worth it!

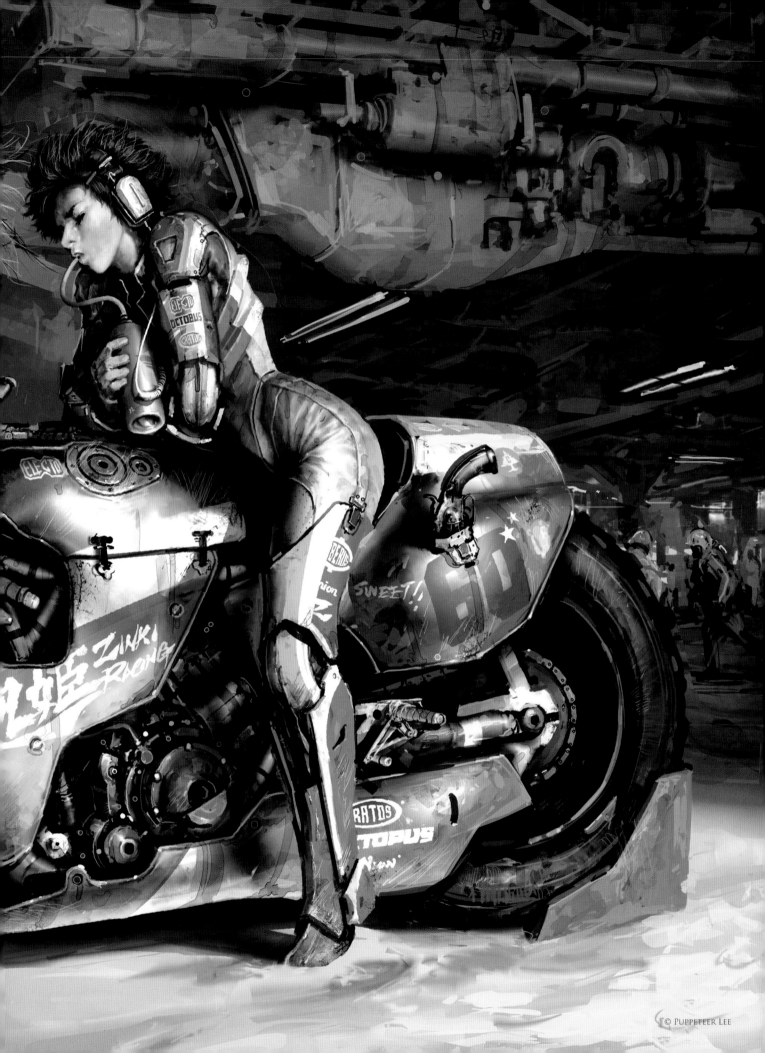

BATTLE READY

BY PUPPETEER LEE

SOFTWARE USED: Painter and Photoshop

INTRODUCTION

I like to create realistic paintings where you take something recognizable from the real world and give it a futuristic twist. Usually I like to paint some sort of made-up event that I have created in my imagination. That event could involve a totally different culture, with different values and ethics, in a different environment and an alternate world.

I am never really sure if my work counts as concept art or illustration. I usually paint illustrations as they are my own ideas on the canvas, but I guess they are also concepts for new and original environments and worlds. I like to portray machines, in particular motorbikes. The reason I love to draw things like this is because my hobby is to spend time with bikes, which in turn makes them more fun to paint.

> " I HAVEN'T GRADUATED FROM ANY FORMAL COURSES; MY TEACHERS HAVE BEEN THE ARTISTS WHOSE WORK HAS INSPIRED ME OVER THE YEARS "

I like to create my personal images without using references and believe that the imagination is capable of creating cool, fresh things we haven't seen before without the use of outside influences. Usually the entire image is pretty firmly in my mind before I start to paint, however even with this vision it can be hard to design some of the structures and details.

I haven't graduated from any formal courses; my teachers have been the artists whose work has inspired me over the years. I guess I should thank the internet for making it so easy to see these artists' work and learn from their processes. However, I do sometimes regret the fact that I didn't take the opportunities that I may have had to further my art skills.

PAINTING

Most of my illustrations are driven by a main focal character, as I feel that it adds to the story if there is someone in the scene you can make presumptions about.

The idea behind this image was that it depicted a scene where a mechanic and driver were preparing for a desert race. In the final image you will see that the bike is covered with weapons and that the driver's suit is for her protection. This is a big hint at the type of race that these drivers are about to participate in; they don't just have to race, they also have to survive.

As touched upon earlier, I had already imagined this image and it had been spinning around in my head for a while before I finally found time to start working on it. I tried to ensure I

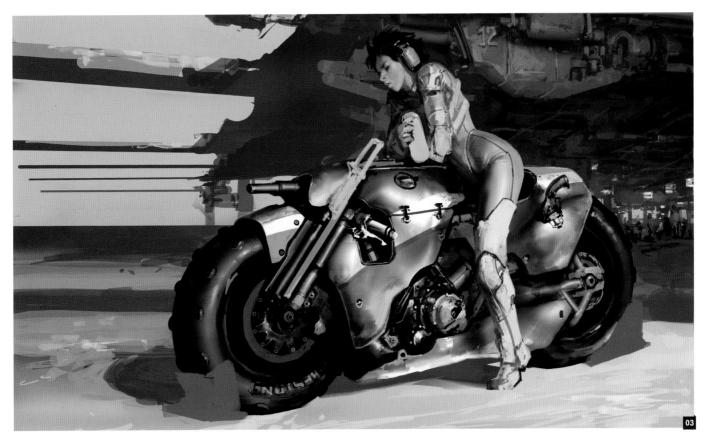

03

included every good idea before I forgot about it. In **Fig.01** you can see that the buildings in the background were done pretty early on in the process. I always find that if you have a good idea of what you want to paint you can work quite quickly. It took me about one hour to get to the point you see here.

> ## MY AIM WAS TO MAKE HER LOOK COOL, EXPERIENCED AND MATURE IN A SEXY WAY!

I then created a new layer to separate the bike from the background. I honestly find it quite hard to choose colors for things like the bike, but in this case I settled on a sharp blue and yellow, which I thought looked quite sporty. I thought it was good to leave some steel colors in there too, to make it look more mechanical. The bike was designed to be huge and heavy, but also look agile and capable of coping with desert conditions (**Fig.02**).

It was then time to start working on the rider. I decided to give her a gray colored suit to match the metallic parts of the bike, which I already knew would work well with the yellow and

blue. I wanted the character to look brave and confident. In the image she is listening to music, having a drink and relaxing, which shows how confident she must be as she's about to go into a deadly race (**Fig.03**).

On another separate layer I painted the mechanic. Again I started with a gray tone for her costume, which I blocked in before adding details. My aim was to make her look cool, experienced and mature in a sexy way (**Fig.04**)!

04

Because the main focal points of the image were now in place I could start to think about the rival vehicles and the team of mechanics that they would have with them. At this point I started to work on the background without adding too much detail (**Fig.05**).

Sponsor's logos are always really important on race vehicles. They can really add to the overall sporty look and add dynamic color variations to your image. They also help to tell a little story and provide a little more information about the world these characters inhabit. For example, the ELECTO logo looks like it could come from some sort of electric energy company; maybe the world is out of petrol and this company have a lot of control. The other logo is for Cerberus and their logo's are on the weapons. You don't really see weapon advertising at the moment, which might imply that this world's attitude towards arms is very different from our current one (**Fig.06**). I always find it hard to create logos, but I think they are really important in this image.

Finishing the Image

During these final stages I did a little more painting to make some of the surfaces look smooth, but not too much. My more recent work looks a bit rough compared to my old stuff, but I think this is because I am always trying to balance the fact that it is a personal illustration in a concept style.

I used a Watercolor tool to add some rust and dirt to the steel to make it look more natural (**Fig.07 – 08**).

After I had painted all the details I took the image from Painter into Photoshop and adjusted the brightness and colors. This was the only point at which I utilized Photoshop as I

generally use Painter exclusively, however I do find that Photoshop is better for these types of adjustments.

This image was made up of three main layers: the character layer, which is always the sharpest; the middle layer with the buildings,

background characters and vehicles; and the final layer composing the sky.

I recall noticing the perspective was wrong on the bike once I thought the image was complete, and you can see how I adjusted this if you compare Fig.04 with the final image.

CARTOON

Tickling without touching is an art of its own. Humor is a very powerful vehicle that can draw our attention to a crude reality, as well as send us on a journey through the artist's wild imagination.

Humor and cartoons are almost inseparable. I see the cartoon artist as a clown. Not the type of clown that shouts at someone with an intention to offend, but the circus artist that brings joy to the audience; a clown that uses wild proportions, lively colors and aims to make you smile and be surprised. That smile should be sparked by a different view of the world.

Original views of the world are what you will find when flipping through the following pages and looking at these master cartoon artists.

JOSE ALVES DA SILVA

jose.zeoyn@gmail.com
http://www.artofjose.com

BILLY THE KID

By Loïc e338 Zimmermann
Software Used: Photoshop

INTRODUCTION

If *Billy the Kid,* by Sam Peckinpah, is now considered to be a classic of the genre, in my opinion it has very little to do with the original script! It was totally surreal and based on some strange historical events. If Pat Garrett shot and killed Billy the Kid, how come he was found dead with his brain missing and traces of deep bites and scratches all over his body? And why was the floor covered in mashed-potatoes? To me this information seemed obscure or incomplete, and as I like my images to be grounded in robust fact I decided to depict what seems to be the most rational explanation as to what happened to Billy the Kid. He was ambushed by a horde of zombie potatoes!

At the same time as I was thinking about Billy's story I was reading a book about composition and storytelling, devouring page after page. In my "to-do list" for 2011 there was "characters in action" written down. Yeah, I like portraits and I have done quite a few of them, but often my subjects are standing still so I wanted to see if I could try out painting some action and dynamic chaos! These were the things I wanted to translate into this specific illustration.

> ❝ SOME MIGHT ARGUE THAT THE CHARACTER LOOKS A LITTLE TOO COOL FOR THE DESPERATE SITUATION HE IS IN, BUT I THOUGHT IT HELPED ESTABLISH A STRONG CONTRAST WITH THE RAGE (FAIRLY TYPICAL) OF THE POTATOES ❞

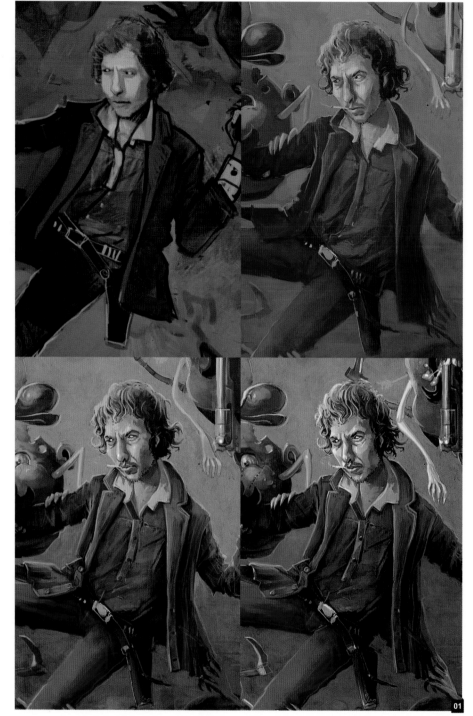

DESIGN

Bob Dylan created the soundtrack for the aforementioned movie and also had a little part in it. I thought it could be cool to use him as a reference for Billy. Also Bob's real surname is the same as mine! Some might argue that the character looks a little too cool for the desperate situation he is in, but I thought it helped establish a strong contrast with the rage (fairly typical) of the potatoes. The outfit is simple (as it is for most of my characters). I don't like to overdo the clothing; the more casual the better as far as I'm concerned (**Fig.01**).

THE POTATOES!

In terms of the simple design, I came up with the idea of using potatoes as the evil opponents after thinking about some of the groups that Hollywood have forced together to keep us all entertained in the past. Cowboy Vs Potatoes, sounds like a hit!

Since the idea was to have a bunch of characters in the frame, it made sense to keep

things simple. I chose to use the same design for all of the potatoes, with only minor variations here and there. This way, they appear as a group and as a single fighting entity! As far as design goes they're pretty much the opposite of Billy, which is a good way to establish who's who (**Fig.02**).

COMPOSITION

Look at the image – what do we have? There is basically a diagonal line that cuts the screen in half.

That diagonal line is actually going down, which is funny because so is our hero. The density is higher on the left where the enemies are standing and it gradually decreases as it gets nearer the hero. There is also an indication that other characters are coming in from the other side and from the distance too, which leads us to believe that Billy's completely surrounded and in real trouble (**Fig.03**)!

Establishing the foreground via an extreme close-up on one of the zombies adds depth to the scene, while giving the audience a little more information regarding the creepy nature of those guys. It took me a while to find a good balance with this guy actually. He's the only one that seems to see us, which makes you ask the question, "Are we intruding or are we part of the horde?" (**Fig.04**).

To contrast with the overall round shape of the zombies, I made their arms very thin, bright and sharp. They look menacing and are all pointing at the character, if not grabbing him already,

which creates tension. Again, I was trying to establish a relationship between Billy and his opponents by having the audience look back and forth between them (**Fig.05**).

HUES

Still using the composition diagonal, I darkened the left side of the screen while keeping the right side brighter (**Fig.06**). The zombies have dark outfits (pants, boots and hats) and red noses. Sticking to this principle makes it easier to read the image and identify the protagonists, even the ones lost in depth. The color red acts as something to grab your attention and since the only other major element in the image that contains that color is the hero's pants, it establishes an additional connection between Billy and the zombies.

ONE SHOULD ALWAYS TAKE A LOT OF CARE WHEN CHOOSING COFFEE

CUSTOM TOOLS, CUSTOM WHAT?

Earlier this year I swore to a friend that I'd never talk about custom tools and brushes again. For this image I used very basic tools as well as some of the classic Ditlev brushes to develop the painting (**Fig.07**). Another important thing to consider when working on this kind of project is to have a good chair, and one should always take a lot of care when choosing coffee!

CONCLUSION

The process of sketching the idea through to detailing the final illustration was really fun. The response I had to the image was a reward in itself! Whilst working I ask myself these questions to help me understand what I'm painting and why: What's happening? Does it read well? Do I need this? Should I keep that? Would it be better with this, or without that?

I didn't only want the audience to smile when looking at this image, but I also wanted people to come back and feel compelled to check what's going on and look more carefully, revealing details and the story in the image. To achieve this you need to establish priorities in the things you want to say with your work, otherwise you may end up with something impossible to read and too confusing to attract anyone.

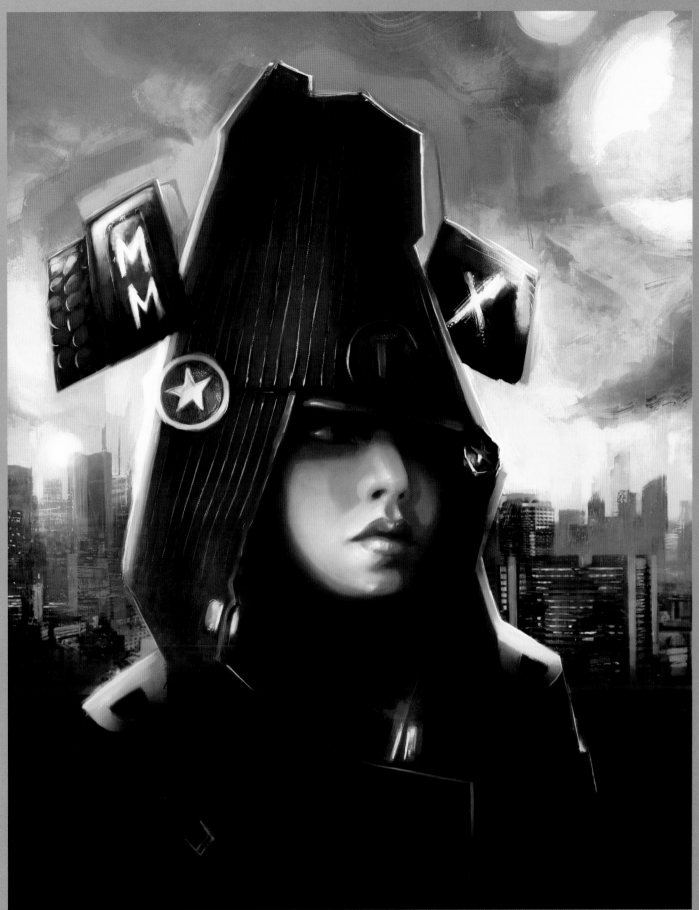

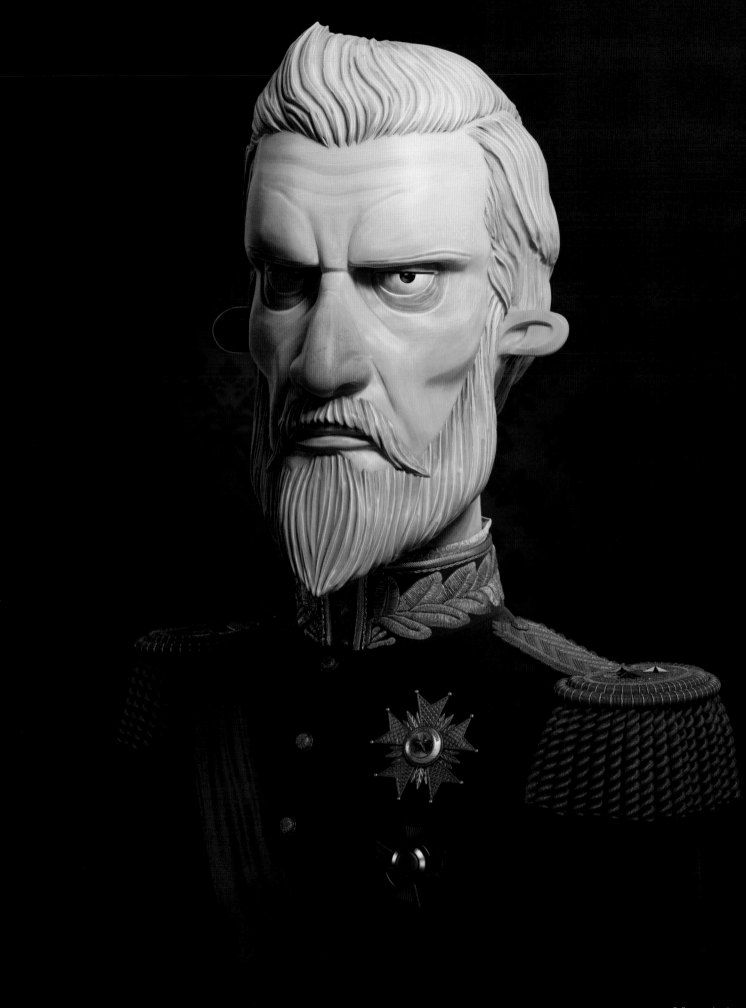

GENERAL

By Bruno Jiménez
Software Used: ZBrush and 3ds Max

Introduction

The original idea for this image came to me while looking for a name for my online portfolio, Brunopia. I wanted to create an imaginary land with its own history and characters, so I came up with a general as one of them.

Concept and References

Fig.01 shows the original concept for this image. It was drawn while watching TV late at night a long time ago and I completely forgot about it. A year later while I was looking for a cartoon character to create and add to my portfolio, I decided to take a look at my sketchbook and pick an image. Personally I prefer to draw my ideas and then look for references to avoid getting too influenced. The final step before I started modeling was to gather some images of classic portrait paintings and images of generals.

> " I ALWAYS START A CHARACTER BY MODELING THE HEAD AS IT IS USUALLY THE FUNNIEST PART OF THE IMAGE. ALSO, IF THE FACE AND EXPRESSIONS ARE GOOD IT IS EASIER FOR ME TO STAY MOTIVATED "

Modeling

I always start a character by modeling the head as it is usually the funniest part of the image.

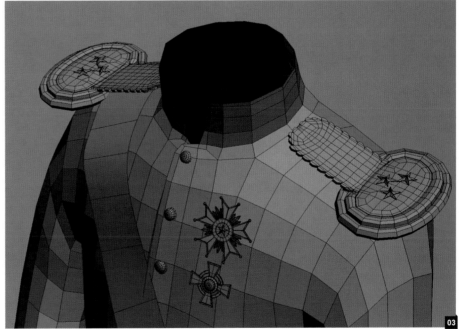

Also, if the face and expressions are good it is easier for me to stay motivated to complete the project. I used ZBrush from the start to nail the personality as quickly as possible. When I'm creating a still I don't worry about topology, so I usually begin modeling from ZSpheres and then subdivide the model to add the detail (**Fig.02**). I always start by using the Clay Tubes brush to build the main forms, which I then define using the Hpolish and Dam Standard brushes.

For his costume and accessories I decided to use 3ds Max. After creating some pretty basic volumes and clean UVs, I went into ZBrush to start adding detail (**Fig.03**).

The most difficult part of the project was the shoulders. For this I had to create multiple alpha brushes within ZBrush (**Fig.04**). After a few minutes of trying to sculpt all the details directly into the mesh with my custom alphas,

I realized that it was way too hard to get the result I was looking for and so decided to build my Displacement map piece by piece in Photoshop (**Fig.05**). For the tassels I just drew a spline and used an Edit Poly modifier to add some subdivisions. I then used a Twist modifier and finally a Push modifier. After putting every strip in place I used an FFD modifier to make each tassel look different. For all the other complex golden objects I used the same method as I described previously (**Fig.06**).

> # I WANTED THE LIGHTING TO ACCENTUATE THE CHARACTER'S SEVERE AND HARSH APPEARANCE

TEXTURING AND SHADING

Since I just wanted a still image, I didn't waste time organizing the topology of the head and hair. After deleting my three lower subdivision levels, I created the UVs using the incredible UV Master in ZBrush. Then I decimated the meshes to export them into 3ds Max with a Cavity map for each mesh.

I was aiming for a handmade and stylized look for the face and hair, and in this instance used the Barontieri set of brushes. I tried to keep it fast and loose, making strokes and spots visible in the final texture (**Fig.07**). I then used an SSS2 V-Ray shader with the brown skin preset.

I wanted to create a contrast between the face and all the accessories, so I decided to texture and shade them in a more realistic way. For the jacket I used a VrayMtl shader with a wide falloff

in the diffuse slot. I then placed my Diffuse map in each falloff slot. Using color correction in Photoshop I created a desaturated and brighter version of the Diffuse map, which I then put in the second slot. I customized the falloff curve to give the jacket a very soft look (**Fig.08**).

For the accessories I made some quick textures with color, brightness and contrast variations to create a more interesting look (**Fig.09**).

LIGHTING AND RENDERING

I wanted the lighting of the scene to accentuate

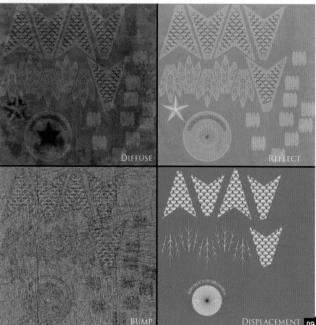

the character's severe and harsh appearance, so I opted for something resembling candlelight rather than strong, harsh studio lighting. To create this I used a small light source with high directional values and gave it a slightly orange tint. I used a common three-point lighting set up for the character and then added one extra light for the background (**Fig.10**).

An HDRI map was added directly to the environment slot in the shaders to achieve the reflections. It's funny to think that I spent a lot of time doing the lighting, when it's actually very simple. Whilst setting up the lighting I was inspired by some of Rembrandt's portraits.

POST-PRODUCTION

I always save most of the render passes and then select those that I consider useful. For this project I used a shadow, specular, reflection, AO, falloff, Z-Depth and wire color pass to allow more control. The reflection, specular and AO passes were mainly used for metallic objects. After adjusting the Levels and making some color corrections I added some volumetric lighting, vignetting and a bit of blur courtesy of the Z-Depth pass and Lens Blur filter in Photoshop. And with that, the image was finished.

CONCLUSION

This piece was an exercise and a way to find my own style. After receiving lots of nice comments from the CG community in different forums, I feel very encouraged to continue creating my own designs and ideas. I dedicate this image to all of the artists that have inspired me since I started learning CG, especially Marek Denko and Krishnamurti M. Costa (aka Antropus).

ARTIST PORTFOLIO

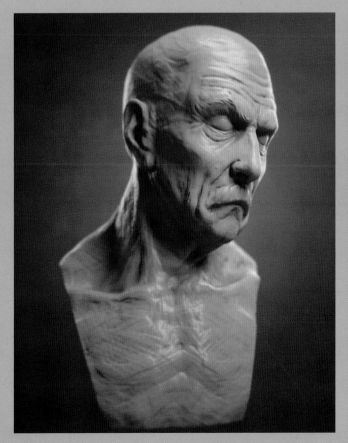

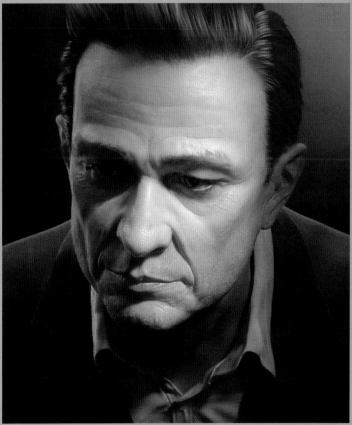

Hippie Happy Land

By David Smit

Software Used: Photoshop

Introduction

Sometimes when I'm working on an illustration, it just flows. It just appears on the screen or on paper and it's no struggle at all. This illustration was not one of those!

The Idea

The idea for this illustration was born from a sketch I did of a hippie girl (**Fig.01**). I felt that this sketch portrayed, in some way, my vision of how hippies in space should look; elongated bodies, interesting fashion and cute, non-aggressive expressions. Now all I needed was an illustration to show this off, and to allow me to experiment with adding colors to try and bring across a happy hippie feeling.

> " IF I FAIL AT THIS POINT OR, EVEN WORSE, SKIP IT, I'M MOST LIKELY DOOMED TO MAKING REVISIONS FOR ETERNITY "

The Sketch

The sketching phase to me is all about the position of shapes and trying to visualize what I actually want within the image. Having an idea is great, but it quite often turns out to be either useless or less defined than I thought it was. This stage is to make sure I can actually define it and show that it works. With this image, when I started I already had a camera angle in mind to show off the tall girl. All that I needed to do now was clarify the fuzziness of my imagination.

To avoid being too confused by the overwhelming hard brush strokes, I started out with a soft brush and restricted myself to only painting in grayscale to try and figure out the basic composition. I played around a bit with some of the elements in the painting to make it read well. I often start like this and it can be quite a struggle, but once I find a solid solution it serves as a strong and solid base for the rest of the painting (usually). If I fail at this point or, even worse, skip it, I'm most likely doomed to make revisions for eternity!

01

In this case, however, I achieved my goal and so the next step was to add color to the gray pool of chaos. Usually I go for a layer with Color as the blending mode, although sometimes I risk a Gradient map. Whatever I choose I usually play around quite a bit until I see what might work and then I refine the image from there. For this one I used the good old Color blending mode to put down the basic colors. These two layers are not designed to make the image pretty; they're just a way of figuring out what I want and clarifying the chaos (**Fig.02**).

PAINTING

Now I had a fluffy, ugly and muddy image that was the base of my painting. One of the first things that needed to be done at this point was to get rid of the muddy fluffiness of the Soft brush. Soft brushes are great if you don't worry about edges, etc., but they've a tendency to make everything look soft and this means a lot of the edges look lost and undefined, which is something that needs to be changed.

I created a brush with a very hard, rough texture that left almost no room for softness and then I started to use it on the image. This was really enjoyable and I simply went over everything with the new brush, using the colors I had laid out in the sketch phase. I didn't try to preserve anything, since everything in the sketch phase was Orc-dung in terms of quality! It was only there to guide the way (**Fig.03**).

STRUGGLING WITH THE GIRL

Now you might think that having done a sketch before starting the actual painting would pretty much be a home-run to the amazing world of internet fame! Unfortunately this is not the case. Sometimes I get lazy during the sketch phase and skip ahead. Sometimes I'm not lazy, but it turns out something wasn't as defined as it could have been. Sometimes things get lost or changed in the over-painting process.

With this image, it might have been all of the above, but things didn't go well once I started tackling the girl. I had quite a clear image of what I wanted with her and with a clear image I mean an actual drawing. But unfortunately that's not a painting and especially not when tackling this angle. For some odd reason, it just didn't seem to work for me. Things looked wrong, most notably the leather which I rendered too clean and smooth. I then rendered it too rough and it became a muddy mess again, after which I made it too clean and smooth again! Everything seemed slightly wrong! Believing you have the image nailed, only to find out halfway down the road that it falls apart hurts. Experience told me that this often ends in total abandonment of an illustration and all attempts to revive it.

So according to that logic, this image should not have existed. And yet it does, because there

are times when the simple fact that a painting is not working out is enough to motivate me to keep pressing on. This is the benefit of limited brain capacity, I guess. There are times when I will abandon an image because of this, but since that is not a wise statement to publish to the world of commercial art, I won't! Anyhow I pushed on with it and the result was the girl you see in **Fig.04**. It was a struggle to get a balance between defining the shapes and keeping the looseness of the painterly strokes, but in the end it worked!

PULLING IT TOGETHER

Having "solved" that little bug in the painting, I stepped back and noticed that the hard fluff-killing brush was still dominating the picture. I like brush strokes when they demonstrate something, but I don't like brush strokes for the sake of brush strokes. At this point they seemed to overwhelm the picture. So I sadly let go of my highly valued brush strokes, picked the Hard Round brush (which was way softer than my hard fluff-killing brush) and started pulling it together. I did this by softening edges where I didn't want attention or felt the image had become too calm (**Fig.05**).

This part is very hard and usually works best if I step away from the painting for a few hours or days. It's tricky to see what is actually there and what your brain tells you is there. Allowing time for this is something I needed to learn. Giving the image that extra love it needed really helped to improve it.

After I had made a few final tweaks I was happy with the image and called it done (**Fig.06**)!

CARTOONS

LOUD SUNSHINE

By Guillaume Ospital

Software Used: Photoshop

CONCEPT

When starting a new piece I usually only have a really basic notion of what I want to draw. In this case I had some sort of snapshot of a girl reaching out to something huge falling from the sky, with everything frozen in time and simply standing still around her.

When starting a new image, the first obvious step is to draw a series of very quick, rough sketches to try and get a sense of what the image could look like, and quickly commit it to paper or Photoshop. I only spend a couple of minutes on each of these, trying to keep things extremely broad and simple. I do not use any colors, elaborate lighting or detail, and instead restrict myself to line and shape. I basically let the image do whatever it wants, and I just try to go along with it. There is no point in controlling anything at this stage. Things just need to be as loose and free as possible.

The only aspect I really focus on is the composition. Ultimately any illustration can be viewed as an ensemble of masses and empty

spaces that work together or against each other, and that's what I tried to achieve here.

I narrowed things down to three different compositions (**Fig.01 – 03**) and finally settled on the third one, which was possibly the least interesting and most obvious, but was the closest to the spirit I wanted in the final illustration. The diagonal shapes of the first version made the image a bit too aggressive, which didn't really fit the almost peaceful atmosphere I had in mind, whilst the second simply didn't tell the same story. The interesting thing while toying with different possibilities is

that even if you ultimately reject most, they're not lost and can still prove useful later on.

MY PAINTING

The next step was to try and establish the overall mood of the illustration before going into a more detailed phase. I did some quick color tests using a controlled palette that included a few dozen shades selected from a swatch file I have filled over the past few years by sampling colors from movies or photographs. Narrowing a movie still down to a few colors is an interesting exercise that often creates some great and unexpected palettes. Color balance

corrections make it really easy to test lots of variations, ranging from blue, desaturated and cold tones to warmer, dry, red/brown hues. In this case, I quickly settled for toned-down, earthy colors and a desert-like setting that I hoped would give the final illustration the out-of-time flavor I was looking for (**Fig.04**).

Now that the composition and global atmosphere were out of the way, I started working on the background. As I painted on top of the colored sketch, trying to refine the initial intention, I realized that the central stone pillar didn't stand out as much as I'd wished. While the character and background had to be treated as a whole and share the same warm, dominant colors, I wanted the stone pillar to look different, more monolithic and threatening. It wasn't necessarily the villain of the piece, but definitely didn't belong there. I toned it down to a bluer, almost grayish hue, which made it stand out more. The other pillars were all left alone. I wanted them to seem lost in the distance, to add a sense of depth to the image (**Fig.05 – 06**).

Having refined the background a bit, I started working on the character. I drew over the original sketch, trying to maintain the overall dynamic and sense of movement, staying as

zoomed out as possible. Working on a reduced canvas size prevents the rendering of tiny details, which in turn helps focus one's attention on the general attitude. It also keeps the design from becoming too crowded too soon, resulting in a more homogenous and solid line (**Fig.07**).

I then did the final clean version of the character, refining the lines and design, and adding detail and color (**Fig.08**).

Throughout this part of the process I constantly flipped my image horizontally, reversing my perception of the character as I'm often affected by the left/right hand bias. A drawing can look perfectly fine, but after flipping it, proportional mistakes and crooked body parts become painfully obvious.

I then went back to the background and tied everything together by working out the final

details. I defined the pillars in the background, such as the one exploding on impact (something I borrowed from one of the initial compositions). I also added pebbles across the ground, refined the depth, painted in shadows, made slight adjustments to the clothes, made some color corrections and shifted the color channels slightly (**Fig.09**).

Depending on the previous stage, this can either be the coolest part of the process or the most boring and mundane. But it is essentially in these final moments that the different elements find their place, details add themselves seamlessly and the illustration adopts a life of its own.

All that was left for me to do now was take a step back and find a fitting title (presumably while drinking some coffee).

ARTIST PORTFOLIO

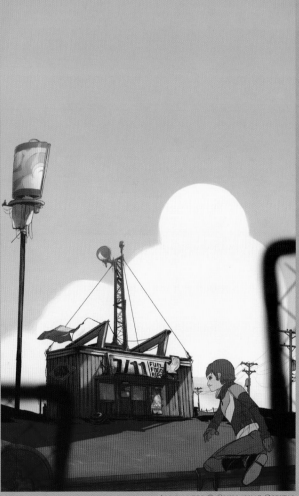

ALL IMAGES © GUILLAUME OSPITAL

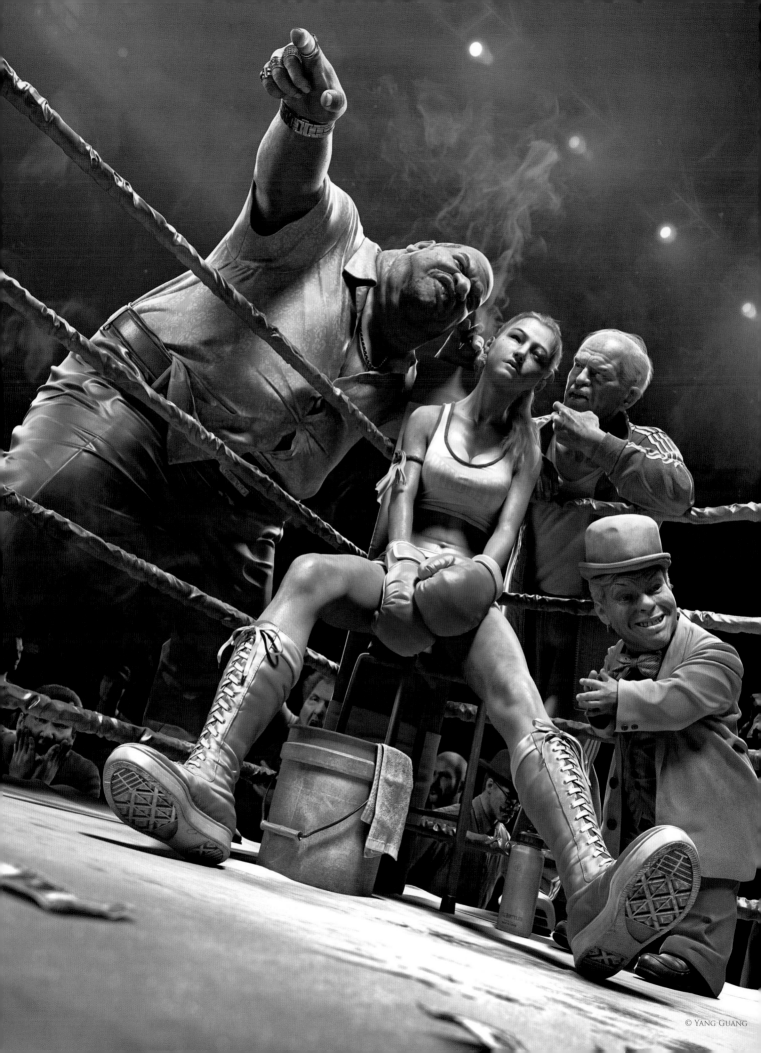

© YANG GUANG

FIGHT IN THE DARK

BY YANG GUANG
SOFTWARE USED: ZBrush and 3ds Max

CONCEPT

In this image I wanted to express a feeling. I wanted the main character to look like she was under intense pressure, but was also tenacious, unyielding and always willing to stand up and fight. The process that I used was not a standard process. As I was focused on the final appearance of the image, I avoided normal routines in an attempt to capture the personality of the characters. I started by thinking about the camera angle and by coming up with a basic concept sketch (**Fig.01**). I then created a simple base mesh for the characters that I could then adjust in ZBrush (**Fig.02**).

DRAFT

Having a good idea about what you want to do is an important part of the process. I spent some time thinking about the way I wanted the final image to look. To help me do this I gathered a selection of references for the characters and the overall theme of boxing. I also took some photos of myself in the poses that I wanted to use (**Fig.03**).

MODELING

In order to improve my efficiency I decided not to make any more base meshes and instead used ZBrush to create the characters from scratch (**Fig.04**). This is a really interesting way to do things as you are not as limited. As each subdivision level reached its capacity for detail, I subdivided the model, improving the detail step by step. During the early stages, the model was created with Symmetry turned on.

REFINEMENTS

Once I was satisfied with their bodies I posed them and then put them into the scene so I could see how they looked with the chosen camera angle. Doing this allowed me to get an idea of how the image would look when it was completed, and check the overall composition and appearance (**Fig.05**).

My main rule of thumb when modelling adheres to the principle of using square rather than round models to begin with. Similar to sculpture, these characters are carved from the same

model following the principle of first looking at local areas and then going back to the overall volume and repeating this step (for example, carving out the larger sections and then working down to details from the bones through to muscle, blood vessels and so on)(**Fig.06 – 07**).

TOPOLOGY

I used 3ds Max in conjunction with PolyDraw to organize the topology, as it is important to pay attention to the placement of three-, four- and five-sided polygons! If you are not careful the mesh will result in an unreasonable number of overall faces. I then used UV Layout to acquire the UVs, which is very fast.

TEXTURING

The texturing is a very important part in the process. A rich texture will add much to the model, with the key being to use a variety of colors to create a strong sense of volume and light throughout the mesh. To achieve this, all of the maps were hand-painted and adjusted until they were satisfactory. When painting the Diffuse map I tried not to pay attention to shadows and lighting because it can affect the rendering. However, at the same time, it can help darken the recesses and lighten the brighter areas, generally adding contrast and emphasizing the details across the model.

LIGHTING

The lighting is a very interesting aspect, which heightens the atmosphere and plays a vital role. It is worth noting that in order to more quickly and accurately render the test lighting, I applied mental ray materials to the entire scene

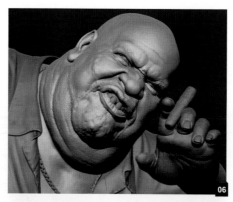

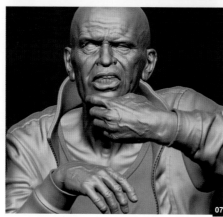

(**Fig.08**). Due to the nature of Arch & Design materials, I turned off the highlight reflectivity and avoided using a pure white. I then used mental ray to do a test render.

RENDERING

There are usually two options to choose from when rendering, one being layered rendering and the other involving an overall rendering. Both have advantages and disadvantages, but to increase productivity, I test-rendered specific layers (for example, I tested the lighting in relation to the unit measurement, which can

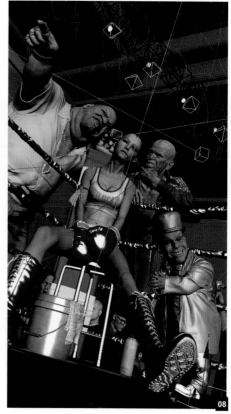

be in millimeters, centimeters or inches and sometimes needs the use of auxiliary objects as a measuring gauge). The depth of the character's skin has an intrinsic relationship with the lighting.

POST-PRODUCTION

As a final result I wanted a photographic quality and so added a Lens Blur and darkened the corners to help focus on the visual center in the form of the female boxer. Color correction was very useful and indeed necessary when it came to expressing the sensation of an underground ring. To do this I reduced the saturation to create the smoke-filled room and also took advantage of Fume FX effects to calculate the smoke. Once again I rendered the edge light to heighten the sense of volume and then composited everything in Photoshop (**Fig.09**).

CONCLUSION

I enjoy the fact that each idea requires its own process, and the associated problems these raise. When an idea cannot be perfectly realized it requires repeated deliberation and reflection, often resulting in numerous tests. Art comes from life and if one's ambitions are artistic then life will become the relentless pursuit of an artistic outlook.

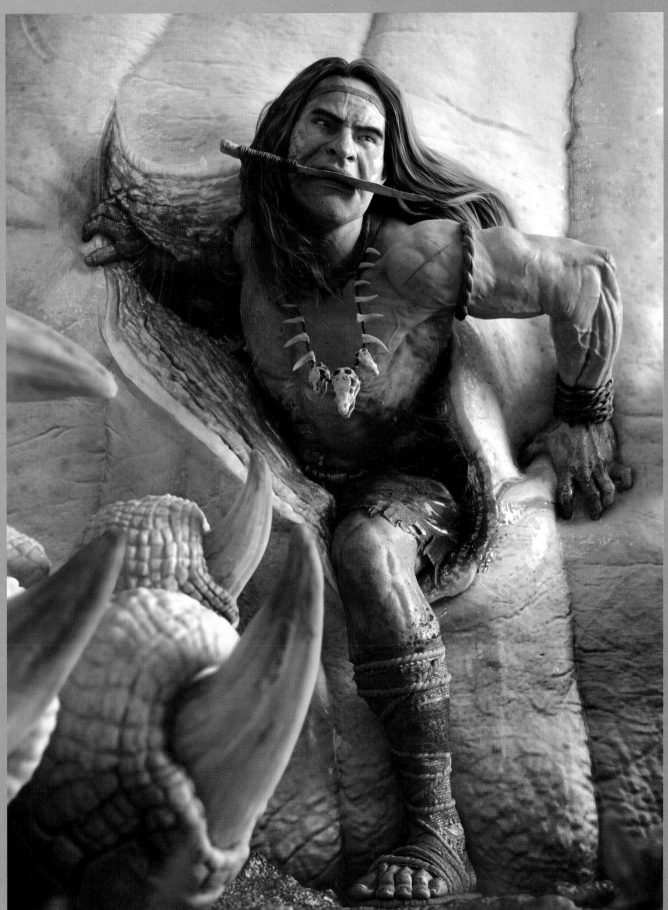

© YANG GUANG

VIKING

BY PEDRO CONTI
SOFTWARE USED: ZBrush and 3ds Max

INTRODUCTION

This image was a personal project I decided to start after watching *How to Train Your Dragon*. The actual idea wasn't to create a simple image, but rather to study each step of the process in depth. This image took me about five months to complete during my free time, which may seem lengthy but I'm sure that it has really helped me to improve my pipeline. My goal was to create a production quality character and therefore I spent a long time making sure it was right. I devoted a lot of time to studying topology, as well as the different hair systems, blend shapes, etc.

CONCEPT ART

I usually tend to create a bit of a story behind my character and this was no exception. One night I woke up with this idea in my mind: a Viking with a pink martini! I thought it would make a funny contrast. Despite the fact that I don't draw very well, I decided to try out a few sketches and to set the camera as if the Viking was being viewed through the bartender's eyes. I also wanted to give the Viking a very specific expression (**Fig.01**).

MODELING

I chose to create the character in ZBrush and by using ZSpheres was able to quickly create a base mesh from which to start sculpting. This process, in my opinion, is one of the most efficient approaches because you can focus on the design instead of worrying about the topology, which makes modeling more complicated.

To help design the character I used references from DreamWorks, Disney and Pixar. This kind of cartoon model is very simple and the hardest part is the design (**Fig.02**). I think having a lot of contrast in the proportions makes the character look more interesting and for this reason I made him fat with small, thin legs

After I had finished the blocking-in I exported the OBJ file into 3ds Max and started the retopology process using the Graphite modeling tools. One of the advantages of using 3ds Max

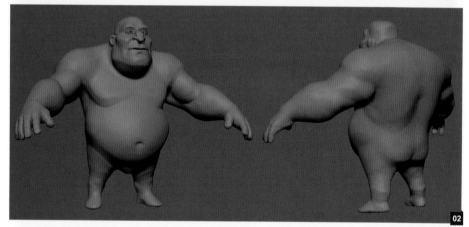

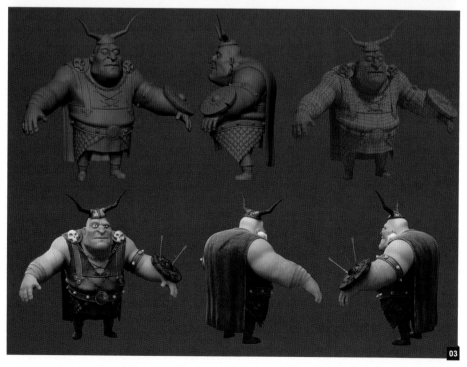

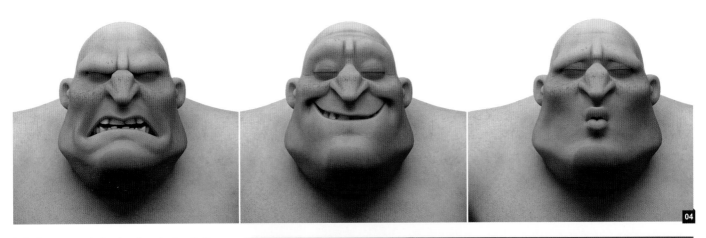

is that you can mix the topology tools with the standard polygon modeling tools. With the base mesh of my character done I was ready to start making his clothes and props inside 3ds Max. The environment was modeled with polygons, but I also used ZBrush to add the detailing and worn appearance (**Fig.03**).

> **USING BLEND SHAPES WAS ONE OF THE STEPS I ENJOYED MOST BECAUSE IT IS AT THIS POINT THAT I COULD DEFINE HIS PERSONALITY**

BLEND SHAPES
Using blend shapes was one of the steps I enjoyed most because it is at this point that

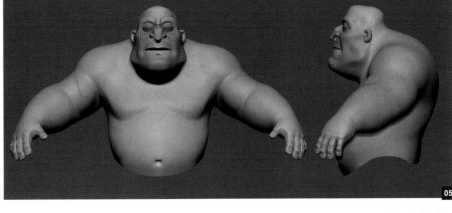

I could define his personality. I used many references to help me achieve stylized expressions, not least of which was Syndrome from *The Incredibles*, who was a great reference for what I had in mind. It's important to exaggerate the expression as much as you

can while still maintaining a natural look. During the modeling process I used a mirror to observe myself and understand how the muscles react in different expressions (**Fig.04**).

TEXTURING AND SHADING
I began creating the textures in ZBrush using polypaint because it's an easy way to define the basic color variation directly on the 3D model. After this I exported the maps into Photoshop so that I could start adding detail to them. For materials like the leather and fabric, I used seamless textures I found on websites like CGtextures.com, but the skin was completely hand-painted (**Fig.05**).

As I was planning to use mental ray to render my image, I chose the SSS Fast Skin material for the character's skin and skulls, and Arch & Design for the other objects. I tried different light rigs to observe how the shaders reacted as my plan was to do an animation using the Viking and so each of the materials needed to work regardless of the lighting scheme (**Fig.06**).

After many nights testing hair shaders, I discovered P_HairTK created by Ledin Pavel. I was looking for realistic hair rendering and

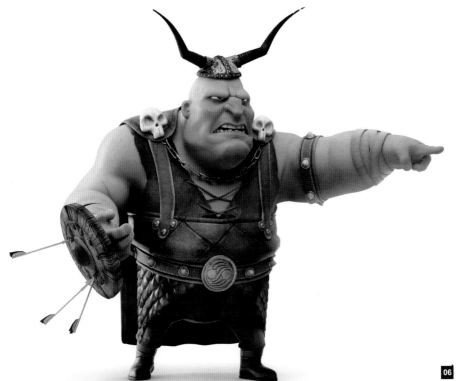

this shader allowed Final Gather, raytraced shadows and many other features with a fast render time.

Hair

The hair was the most challenging part of this project. As the character is stylized I had to stylize his beard and hair as well, which was a nightmare. Initially I tried the new plugin called HairFarm, but after many tests I decided to move back into 3ds Max's native Hair and Fur. The solution I eventually used was to divide the beard into different meshes. It gave me better control of the general shape and made the styling process easier (**Fig.07 – 08**).

Rigging

The rigging was done by my friend Alex Angelis. Before he began I showed him some rigging references by Alan Camilo (an amazing animator and rigger). This formed our starting point and once we had discussed what we both thought about how it should be done, we were confident we could come up with something approaching a professional quality. Despite

doing things quickly, he made and remade several parts and worked tirelessly until the best result was achieved.

Lighting and Rendering

As I mentioned before, I used mental ray to render the scene. There are about twelve photometric lights in my scene, consisting of two main light sources: yellow being the

main light and another blue light providing the rim lighting. All the remaining lights work as fill lights and light bounces. To help the light bounce I used Final Gather with a low preset (**Fig.09 – 10**).

Compositing

The final image was rendered at 4500 pixels wide and took about 10 hours to complete

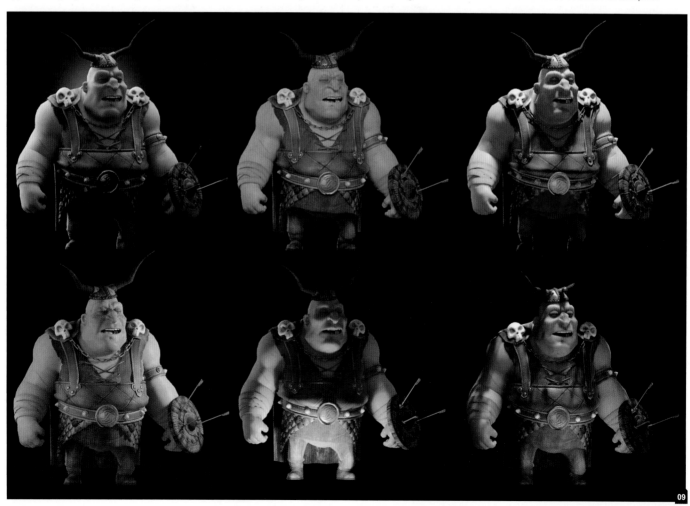

on an Intel I7 950. I rendered three passes: a beauty pass, a hair pass (to speed up the final render I separated the hair pass) and a Z-Depth pass. The Z-Depth pass was used to create the Lens Blur using the amazing Lenscare plugin for After Effects (**Fig.11**). For the color corrections I used Curves and Photoshop Gradient maps. Lightroom was used to add grain, vignetting and subtle chromatic aberration.

CONCLUSION

This project took me a long time to do, but provided me with an opportunity to grow as an artist and develop my perception and skills in both artistic and technical direction. Sometimes it is hard to manage my free time to complete a project, but it is definitely worthwhile. I'm really happy with the final result and with the opportunities this character presented to my professional career (especially this one in *Digital Art Masters!*). I would like to say thanks to my family, girlfriend and friends who supported me during this project.

ARTIST PORTFOLIO

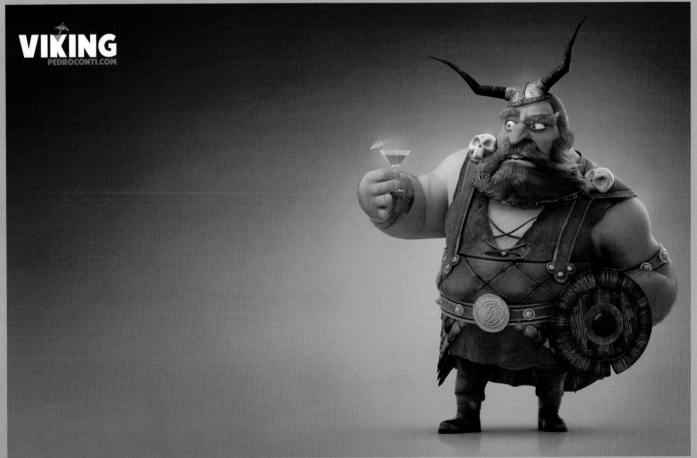

© PEDRO CONTI

The 2012 Digital Art Masters

ALESSANDRO
BALDASSERONI
baldasseroni@gmail.com
http://www.eklettica.com

BRUNO
JIMÉNEZ
br1.jimenez@gmail.com
http://www.brunopia.com

DENNIS
CHAN
dchan.art@gmail.com
http://www.dchan.se

ANDREW
BAKER
androo.baker@gmail.com
http://andbakerdesigns.
blogspot.com

CAIO CÉSAR
BRACHUKO FANTINI
caio.fantini@globo.com
http://caiofantini.blogspot.com

ETIENNE
JABBOUR
etienne@slidelondon.com
http://www.slidelondon.com
http://etienne.cghub.com

ANDREW
THEOPHILOPOULOS
theonidesart@gmail.com
http://cargocollective.com/
Theonides

CHASE
TOOLE
chasetoole@gmail.com
http://www.chimpsmack.
blogspot.com

FILIP
NOVY
info@filipnovy.com
http://filda.cgsociety.org/
gallery

ANDRZEJ
SYKUT
eltazaar@gmail.com
http://www.azazel.
carbonmade.com

DANIEL
SCHMID LEAL
dslvfx@gmail.com
http://www.danielvfx.com

FRANCISCO
JOSE ALBERT ALBUSAC
francis.jaa@gmail.com
http://www.tatitati.deviantart.
com

ARDA
KOYUNCU
ardakoyuncu@gmail.com
http://www.ardakoyuncu.com

DARYL
MANDRYK
blackarts@shaw.ca
http://members.shaw.ca/
dmandryk/index.htm

GILLES
BELOEIL
gillesbeloeil@hotmail.com
http://www.gillesbeloeil.com

BLAZ
PORENTA
blaz.porenta@gmail.com
http://blazporenta.blogspot.
com

DAVID
ARCANUTHURRY
daounin@gmail.com
http://daounin.cgsociety.org

GUILLAUME
OSPITAL
cakeplease@cakeordeath.fr
http://www.cakeordeath.fr

BORISLAV
KECHASHKI
b.kechashki@gmail.com
http://galero.cghub.com

DAVID
MORATILLA AMAGO
dmoratilla@gmail.com
http://www.davidmoratilla.com

IGNACIO
BAZAN LAZCANO
i.bazanlazcano@gmail.com
http://www.neisbeis.deviantart.
com

BRAD
RIGNEY
cryptcrawler@comcast.net
http://cryptcrawler.deviantart.
com

DAVID
MUNOZ VELAZQUEZ
munozvelazquez@gmail.com
http://munozvelazquez.com

IOAN
DUMITRESCU
jononespo@yahoo.com
http://jonone.cghub.com/
images

BRANDON
MARTYNOWICZ
lnfa_reds@yahoo.com
http://blazing3d.com

DAVID
SMIT
david@davidsmit.com
http://davidsmit.com

JAMA
JURABAEV
jama_art@tag.tj
http://jamajurabaev.
daportfolio.com

THE 2012 DIGITAL ART MASTERS

JEAN-MICHEL
BIHOREL
jm_bihorel@hotmail.fr
http://jmbihorel.wordpress.com

LUPASCU
RUSLAN
vearusden@yahoo.com
http://www.lucrari.carbon-made.com

SERGIO
DIAZ
diaz.sergio@live.com
http://www.sergiodiaz.com.ar

JESSE
SANDIFER
jessesandifer@gmail.com
http://www.chickwalker.com

MACIEJ
KUCIARA
kuciaramaciej@gmail.com
http://www.maciejkuciara.com

SIMON
ECKERT
se@holyquid.de
http://www.holysquid.de
http://scebiqu.deviantart.com

JOHANNES
VOß
algenpfleger@googlemail.com
http://algenpfleger.cghub.com

PEDRO
CONTI
pedro_conti@hotmail.com
www.pedroconti.com

THEO
PRINS
theo.w.prins@gmail.com
http://www.variousplaces.org
http://www.theoprins.com

JOHN
PARK
jpforjohnpark@aim.com
http://jparked.blogspot.com

PUPPETEER
LEE
puppeteeer@gmail.com
http://puppeteer.cghub.com

TOBIAS
TREBELJAHR
tt@glarestudios.de
http://www.trebelja.com

JUSTIN
ALBERS
albers.justin@gmail.com
http://www.justinalbers.com

RAFAEL
GRASSETTI
rafagrassetti@gmail.com
http://grassettiart.com

YANG
GUANG
as_artsunshine@hotmail.com
http://artsunshine.cghub.com/

KENICHI
NISHIDA
kenichi.nishida@gmail.com
http://www.kenichinishida.com

ROBH
RUPPEL
robhrr@yahoo.com
http://www.robhruppel.com

KIERAN
YANNER
kieran@kieranyanner.com
http://www.kieranyanner.com

ROBIN
BENES
tes@tes3d.com
http://www.tes3d.com

LEVI
HOPKINS
levimhopkins@hotmail.com
http://levihopkinsart.blogspot.com

RUDOLF
HERCZOG
rudy@rochr.com
http://rochr.com

LOÏC E338
ZIMMERMANN
info@e338.com
http://www.e338.com

SERGE
BIRAULT
serge.birault@hotmail.fr
http://www.sergebirault.fr

INDEX

ZBrush Character Sculpting
Projects, Tips & Techniques from the Masters

ZBrush Character Sculpting
Projects, Tips & Techniques from the Masters

3dtotal
PUBLISHING

V1

3dtotal

"Often you find a little information here or there about how an image was created, but rarely does someone take the time to really go into depth and show what they do, and more importantly why. This book contains clear illustrations and step-by-step breakdowns that bring to light the power of concepting directly in ZBrush, using it for full on production work and using the software with other programs to achieve great new results."

Ian Joyner | Freelance Character Artist
www.ianjoyner.com

ZBrush has quickly become an integral part of the 3D modeling industry. *ZBrush Character Sculpting: Volume 1* explores the features and tools on offer in this groundbreaking software, as well as presenting complete projects and discussing how ZSpheres make a great starting point for modeling. Drawing on the traditional roots of classical sculpture, this book also investigates how these time-honored teachings can be successfully applied to the 3D medium to create jaw-dropping sculpts. Featuring the likes of **Rafael Grassetti**, **Michael Jensen** and **Cédric Seaut**, *ZBrush Character Sculpting: Volume 1* is brimming with in-depth tutorials that will benefit aspiring and veteran modelers alike.

This book is a priceless resource for:

• Newcomers to ZBrush and digital sculpting in general
• Artists looking to switch from a traditional medium
• Lecturers or students teaching/studying both traditional and digital modeling courses
• Hobbyists who want to learn useful tips and tricks from the best artists in the industry

Softback - 22.0 x 29.7 cm | 240 pages | ISBN: 978-0-9551530-8-2

3DTOTAL.COM
Visit 3dtotalpublishing.com to learn more about our book range

DIGITAL PAINTING
techniques

DIGITAL PAINTING
techniques

VOLUME 3

3

"Digital Painting Techniques: Volume 3 is a brilliant book. It has so many incredible images from so many astounding artists that it melted my eyes very slightly trying to take it all in. It should come with some sort of warning really – that would be fair. In fact, it should come with a voucher for five hundred bucks worth of laser eye surgery and a note to your boss or teacher asking for a day off for a lie down."

Greg Broadmore | Senior Concept Artist – Weta Workshop
www.gregbroadmore.com

The popular *Digital Painting Techniques* series returns for a third volume, bringing together another great collection of tips, tricks and advice from some of the world's best digital artists. Industry veterans including **Robh Ruppel**, **Chee Ming Wong** and **Ignacio Bazan Lazcano** tackle topics ranging from matte painting through to painting portraiture and concept art for games. Their in-depth tutorials offer an insight into the working practices of artists in the digital art industry, making *Digital Painting Techniques: Volume 3* a great source of inspiration and a motivational learning tool for artists of all levels.

VOLUME 2
Digital Painting Techniques: Volume 2 covers a wide variety of themes and topics, and provides in-depth tutorials to aid and inspire any digital artist, whether beginner or veteran. Custom brushes, speed painting, characters and fantasy are just a few of the subjects covered in this must-have book, with each tutorial providing a logical and professional approach to image creation.
Softback - 21.6 x 27.9 cm | 288 Premium full color pages | ISBN: 978-0-9551530-1-3

DIGITAL PAINTING
techniques
VOLUME 2